TATE MODERN
the handbook

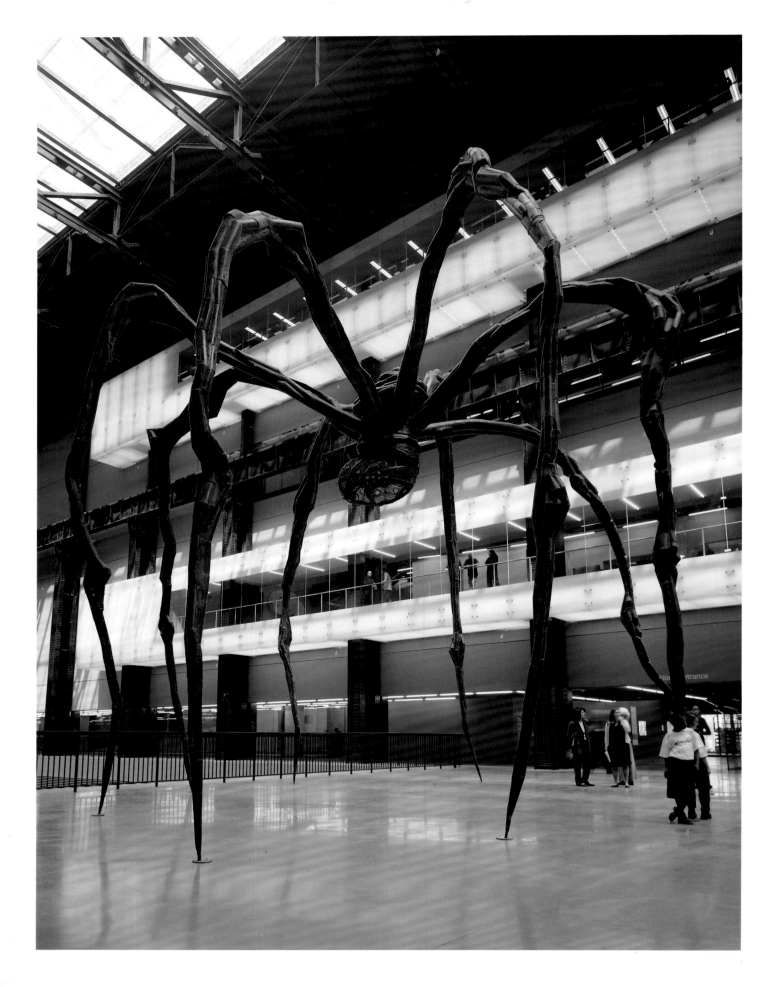

Edited by Iwona Blazwick and Simon Wilson
Tate Publishing

TATE MODERN
the handbook

Published by order of the Trustees
of the Tate Gallery 2000

ISBN (paper) 1 85437 312 9
ISBN (cloth) 1 85437 330 7

A catalogue record for this book is
available from the British Library

Published by Tate Gallery Publishing Limited
Millbank
London SW1P 4RG

Designed and Typeset by SMITH
Printed in Great Britain by Balding + Mansell, Norwich

Cover: Tate Modern
Photo: Marcus Leith
Frontispiece: Louise Bourgeois *Maman* 1999
installed in the Turbine Hall
Photo: Marcus Leith

Sponsor's Foreword

Throughout history, art, in all its many forms, has been one of
the most powerful and enduring ways in which people have
communicated feelings, ideas and emotions. So it is entirely
appropriate that BT, a company dedicated to encouraging and
sustaining a communicating society, should be an enthusiastic
promoter and supporter of the arts through its Community
Partnership Programme.

With the opening of Tate Modern and the new Tate Britain, Tate is
going to play an increasingly important part in the cultural fabric
of this country and we are delighted to be supporting it at such
an exciting time.

Sir Iain Vallance
Chairman, British Telecommunications plc

Tate Modern: Collection 2000
in association with BT

Tate Modern
supported by **Bloomberg**
NEWS

Tate Modern was built with the support of

THE MILLENNIUM COMMISSION

A MILLENNIUM PROJECT
SUPPORTED BY FUNDS
FROM THE NATIONAL LOTTERY

english
PARTNERSHIPS
LONDON

The Arts Council
of England with
National Lottery
funds

Southwark
Council

Acknowledgements

The opening of Tate Modern is the culmination of a process which began nearly ten years ago when the Trustees first debated the future of the growing Tate Collection. In 1992 the Trustees took the momentous decision to create a museum of modern art for the nation on a new site in London. Since then several thousand people have played their part in making the idea a reality, by their energy, generous financial support, artistic endeavour, professional expertise and building skills.

Singling out any one individual is extremely difficult but at a personal level I should like to pay special tribute to Dennis Stevenson, now Lord Stevenson, Chairman of the Trustees from 1989–1998, who boldly led the Trustees on the path to a new future.

I should also like to thank everyone who has contributed to the creation of the building and its programming, from the earliest planning groups and those who provided start up funding in 1994, to those who are supporting exhibitions and other activities in the new gallery. Of particular importance has been the commitment of The Millennium Commission, English Partnerships, The Arts Council of England and Southwark Council, without whom realisation of the building would have been impossible. Public and private donors are listed at the back of this book, and we extend to them our deepest gratitude for supporting our vision.

On behalf of our future visitors may I express our warmest thanks to all the benefactors, artists, advisors, builders and Tate staff who have shared the Trustees' belief in the cultural and social importance of modern art in contemporary society. *Ars longa vita brevis.*

Nicholas Serota
Director, Tate

Director's Foreword

A new gallery – and a new book. Tate Modern is new yet has roots that extend back more than one hundred years. It is a direct descendant of Sir Henry Tate's foundation which opened in 1897 as the National Gallery of British Art, but which was popularly known from the start as the Tate Gallery. The precise origin of Tate Modern came in 1917 when the Tate was given the task of putting together a national collection of international twentieth-century art.

A new gallery – and a new book. It is our hope that both the visitor's experience of the gallery and the reader's experience of this book will reflect what lies at the heart of Tate Modern: its origins in an institution whose distinguished tradition of scholarship and research, and ambition to stand alongside the great museums of modern art, have borne beautiful and provocative fruit in an extraordinary collection of twentieth-century art, built over more than eight decades, and including many classic modern master-pieces. But there is also something else, equally important. We hope that those who walk through the spacious rooms of Tate Modern, or immerse themselves in *The Handbook*, will always feel that what they are experiencing is part of their own time. We hope that our visitors will perceive meaning in early twentieth century art as viewed from today's perspective, while at the same time according contemporary art the same importance as established masterpieces.

The Tate collection of international modern art begins at the turn of the twentieth century with the revolutionary developments that were taking place, primarily in painting, in Paris. It then takes us through the century to the radically different situation today, when media, techniques, and forms of presentation inconceivable then, seem to dominate the art scene. The traditional way of structuring such a collection, either in terms of displays or as a book, is to present it as a linear chronology. For both Tate Modern and *The Handbook*, however, we have chosen instead to look at the art of the last hundred years from the vantage point of four separate themes that cut right through history. The arguments for adopting this new approach to the story of modern art are many, and are developed later in this book; but the benefits are often immediate, straightforward and wonderful – as in being able to view, for example, Monet's *Water-Lilies* next to a stone circle by Richard Long of 1991. Such pairings modestly and eloquently bear witness to both the great distance and the tremendous affinities between works of art and ways of working at either end of a century.

Tate Modern: The Handbook, like Tate Modern, the gallery, emphasises that nothing surrounding a work of art is neutral; that everything has an impact on the way we interpret what we see – from the way a collection is displayed, its narrative structure and physical rhythm, to the character and even the location of the building, the place where we, the visitors, find ourselves. Every museum is unique; Tate Modern's individuality lies not just in its collection or its location in the middle of London, across the river Thames from St Paul's Cathedral, in the historical and culturally diverse Bankside district of Shakespeare and Dickens, but also in its architecture – Herzog & de Meuron's minimalist yet dramatic conversion, or rather appropriation, of Sir Giles Gilbert Scott's Bankside Power Station.

The Handbook is a reflection and a complement to a visit to Tate Modern. But a book can also offer things that a museum cannot. The concluding section is an A to Z of one hundred of the foremost artists in one of the world's leading collections of twentieth-century art. Its texts also discuss the movements and terms that have shaped our understanding of the past century. In this way, this book is not just about one of the most important museums in its field, but is also a flexible tool for the understanding of modern art.

The major task of developing the opening displays for Tate Modern has been a highly collaborative undertaking involving large numbers of Tate Modern staff, working alongside curators from the Tate Collections Division. A few individuals should be especially mentioned because of their central role in the process.

Iwona Blazwick, Head of Exhibitions and Display at Tate Modern, and Frances Morris, Programme Curator at Tate Modern are due particular thanks for their work in developing the conceptual framework of the displays. The process of implementation and detailed development of individual rooms has been led by Frances Morris. She worked with a team of curators: Catherine Kinley, Sean Rainbird, Jennifer Mundy, Paul Moorhouse, Tanya Barson, Kirsten Berkeley and the late Monique Beudert. They were supported throughout the process by Jeremy Lewison, Director of Tate Collections. Jane Burton, Interpretation Editor, Tate Modern, originated and managed the programme of interpretation.

The displays at Tate Modern have been enormously enriched by generous loans from individuals in Britain and abroad. Our warmest gratitude goes to such long term Tate supporters . We would especially like to thank Josef and Anna Froehlich, who have lent several key groups of works in order to enhance particular themes.

Tate Modern: The Handbook has also been a large and challenging project. Our most heartfelt thanks go to the authors, for such thoughtful and scholarly texts; to Iwona Blazwick, and to Simon Wilson, Tate Communications Editor, who have worked with Sarah Derry and Mary Richards, Tate Publishing Editors, to realise such an ambitious book.

The installation of hundreds of works of art in more than eighty new gallery spaces has not only been a major intellectual and curatorial undertaking. Without the skill, patience and dedication of Tate Modern's Art Installation Manager, Phil Monk and his team, working closely with Programme Curators Helen Sainsbury and Sophie Clark, as well as the keen co-operation of all the Tate Conservators led by Jim France, Director of Collection Services, it simply would not have happened.

Neither could these new displays have happened without substantial financial support. We would therefore like to direct our warm thanks to British Telecommunications plc, and its Chairman, Sir Iain Vallance, for support of *Tate Modern: Collection 2000*.

Lars Nittve
Director, Tate Modern

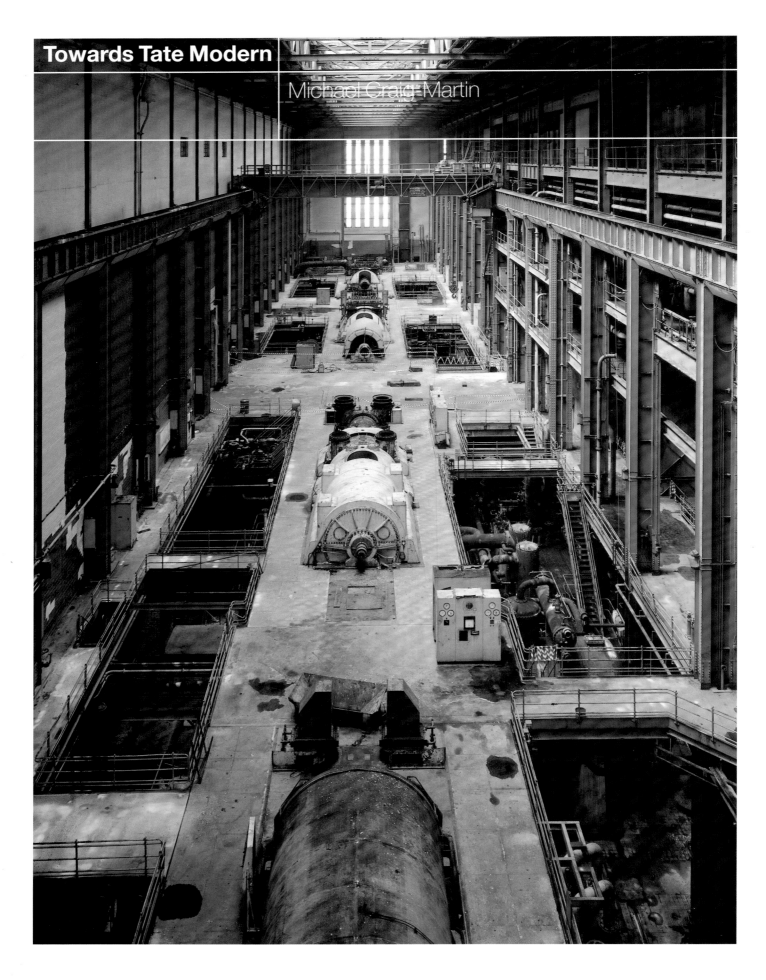

Towards Tate Modern

Michael Craig-Martin

I had the good fortune to be appointed as an Artist Trustee of the Tate Gallery in 1989. The ten-year period of my Trusteeship proved to be one of the most proactive and expansive in Tate history. As a Trustee I had the opportunity to participate in the sequence of discussions and decisions that led to the creation of Tate Modern at Bankside.

Soon after his appointment as Director in 1988, Nicholas Serota initiated a number of key changes. He decided to restore the original architectural integrity of the Millbank building by the removal of all the temporary walls and false ceilings that had been constructed over the years. Most significantly, he decided to entirely reorganise the display of the Collection. These changes brought into sharp focus the limited and inadequate exhibition space, and the urgent need for new buildings.

In the early 1980s an architectural master plan for the Millbank site had been created by James Stirling, shortly after his design of the Clore Gallery in 1981. On reconsideration of this plan, the Trustees decided that it did not provide for sufficient new exhibition space for the present and anticipated needs of the gallery. Although significant development possibilities at Millbank were identified, it was clear that these alone would not be adequate for the Tate properly to fulfil its responsibilities while maintaining and enhancing its international status.

The Trustees concluded that a second site in London would have to be found. This decision raised the critical curatorial and administrative problem of determining the basis on which work would be shown at each site. Should the Collection be divided, and if so along what lines? Extensive discussions were held with a wide range of participants from both inside and outside the institution.

The Trustees decided to maintain and continue to develop the Collection as a single holding, but to divide what might be shown at each London site on the basis of its two principal areas of responsibility: British art at Millbank, international modern art at Bankside. This would mean, in effect, that Bankside would become the extension of the National Gallery, showing work from 1900 onwards. It would also mean the work of any modern British artist held in the Collection could be shown at Bankside as well as Millbank.

A search was begun to locate a new site. The basic requirements were not extensive and more or less obvious, but had the effect of severely limiting the options: a large-scale central location, ready accessibility by public transport (particularly the tube), within reasonably easy reach of Millbank, and available for development in the near future.

A number of sites were considered, but most fell through or were rejected as inadequate: the car park area on the river between Hungerford Bridge and Jubilee Gardens (very limited for building because of height restrictions); at the centre of a new park to be created as

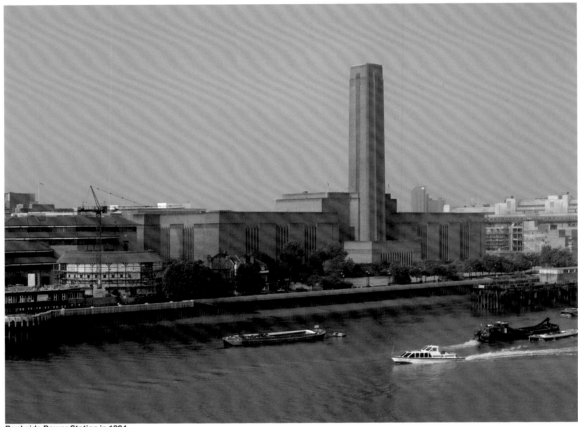

Bankside Power Station in 1994

part of a proposed redevelopment of the wasteland area behind King's Cross (project eventually shelved); a docklands site east of Canary Wharf (too isolated and inaccessible).

Francis Carnwath, Deputy Director at the time, came across the decommissioned Bankside Power Station in Southwark and recommended that Nicholas Serota and the Trustees consider it. Despite its immense size and its key location on the south side of the river opposite St Paul's Cathedral, this building, more or less inaccessible from the riverwalk and hidden by seedy office buildings on the south side, was largely unknown. Abandoned as a power station for more than ten years but still housing an electricity switch station, the building had become a brooding presence and a blight on the redevelopment of the surrounding area.

Bankside Power Station was designed and built after the Second World War by the distinguished British architect Giles Gilbert Scott, to provide electricity for the City. Scott is best known as the designer of London's other great power station at Battersea, now sadly derelict, and Liverpool Anglican Cathedral, as well as the once ubiquitous red telephone box.

The Bankside building was notable for its plain red brick exterior and the powerful

symmetry of its horizontal mass, bisected at the centre by a single tall, square chimney. The building was articulated on three sides by a series of immense, well detailed windows. The only decoration came from the brickwork crenellation along the building's edging, cleverly mitigating its great bulk.

Inside, the building proved to be just as striking and unusual. Built to house the immense turbines, boilers and ancillary equipment of a power station, the building itself was architecturally simply a shell, a box. Its vast interior was divided along its entire length by a series of great steel columns, creating two interlocking spaces, the boiler house and the turbine hall. There were no normal floors, no staircases, no interior walls: everything inside had been built as part of the machinery, not part of the building. Removing the machinery would mean revealing a vast empty space within which virtually any construction might be possible.

The power station was far larger than anything we as Trustees had imagined building from scratch. From the beginning of the project, it had always been our assumption that we would be commissioning an entirely new building. The discovery of Bankside dramatically altered our perception of the possible appearance, scale and function of the new gallery.

The Trustees decided to acquire Bankside and develop it as the site for the new gallery of modern art. The site answered all the criteria governing the search: an unparalleled large-scale central London location, excellent transport facilities (including the new tube station at Southwark), the possibility of a riverboat connection with the gallery at Millbank, and immediate availability for development. The local council, Southwark, recognising the potential impact of the Tate project on development and employment in this largely run-down area, enthusiastically supported it from the start.

The vast size of the building meant that the Tate would be able to more than double its capacity for showing its collection as well as housing major large-scale temporary exhibitions. Bankside also provided a remarkable bonus for an institution with the remit to increase its holdings constantly: even after realising our most ambitious development plans, more than a third of the space in the existing building (the present switch station on the south side and the cavernous underground area below) would remain untouched, waiting for development in due course.

Anyone who has had experience of working on a major architectural project will tell you that for it to be truly successful there has to be a single-minded project leader, someone who has a clear idea of what is needed and a vision of what the best might be, who oversees the project from conception to completion. In this case such leadership was provided by the Director, Nicholas Serota. Early in the planning stages of the project, he asked the sculptor Bill Woodrow

Constructing the light beam

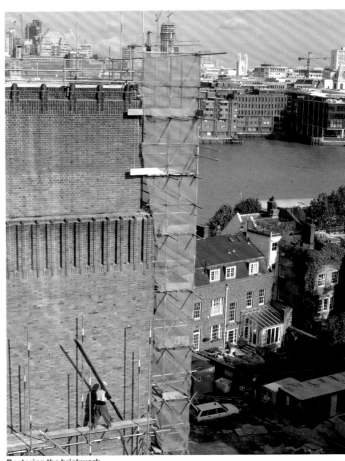

Restoring the brickwork

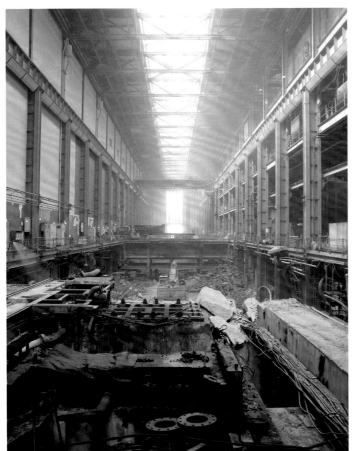

Transforming the Turbine Hall

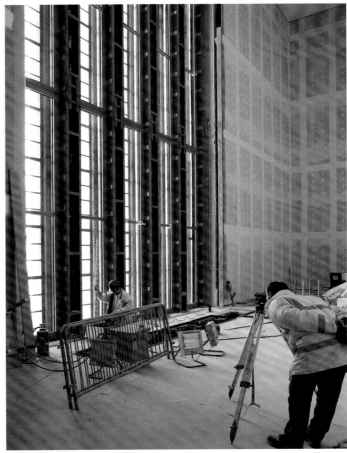

Working on a double height gallery

and myself to tour a number of recently built museums of modern and contemporary art on the Continent, to consider them critically from our point of view as artists, and report to the Trustees. We went to a variety of institutions including those at Bonn, Frankfurt, Münchengladbach and Maastricht, and came to several conclusions. In general these modern museums seemed to serve the interests of architecture and architects more clearly than those of art and artists. Many architects clearly considered designing a museum to be a prime opportunity for high-profile signature work. On the other hand few architects seemed truly to understand or be interested in the needs of art.

In comparison with the entrance halls, staircases, restaurants and other facilities, the galleries for showing art were often, in our view, the least successful spaces in the building. Few architects appeared to have established properly considered criteria for the design of good modern galleries. They tended either to create sequences of more or less identical and characterless neutral spaces or to make self-consciously over-designed spaces where art was barely necessary.

By contrast we found that the most sympathetic and stimulating places in which to see modern and contemporary art were in older buildings converted from an earlier industrial or other purpose, such as the private Dupont Foundation in Tilburg (similar in character to the Saatchi Gallery in London) and the Hallen für Neue Kunst at Schaffhausen near Zurich. None of the purpose-built museums could match the stimulating quality and variety of these exhibition spaces, nor the opportunity for interaction between the art and the space.

We reported these views to the Director and to the other Trustees, and they were later confirmed by the majority of artists responding to a questionnaire on the subject initiated by the Tate. As a consequence, a decision was taken that *the* central concern of the design of the new building would be to address the needs of art through the quality of the galleries and the range of opportunities, both sympathetic and challenging, for showing art. While seeking the best possible architectural solution, we determined that the project would be art led not architecture led.

Many architects were bitterly disappointed by the Trustees' decision to make use of the existing Bankside building rather than to create something entirely new. Some, seeing this as the betrayal of a unique architectural opportunity for London, interpreted it as the result of a loss of institutional nerve. I believe that the Tate showed exceptional courage and ambition in its decision to go to Bankside, which in turn demanded a radical architectural solution.

Under the guidance of Richard Burdett, Director of the Architecture Foundation, an open international architectural competition was initiated with the stated aim of finding the right

architect for the Tate to work with, rather than a highly resolved design proposal. A jury of ten members was appointed, with Janet de Botton and myself representing the Trustees. The jury sought to consider the proposal of each architect in the light of three principal questions: their approach to the architectural problem, particularly how to deal with the existing building and its position in the urban context, their ideas for the display and presentation of modern and contemporary art, and their interest in and understanding of art itself.

Nearly 150 architects entered the competition, including many of the world's most distinguished, but it was clear from the start that few were comfortable with the problem of working with the shell of the Giles Gilbert Scott building. Some essentially ignored the structure and designed within it the building they would have had it not existed, while others attempted to neutralise it by completely altering or removing significant parts. Some sought to dramatise the architectural confrontation of old and new by having parts of their proposed new internal museum structure pierce through the older power station shell.

The six finalists in the competition could be seen to represent two generations of architects: the established masters Tadao Ando, Raphael Moneo and Renzo Piano, and the rising generation of David Chipperfield, Jacques Herzog and Pierre de Meuron, and Rem Koolhaas. It would be difficult to exaggerate how stimulating and challenging it was to be part of a jury charged with interviewing architects of this calibre and evaluating their proposals, and how daunting was the sense of responsibility in making a final selection for a building of such lasting national importance. In the end the jury came to a unanimous decision to recommend to the Trustees that they appoint the Swiss architects Herzog & de Meuron.

Why did Herzog & de Meuron win against such formidable competition? There are of course many reasons, but one seems to me to be absolutely central. All the other proposals treated the existing building as a shell within which their new structure would stand. Herzog & de Meuron's was the only proposal that completely accepted the existing building – its form, its materials and its industrial characteristics – and saw the solution to be the transformation of the building itself into an art gallery. They proposed a true union of their design with that of Giles Gilbert Scott, turning the box into a new building. Open, flexible and pragmatic, Herzog & de Meuron's approach to the project was concept rather than design based, reflecting the similarity of their practice with that of many contemporary artists.

Their proposals acknowledged the symmetry of the exterior by creating within the boiler house a new five-storey structure, with three floors given entirely to six suites of galleries, two to a floor, built around a central service core containing the main staircase, escalators, lifts and toilets. The intention was to divide the displays into manageable units for visitors and create a building in

Concourse, level five

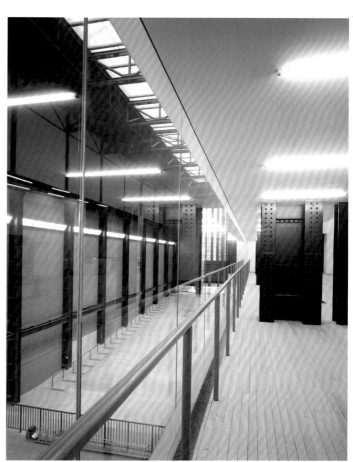

Concourse, level three

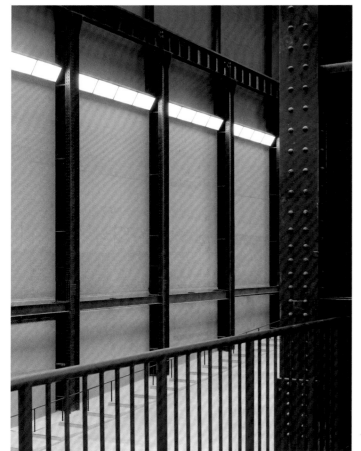

Detail of the Turbine Hall

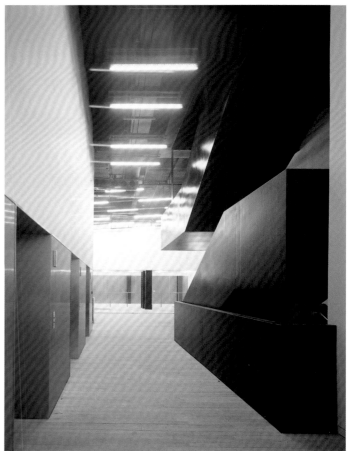

Lifts and staircase, level three

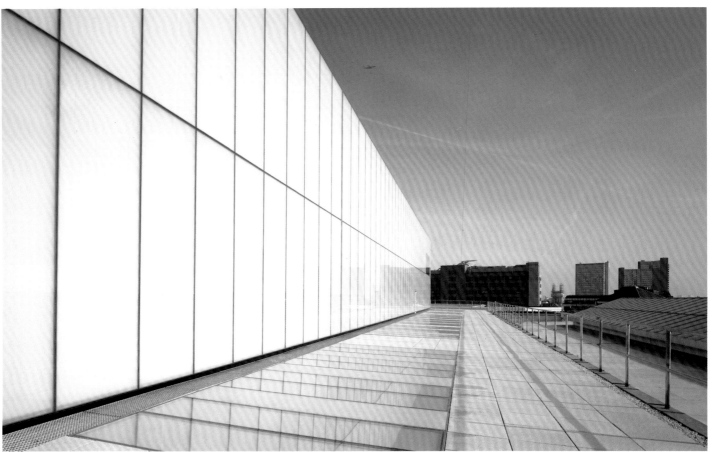

View of the light beam from the roof

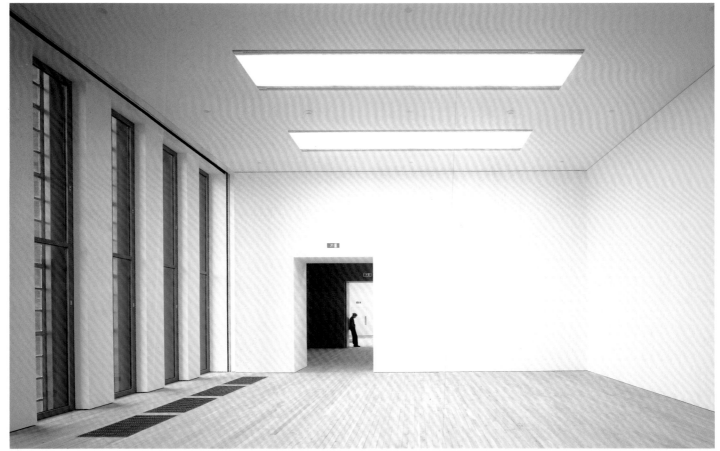

A gallery on the third level

which, despite its great size, one would always have a sense of where one was. The galleries would all have high ceilings and whenever possible be lit by the large existing windows.

The most dramatic alteration to the appearance of the existing building would be a new two-storey-high frosted-glass beam running its whole length, acting architecturally as a translucent horizontal counterfoil to the dark vertical mass of the chimney. This light beam would clearly signal the change of function of the building from power station to art gallery, its welcoming beacon a striking addition to the London skyline. The beam would, of course, provide exceptionally beautiful skylighting for the top floor galleries, but also house all the building's service equipment and make possible a restaurant with views across the river to St Paul's. At ground level the architects proposed removing most of the building's smaller wings and outcrops to create a simpler perimeter. The building would rise dramatically from the newly created open piazza stretching to the river.

During the intensive design period following their appointment, the architects, led on site by Harry Gugger, proposed that the existing turbine hall should retain its character more or less unaltered and function as the entrance to the new gallery as well as providing a vast new exhibition space. However, instead of the ground floor being at ground level, they decided it should be established at basement level, opening up the existing space even more. This interior ground floor would be reached by the public from outside down a long concrete ramp the width of the turbine hall. The new building in the boiler house would thus effectively gain a complete floor in height rather than a windowless basement. The turbine hall would become even higher and be crossed at actual ground level by a wide bridge.

Regular and intensive discussions took place between the design team, led by the architects Jacques Herzog and Harry Gugger, with the engineers Ove Arup & Partners and quantity surveyors Davies Langdon & Everest, and representatives of the Tate, both Trustees and staff (notably Peter Wilson who led the Tate team). The final character of the building and especially that of the gallery spaces, emerged from those meetings. It is important to remember that despite constructing the new gallery within an old building, this is not, in a conventional sense, a conversion: everything one sees is new, except the windows – and even these have new internal fittings. It was decided, however, that the basic aesthetic of the old building, its strong simple industrial character, should be continued into the new.

The exhibition galleries were designed to have the feel of real rooms, with substantial walls, plain ceilings, and oak doors, rather than the temporary quality of partitioned spaces. The overhead light fittings are hidden in deep boxes and show only as translucent glass rectangles flush with the ceiling. To emulate the quality of natural light on every floor, they offer a

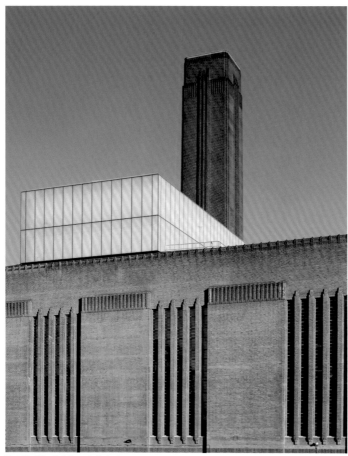
Detail of the brickwork, light beam and chimney

wide and flexible range of light from warm to cool. Though fitted with tracks for supplementary spotlighting where necessary, they have eliminated the need for the banks of light fittings that clutter the ceilings of most galleries. The floors are either rough-cut unpolished oak, which will develop a natural patina over time from the footsteps of millions of visitors, or polished concrete. Set into these floors are the forthright cast iron grids of the air vents.

There is a great variety of gallery spaces, rooms large and small of true individual character. The pride of the new gallery are the grandest of these rooms, the double height gallery on the third floor, with its full-size window, and the four central galleries on the fifth floor. These beautifully proportioned galleries do not have the usual ceiling skylights but receive natural light through massive clear-storey bands of frosted glass above and flush with their side walls. In my view they are the most beautiful exhibition spaces to be found in any modern museum of art in the world.

I have had the pleasure of watching this project grow from dreams and ideas through drawings and more drawings, from models and mock-ups through raw construction to finished rooms. I believe that Herzog & de Meuron have given the Tate precisely what it sought from the beginning: a great building where concern for the needs of art are given the highest priority.

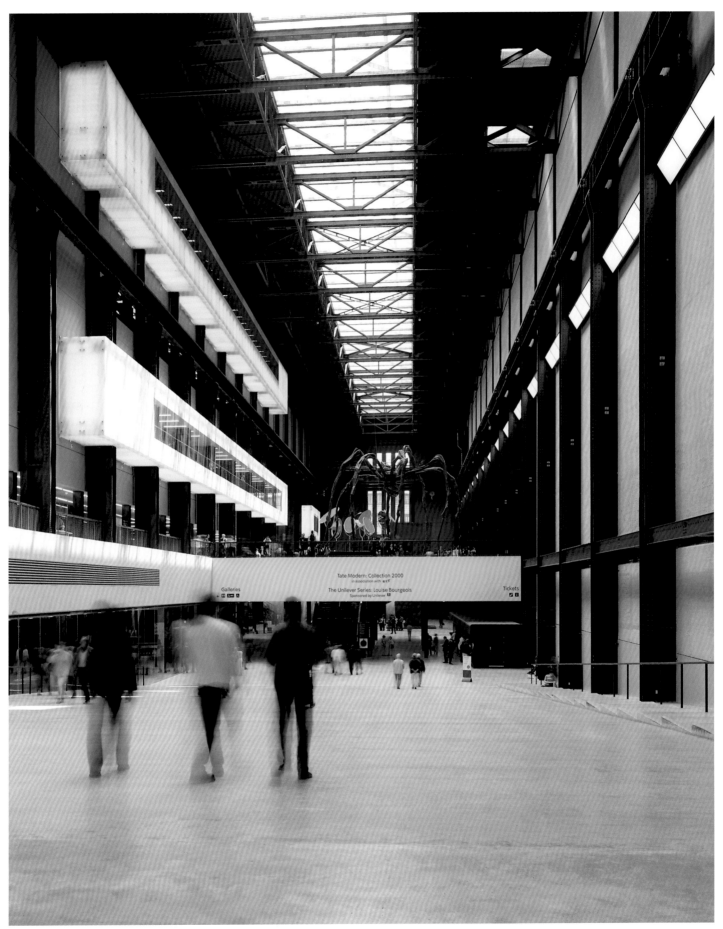

The Turbine Hall

Bankside: International Local

Doreen Massey

Bankside, and Southwark in which it lies, grew up at the south end of London Bridge, from Roman times a principal entry to London from the south. Medieval palaces once lined the banks of this stretch of the river Thames. The rich and famous chose it as the place to display their accumulated wealth. Later, and over centuries, the locality drew to itself less orthodox activities. Bear-baiting, pleasure gardens, and arts-related industries; brothels and a proliferation of inns. For a long time, the lingering presence of the establishment was jostled by an increasingly rowdy hoi-polloi. London's five main theatres clustered on this southern bank and a minor bohemia gathered here. It was an area which, in the imagination of those times and in the words of its historians ever since, has attracted epithets of disapproval (and perhaps also of desire): 'degenerate', 'dissipated', 'disreputable'.

Henry VIII closed the brothels down (though they were open again by the seventeenth century); many of the prelates' houses fell during the Reformation. In the struggles of the Civil War, new puritan rules of behaviour and decorum saw the theatres closed; and much remaining palatial opulence was destroyed. Bankside and its area entered a period of (relative) quiescence from which it was only slowly aroused.

What aroused it was the coming of industry. Gently, from the mid-eighteenth century but gradually gathering speed, the area became part of a swathe of London dominated by manufacturing, trade, and an industrial working class. By the later nineteenth century there was a gas works, an iron foundry, glass making, a coconut fibre works, a boiler works, a vinegar distillery, breweries; wharves lined the river; and 90,000 people were crammed into the Bankside ward alone. From being the location of spacious palaces of the powerful and pretentious, the area was now one of poverty and horrifying squalor, tightly packed with alleyways, factories and slums.

The twentieth century brought a thinning out. Partly by clearance, rebuilding and social programmes, conditions were improved. But the thinning out was also partly due to the long process, common to so many cities, of urban deindustrialisation. While the City has spiralled into extreme riches, at the turn of the millennium this side of the river still bears a legacy of poverty and unemployment.

And all the while, through all this history, and instrumental in its creation, has flowed the Thames. The building of its bridges has both

James Barry *The Thames or the Triumph of Navigation* first published 1792

marked and made the shifts of the city around this site: upstream towards the west in the eighteenth century, south across the river in the nineteenth. The Thames has been both an artery (of national and international trade – the starting point for communication around the world) and a barrier (of class and status and power, restricting communication within the capital city of that trade). South bank has faced north bank as subordinate, and sometimes also *in*subordinate. This locality has often had outsider status. Here were gathered, in the era of its notoriety, all the activities forbidden by the rules and proprieties of Establishment and Church across the river: an irreverence and licence which provoked disquiet and attempts at regulation. In its industrial heyday, the area did the labour of manufacturing and trade while the City across the river ran the finances of nation and empire. Two centuries of hard work and poverty were the metropolitan underside of a world-wide economic dominion largely controlled from the opposite bank of the Thames. Southwark became known as a strongly radical district. Even after wartime bombing, plans for gardens, light industry and workers' housing gave way before the City's need for electricity – and the unthinkability of siting a power station north of the river. And so came about (with the height of its central chimney restrainedly not challenging St Paul's) the building which in large part we still see today.

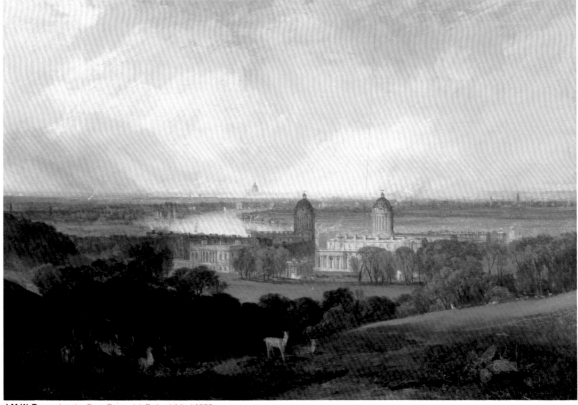

J.M.W. Turner *London From Greenwich Park* exhibited 1809

It is on this spot, then, so often humbled and which has so frequently already changed its character, that Tate Modern is now established. Another chapter in local history is beginning. Already, new kinds of links to the local area are being forged. But the new gallery is more than a local establishment. It aims to be 'a flagship for London', 'a new landmark for the nation' and one of the premier global centres of modern art. It will bring together local, national and international; a relationship between local and global that will have to be newly negotiated.

But then this place has never been just local. The character of all places – their local feel – comes also from their particular relations with the world beyond. To Bankside have come Romans, Saxons, Danes, Normans; as a part of the capital city it has had its national icons and institutions: Chaucer's inn (the Tabard); the Globe theatre; Southwark Cathedral (previously St Saviour's, before that St Mary Overy) with its Harvard Chapel; the Clink prison. A long history of trade connected it to Europe, and by the nineteenth century it was at the very hub of Empire. Tate Modern joins the story of an area which already has a long and widely connected history.

So how will it contribute to the continued making of this place?

Nationally, the location of the new Tate marks, for good or ill, a reinforcement of London's primacy; internationally it joins the competition between cities to become a prime site on the cultural map. Thirty percent of its visitors are expected to come from overseas. There are unequal geographies here too. For while the internet may change the whole notion (and the geography?) of 'visiting', most of those who travel to this site will come from the presently industrialised, and richer, areas of the world. It is a geography reflected too in the roots and routes of the art they come to see. Is Tate Modern to be a collecting in of art which is itself a product of the radiating out of a stream of western culture, or can new developments disrupt this mirroring of imperial geographies?

Within London, Tate Modern marks a new assertiveness. From the restaurant you can stare the City and St Paul's more equally in the eye. What kinds of interchange will the new bridge enable? Bankside is part, maybe, of the city's shifting east again, of an extended cultural south bank. The challenge is to combine this reborn centrality with a real embeddedness in place – and to preserve within its new-found authority that old ability, on occasions, to cock a snook at the powers that be.

Showing the Twentieth Century

Iwona Blazwick and Frances Morris

Filippo Tommaso Marinetti *Futurist Manifesto* 1909

'Museums: cemeteries! … Identical, surely, in the sinister promiscuity of so many bodies unknown to one another. Museums: public dormitories where one lies forever beside hated or unknown beings. Museums: absurd abattoirs of painters and sculptors ferociously slaughtering each other … (cemeteries of empty exertion, Calvaries of crucified dreams, registries of aborted beginnings!)'

Perhaps the most significant feature of the post industrial cultural landscape has been the rise and growth of the museum. In the metropolitan centres, museums are expanding, assimilating smaller institutions and even creating satellites. Those cities formerly relegated to the cultural margins are opening their own new museums, asserting counter claims to cultural primacy. Yet as museums of art and culture have proliferated throughout the twentieth century, so has a parallel, thoroughgoing and persistent critique.

The early avant-gardes saw in museums their own nemesis. The fulmination from Marinetti's *Futurist Manifesto* of 1909 quoted above, developed the notion of the museum as mausoleum. It was a theme which artists continued to reiterate through the twentieth century. The development of what is surely an Oedipal relationship between practitioners and institutions, however, was marked in the second half of the twentieth century by a shift of emphasis. No longer calling for their destruction, artists such as Art & Language, Marcel Broodthaers, Joseph Beuys, Daniel Buren, Mark Dion, Hans Haacke or Susan Hiller have made the museum the actual subject of their art. Each has dissected the processes of classification, the formalities of labels, plinths, frames and display cases, the legitimisations of value that characterise museum practice. Their art has revealed the unconsciously surreal poetics of these rationalisations, or exposed the ideological frameworks which lie behind them, making explicit the economic

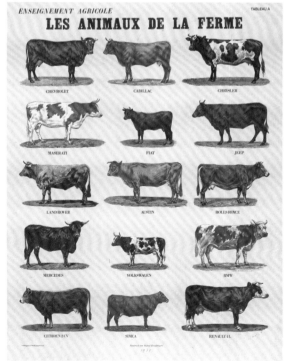

Marcel Broodthaers The Farm Animals 1974

and political agendas that inform acquisition and exhibition policy, patronage and sponsorship. These deconstructive tendencies have even created a genre known as 'institutional critique' which, ironically, has itself become the subject of museum shows. In 1999 the Museum of Modern Art in New York made a survey of these artists' strategies of attack in the paradoxically titled exhibition *Museum as Muse*. In such ways museums absorb their critics.

As ever more sophisticated display and marketing strategies have evolved around museums, so their characterisation has changed. Cultural theorists such as Pierre Bourdieu, Jean Baudrillard and most recently Andreas Huyssen have defined a shift in the perception of the museum from mausoleum to 'white cube', department store or theme park; to either a modernist palace of the elite or a purveyor of mass spectacle.

In the development of these various critiques, the spectator has tended to remain an undifferentiated, passive consumer, part of a homogeneous construct called 'the public'. From the 1970s however, numerous groups have forced the issue of who museums represent and of whether they can reflect the heterogeneity of the communities they apparently serve. For those who have found themselves absent or misrepresented by virtue of gender or geography, the museum is a triumphal temple to patriarchal and western hegemonies. The international, civic and social status of the large institution ensures that the art it collects comes to represent a canon, an official pantheon of greatness. All such assertions rest as much on what is absent as what is included. Yet the authority of the museum works to transform, in Daniel Buren's words, 'History into Nature'. Creating master narratives which assert aesthetic values and historical accounts as objective, autonomous and universal, most twentieth-century collections of art have more recently been critically redefined as subjective, contingent and western in their perspective.

Yet museums have become increasingly central to contemporary culture. They have provided the springboard for some of the most exciting architecture, design and engineering of

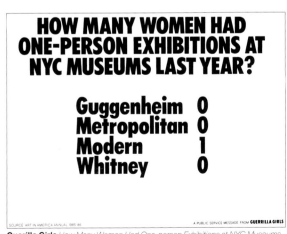

Guerilla Girls *How Many Women Had One-person Exhibitions at NYC Museums Last Year?* 1985

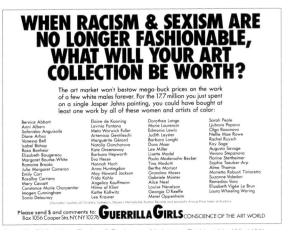

Guerilla Girls *When Racism & Sexism are No Longer Fashionable, What Will Your Art Collection Be Worth?* 1985

the late twentieth century. Innovation in new media flourishes around them. They have transformed local economies (witness the Guggenheim in Bilbao), generating employment and tourism. They stimulate a sense of civic and communal pride. Most importantly they provide a platform for education, discourse and, overridingly, aesthetic, intellectual and sensory pleasure.

Funny Face 1957, directed by Stanley Donen

To enter the museum, we cross a threshold which takes us out of the intense dynamic of the city, through a kind of decompression chamber – the foyer – into the zone of the *flâneur*, of the aimless stroller. Leaving the chaotic yet regimented routines of the city behind, we are free to wander, to become immersed in a complex and shifting set of spatial and visual encounters. In a sense we prepare to open ourselves to aesthetic experience. Works of art are rarely encountered in isolation. They are experienced in relation to each other and articulated by the architectonics of a building and the unconscious choreography of other people. Museums are activated by wandering groups and individuals who are busy looking, at art and at each other. Museums can be playful, even libidinous spaces, where images of the human body abound. From Hitchcock's *Vertigo* to Woody Allen's *Manhattan*, cinema has long recognised the museum as a potent cruising zone, where the *flâneur* may become voyeur.

How to Steal a Million 1966, directed by William Wyler

The Clock 1945, directed by Vincente Minnelli

Despite the fact that most visitors will resist curators' carefully plotted arrangements of works of art, preferring to zigzag back and forth, nonetheless a certain logic tends to prevail in the display and ordering of objects. An organising principle which came to dominate most modernist collections around the world was inspired by a flow chart invented in 1936 by the then director of MOMA in New York, Alfred H. Barr Jr. Devised to accompany the exhibition *Cubism and Abstract Art*, his chart did more than trace chronology. Barr created a didactic diagram which charted a stylistic evolution of 'isms', a succession of European avant-garde movements which suggested progress towards abstraction as point zero. In its neo-scientific style and its authoritative clarity, it provided a

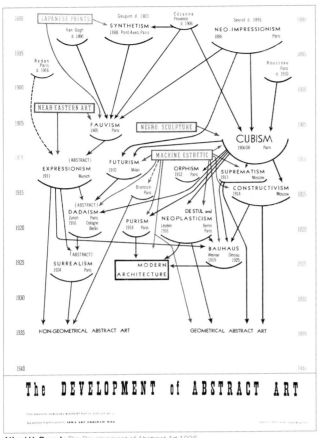

paradigm for the understanding and display of modern and contemporary art which dominated museum practice until the end of the century. Barr's assumption, articulated by many others including Maurice Denis, Clive Bell and Roger Fry and finally theorised by Clement Greenberg in the 1940s and 1950s, was that modern art developed in a series of self-determining advances towards a concentration of aesthetic experiences vested in form rather than content, isolated from the contingencies of the world. It is a system of categorisation which is still used to delineate art into periods and movements, suggesting that individual practice can be encompassed in broad tendencies, which neatly begin and end, each in reaction to the last. Most art originating from beyond the Nato alliance countries, or art which adheres to pre-modernist traditions or radically challenges the modernist line, is excluded.

Although shaped by the individual passions of its directors and curators, by the vagaries of the market place and the generosity of artists and collectors, the Tate collection of modern art has been broadly constructed on these same principles. Tate holds what can be regarded as two complementary collections: one of British art from the sixteenth century to the present, the other of modern international art, from 1900 on. Initiated at different times and with distinct remits, the first has developed as a broad based, in-depth collection while the second is a selective history of predominantly western European and North American art. Like all collections it has its highlights – Bonnard, Brancusi, Giacometti, Matisse, Picasso, Pollock, Rothko, Surrealism, Pop art – and its weaknesses. Very few important women artists are featured from the earlier part of the century, and inter-war realism, and politically engaged art are also barely represented. Its geographical focus moves from Paris before the Second World War to New York in its aftermath. Until the inclusion of photography and video from the 1970s on, the collection could be described as primarily comprising painting, sculpture and works on paper.

The advent of a new museum of modern art offers the possibility of taking up the challenge issued by artists and historians to review the canon of art history and the museum's

relation to it. The debate has evolved within the context of a wider theoretical dialogue informed by semiology, Marxism, feminism, psychoanalysis, analytical philosophy and the politics of identity. Broadly, the impulse to question follows Walter Benjamin's maxim 'to brush history against the grain'. This debate has been explored by the dynamic counterpart to the permanent collection, the temporary exhibition. Increasingly in the second half of the twentieth century, loan exhibitions, biennales and public art projects explored the powerful but complex influences of politics, society and geography on art. They have celebrated divergent ideas which either maintain pre-modernist traditions or rupture the modernist paradigm. Exhibitions have looked at art inspired not by aesthetic inner necessity, but by external coercion or the equally powerful compulsion of extreme suffering. The narrowness of geographical boundaries has been opened up to reveal a global perspective of not one but many modernities and modernisms.

These broader terrains are now increasingly reflected in Tate acquisition policy towards contemporary art. But it is more difficult to expand a collection retrospectively. The challenge for Tate Modern has been to find ways of rehanging the collection, of expanding the possible meanings generated by and around the works of art within it – to replace one history with many stories. In the mid-1990s, discussions began between colleagues at Tate and artists, art historians, educators, curators and critics outside the institution. The debate focused on devising new ways of showing works of art and creating frameworks within which to deploy them with conviction, animation and flexibility.

These discussions were also informed by the actual architecture of Bankside Power Station. Until the year 2000, the Tate gallery at Millbank comprised a single main floor, with interconnecting rooms that lent themselves to demonstrating chronologies in art. By contrast, the galleries dedicated to the collection at Bankside are arranged on two floors and organised into four architecturally coherent suites. Each suite provides a series of peripheral galleries around one or two large central spaces and core service areas. The adjacent suites are separated from each other by the central concourse area, but are joined by linking gallery spaces behind Bankside's giant chimney. An incredible architectural vocabulary of spaces, ranging from the autonomous purity of the 'white cube', to rooms which suddenly admit exhilarating views across London, the complexity of the floor plan and the sheer size of each suite, demanded a new approach. There was the strong possibility that visitors might choose to visit only one of the four suites. The view, advocated by many voices throughout the consultation process, was that each suite should offer some kind of rounded experience of the twentieth century, where the historic would be encountered in dialogue with the contemporary. This suggested that we either adopt four parallel yet distinct chronologies, or adopt four themes

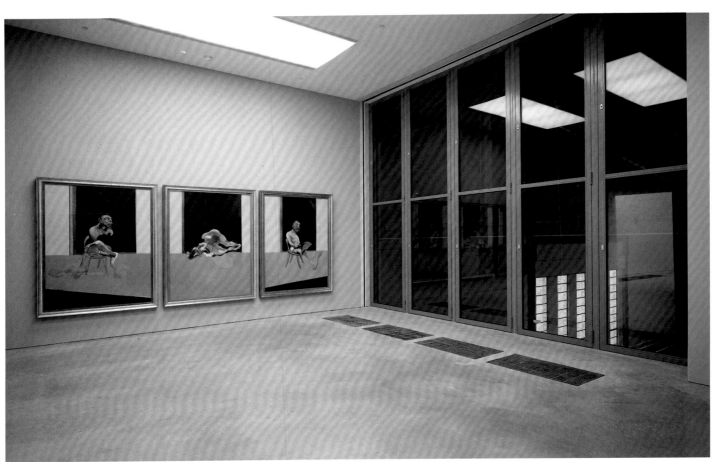

Nude/Action/Body Francis Bacon *Triptych – August 1972* 1972

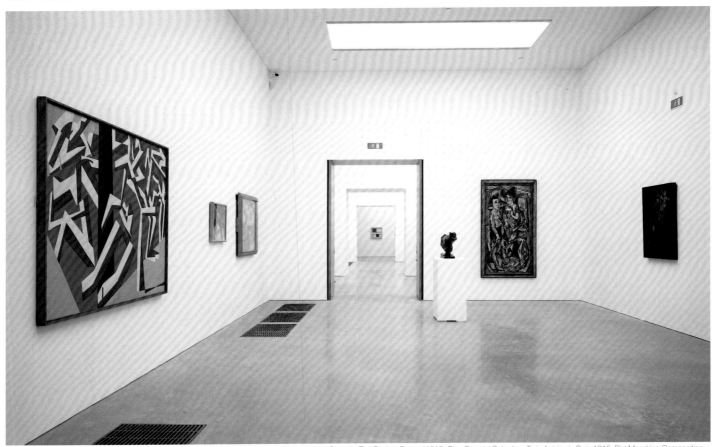

History/Memory/Society L to R: David Bomberg *The Mud Bath* 1914, Giacomo Balla *Abstract Speed – The Car has Passed* 1913, Gino Severini *Suburban Train Arriving in Paris* 1915, Piet Mondrian *Composition with Red and Blue* 1935, Ernst Barlach *The Avenger* 1914, later cast, Max Beckmann *Carnival* 1920, George Grosz *Suicide* 1916

which were sufficiently flexible and provocative to contain displays from throughout the century.

Through a process of brainstorming and debate, key questions emerged: is it possible to reconnect art with social and cultural history, to locate it in a wider context of ideas and circumstances? Can we demonstrate the material and conceptual processes behind the creation of art objects? Can we identify themes and tendencies that transcend movements and periods? Can we show continuities across time and practice?

Having examined where, when and how a work of art might have been made and the context of its reception, we focused on its subject matter. We speculated as to whether form and content might fall into any particular categories and found ourselves considering a form of classification which is almost as old as the making of art itself – the genre. Although formally defined as genres in the seventeenth century, certain types of subject matter have prevailed throughout western art. Broadly speaking, for the purposes of this process, we have defined these as the still life, the landscape, the human figure (including portraiture and the nude) and the historic narrative or allegory. We considered whether these typologies could have any relevance in the twentieth century. Certainly, the supposed boundaries of conventional genres and their embeddedness in hierarchical social and political structures have inspired artists to acts of vanguardist transgression and departure. Yet even taking account of this trajectory towards the autonomous work of art that underlined the modernist sensibility, it appeared that these subjects or forms still adhered. If however, another overwhelming tendency within modern and contemporary art can be seen as a move from illustration and metaphor to a material and subjective reality, so these categories themselves can be seen in terms of an expanded field. This is not to suggest an evolution, but a radical expansion in time and space. For landscape therefore, one might read environment; for the nude, the body; for still life, real life; and for history, society.

Within each of these broad themes it is possible to explore a rich syntax of intention and strategy. The genre of landscape is primarily understood as a representation of a natural or urban scene, which might be topographic, metaphoric or sublime. But it might also encompass the creation of phenomenal environments of space, light, texture and colour. A map is a form of landscape, a diagrammatic system for understanding, containment, ownership and territorial aggression. It has also been manifest as an action – mapping through walking. An exploration of growth and form in the organic world might feature here, as well as the notion of archaeology and geology, wherein the landscape becomes a historic sedimentation, an analogue for time. This 'genre', reconceived at Tate Modern as *Landscape/Matter/Environment*, also includes the zone of the imaginary, uncanny dreamscapes, symbolic visualisations of anxiety and desire.

A preoccupation with the human figure has and will remain a constant through art. In the

modern period however it has been increasingly animated, ritualised and deconstructed, as artists have made the body both subject and object. Within an overall framework titled *Nude/Action/Body*, the conventions of the nude as a means of exploring anatomy, movement and formal composition within the hermetic space of the studio is juxtaposed with a range of works that rupture and fragment idealised beauty. Here we might encounter the body as a symbol for states of being, from alienation to abjection, from *jouissance* to mortality. The female body is reclaimed from the objectification of the male gaze to the assertion of an active, subjective female identity. In the movement of art from representation to reality, artists use their own bodies, staging and recording actions that test physical endurance or confront social taboos. The body in question might be an absent presence, signified only by traces; it might be that of the viewer. As audiences we might find ourselves performing a work, participating in its meaning by virtue of our own actions and field of perception.

Still life, or the representation of the world of natural and man-made objects, was traditionally regarded as the lowest of the genres, concerned as it is with the humble artefacts of domestic space. Yet it is the ubiquity, and on one level, the timelessness of foodstuffs and vessels that make them both immediate and economical for artists to work with, and at the same time capable of evoking a universal chord of recognition. *Still Life/Object/Real Life* shows the still life as a springboard for the sculptural analysis of ideal forms, or for optical adventures in the effect of colour. In their deployment of the latest methods of production, design and style, the works here might provide a picture of an era. For some artists they represent a celebration of the everyday, or a rejection, through the use of the ready made, of aesthetic value, or a critique of consumer capitalism. Their forms can be both erotic and melancholy, as much signifiers of desire as intimations of mortality. As symbols of the process of labour, the utilitarian objects of the still life have also been deployed as the tools of revolution.

The history painting, as contested a genre as the nude, is perhaps more difficult to define from a contemporary standpoint. Its conventions can, however, be seen as a fundamental dynamic behind two prevailing tendencies in modern and contemporary art – autonomy and engagement. The 'painting of modern life', to use Baudelaire's term, might be understood as picturing history. *History/Memory/Society* draws together works which picture both the epic and the everyday, from the great convulsions of our times encompassed by war, exile and the ruthless pursuit of ideology, to the celebration of systems of belief and the power of cultural icons. The rise of the media and mass communications might be seen as an undercurrent informing and shaping these representations. At the same time this framework embraces both realist and abstract artists who have sought to change history itself, by erasing what had gone

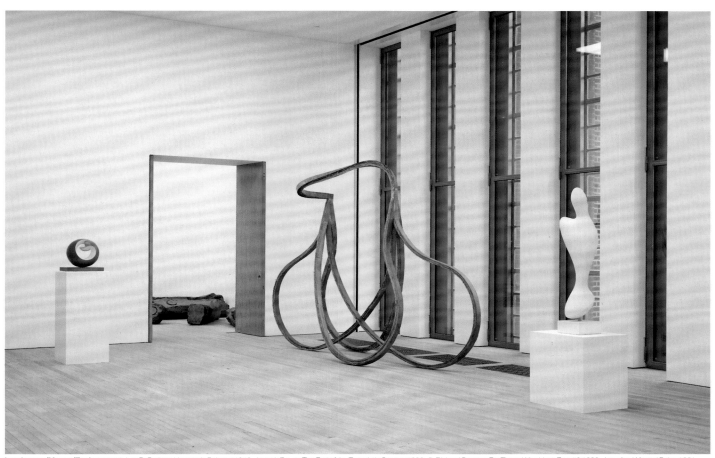

Landscape/Matter/Environment L to R: Barbara Hepworth *Pelagos* 1946, Joseph Beuys *The End of the Twentieth Century* 1983–5, Richard Deacon *For Those Who Have Ears #2* 1983, Jean Arp *Winged Being* 1961

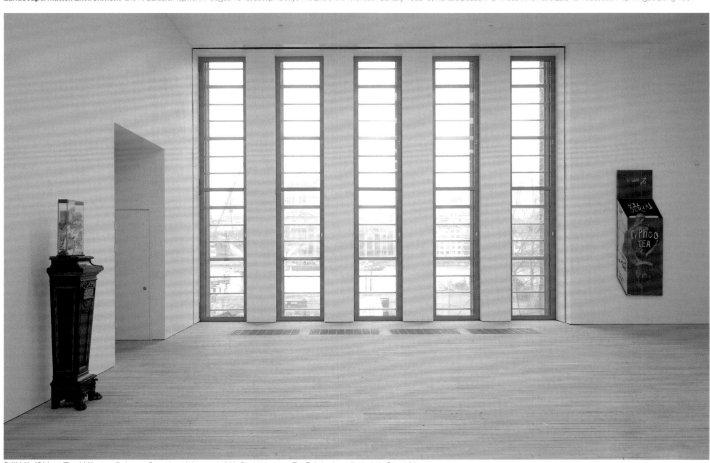

Still Life/Object/Real Life L to R: Arman *Condition of Woman I* 1960, David Hockney *Tea Painting in an Illusionistic Style* 1961

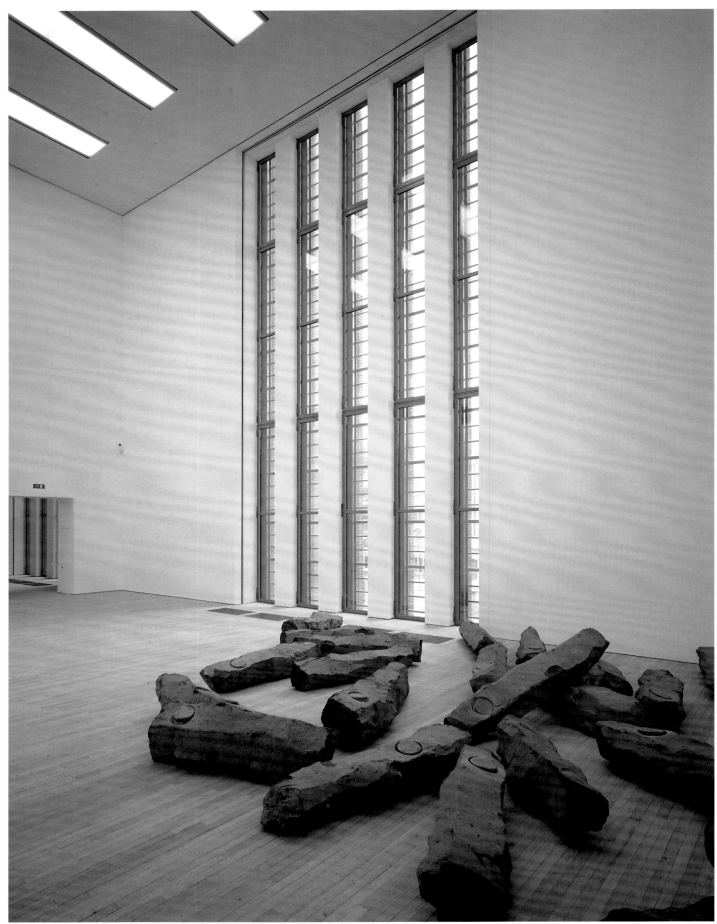

Landscape/Matter/Environment Joseph Beuys *The End of the Twentieth Century* 1983–5

before and creating a new present. Their utopian strategies included breaking down boundaries between form and function, offering a synthesis of fine art, product design, architecture and graphics, the latter a potent medium in the circulation of ideas through the form of the manifesto. The call for revolution resonates here and might be encountered as protest or play.

Inevitably these broad themes overlap. It is clear that many artistic practices could be relevant to more than one. They are not being imposed however, as static, rigidly defining categories. Some artists may, over time, be shown in all four suites, reflecting both the broad resonance of their practice and the contingency of interpretation. The open-endedness of these thematic constructions in fact allows for an anthology of exhibition types, from the solo show, a single work in focus, the analysis of one movement or medium, to the use of a theme to bring together artists from across the century. Different perspectives might be provided by Tate curators or by contemporary artists, scholars or voices from other disciplines.

The challenge for the museum of art today is twofold. Can we create the museum envisaged by artists, critics and the range of communities that constitute our public, one that can, in the words of Andreas Huyssen, 'work with changes, refine its strategies of representation and offer its spaces as sites of cultural contestation'? Can we also create conditions of viewing which reflect artistic intention, celebrate the aesthetic and intellectual achievement of those artists whose works are part of our national patrimony and provide lucid and informative critical frameworks for their enjoyment and understanding? Over a five year period we will see not one, but many stories of the twentieth and twenty-first centuries, understood through a shifting and multi-faceted perspective. They will allow flexibility, dynamism and a continued commitment to new scholarship, and new ways of seeing and of understanding the past in relation to the present.

Landscape | Matter | Environment

Jennifer Mundy

Landscape is a term with several overlapping meanings. Much of its resonance derives from the often uncertain boundary between nature and culture, the objective and the subjective. It can refer in a neutral way to a specific geographical terrain, as in the phrase 'the Norfolk landscape'. Often, however, it is used to denote a *natural* environment, distinct from human society. In this case the term landscape embraces a particular idea of nature and of what is natural in man, an idea that is inevitably rooted in culture. The term landscape can also refer to painted depictions of natural scenery. Frequently, as in the case of Dutch seventeenth-century landscape paintings, these appear to be faithful representations of the real world, snapshots of identifiable scenes. However, even the most realistic landscapes are shaped as much by traditions and myth, dreams and memories, as by perceived reality.

All human societies have defined themselves in relation to the landscape, but, as Kenneth Clark noted in his study *Landscape into Art*, landscape painting as we know it has had a 'short and fitful history' in the west. In the classical world nature was extolled as a locus of harmony, peace and simplicity, but in the paintings of the period landscape seems to have functioned simply as a backdrop to the more engrossing dramas of men and gods. From the late Middle Ages, however, nature came to be appreciated once more for the visual delight and spiritual refreshment it offered, and landscape became a progressively more important element in art.

In the seventeenth century the inspiration behind landscape painting was largely classical – as in the grand arcadias of Poussin and Claude or, more indirectly, in the idyllic scenes of Ruysdael and Cuyp. From the second half of the eighteenth century Romanticism injected a darker note: no longer nature as a pastoral setting, controlled and largely unthreatening, but nature as energy and force, sublime, overpowering, and unpredictable, as seen in the grandeur and turbulence of Turner, and the apocalyptic awesomeness of John Martin. The decline of religious orthodoxy also encouraged new spiritual readings of the landscape, and nature was viewed as the repository of the divine, as in the haunting images of Friedrich. The emergence of nationalism after the French Revolution also generated the idea of the national landscape, landscape as the embodiment of national character or national identity, most notably, perhaps, in Germany and America. Although modern artists may have used different media, all these themes, classical as well as romantic, continued to influence art in the twentieth century.

At the beginning of the twentieth century landscape painting was the dominant genre of modern art. The Impressionists' bright and spontaneous depictions of nature appealed to the urban middle classes, for whom the countryside was primarily the arena of leisure and enjoyment. The Impressionists' search for perceptual veracity was being followed through by Claude Monet, as well as by younger artists such as Henri Matisse and Paul Cézanne (see p.194, 136).

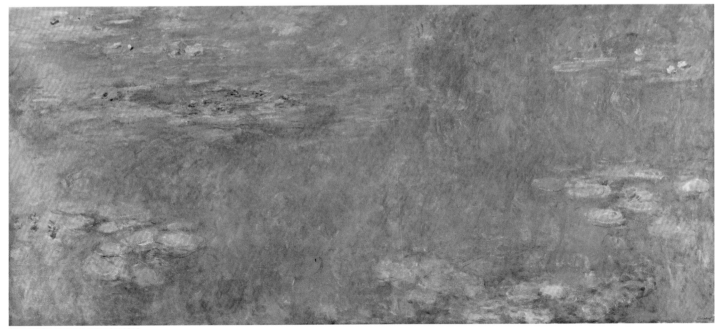

Claude Monet *Water-Lilies* after 1916

Moving away from his earlier fidelity to reality, Monet employed such 'non-subjects' as haystacks and water lilies in order to focus entirely on presenting a vision of evanescent light and colour. The short-lived Fauve group, led by Matisse, took Impressionist colour theory to an extreme, juxtaposing pure, vivid colours to create intense effects. Of more enduring significance was the attempt by Cézanne to marry the representation of light and colour to volume and depth. His Provençal scenes contained the seeds of both Cubism and abstraction, as later artists interpreted his use of faceted planes of colour as an incitement to distance the language of art from its representational role.

Landscape painting was to continue through the century, as artists found inspiration in the appearance of the natural world, and willingly worked within the tradition of past masters. Some expressed through landscape their personal attachment to particular locales, others their delight in the sensations of colour, light and space. National traditions played a part, too. The French painters Pierre Bonnard (see p.129) and Raoul Dufy celebrated a classically inspired vision of the French landscape as a site of repose and reverie. For the German artist Emil Nolde, however, nature was a mirror to man's darker, untamed emotions. However, there was no new school of landscape painting, and the works of these artists remained recognisably within the parameters of tradition. For those interested in challenging convention and giving voice to new responses to the natural world, the genre of landscape painting was perceived as less and less relevant.

Some commentators have attributed the genre's decline to the modern era's loss of religious faith. Earlier artists could regard man and nature as part of the continuum of God's creation, and even the Impressionists' claims to scientific truth can be seen as reflecting the nineteenth century's beneficent (and ultimately religious) view of the laws governing the world. This optimistic vision of nature began to be challenged from the later nineteenth century. Darwinism revealed nature to be arbitrary, constantly changing and brutally competitive. It also showed the earth to be much older than had been thought before, with man and the natural world products of a long and seemingly random process of evolution, rather than fixed and finite creations. In the early twentieth century developments in microscopy unearthed new, more remote and complex levels of material reality, while physics proved that matter itself was made up of electrical units. In the light of this new knowledge it became harder to conceive of nature as a unity and to consider man as situated at the centre of the natural order.

For abstract artists the representation of the outer appearances of nature was, of course, anathema. However, some reference to the phenomenal world, albeit metaphorical, was seen as unavoidable even by practitioners of the most severe geometric styles of abstraction. Piet Mondrian (see p.200) spoke in the late 1910s and early 1920s of revealing the universal laws of

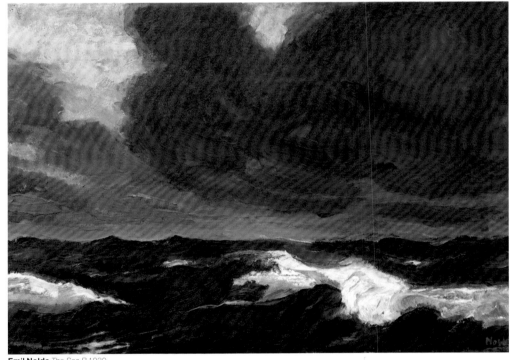

Emil Nolde *The Sea B* 1930

nature in his paintings of vertical and horizontal lines and rectangular planes of colour. Wassily Kandinsky (see p.182), pioneer of an expressive form of abstraction, wanted to create spiritual equivalents to nature in his art. In the inter-war years, however, newly available photographs of cells, films of organisms seen close-to, and mathematical texts on the principles of natural morphology encouraged artists and public alike to reconsider the relationship between abstract art and nature. In making sculptures that evoked weather-worn boulders or whose curves suggested the fluid shapes of amoebae, such artists as Jean Arp, Henry Moore and Barbara Hepworth (see p.116, 202 and 169) believed they were expressing affinity with the underlying forces of nature rather than nature itself. By contrast, the constructivist artist Naum Gabo (see p.157) found in scientific studies of crystals and spiral patterns in nature confirmation that his sculptural exploration of form and space was allied to the truths of science. By the mid-century the parallels between art and science encouraged hopes that the 'two cultures' might be brought together. But this aspiration faded as science grew more complex, and became associated with the increasing technological exploitation of nature, and its potential destruction.

If many abstract artists of the inter-war period looked to the outside world as a point of reference, albeit oblique, for their work, Surrealist artists turned inwards and used the genre of landscape to represent the mental world of childhood memories, dreams and waking visions. André Breton, leader of the Paris-based Surrealist movement, declared that the 'model' (that is, the subject of Surrealist art) was to be 'interior'; and taking up this challenge, artists such as Joan Miró, Max Ernst, Yves Tanguy and Salvador Dalí (see p.198, 151, 225 and 140) developed new ways of picturing the workings of the mind. For Miró, in his atmospheric, dreamy spaces, as much as for Dalí, in his meticulously painted scenes of the Spanish landscape of his youth, the intimation of a credible, illusionistic space was important: it allowed their paintings to be seen as windows onto the mind. At the same time, unfamiliar settings, irrational perspectives and impossible combinations of objects challenged realism, and revealed the weakness of the hold of reason and logic over the human consciousness. Influenced by certain German Romantic writers and esoteric traditions, the Surrealists saw nature as infinitely powerful and mysterious: a photograph in one of their periodicals of a railway locomotive abandoned in the depths of the jungle revealed much about their vision of the relationship between western culture and nature.

Drawing on aspects of both abstract and Surrealist art, American painters in the 1940s and 1950s created in their wall-scale abstract paintings works that filled the viewer's field of vision and became a form of environment. Creator of the Tate Seagram murals, Mark Rothko (see p.218) spoke of wanting the viewer to feel inside the pictorial space, enveloped, as it were, in his canvases' luminous colour and apparitional surfaces. He and others such as Barnett

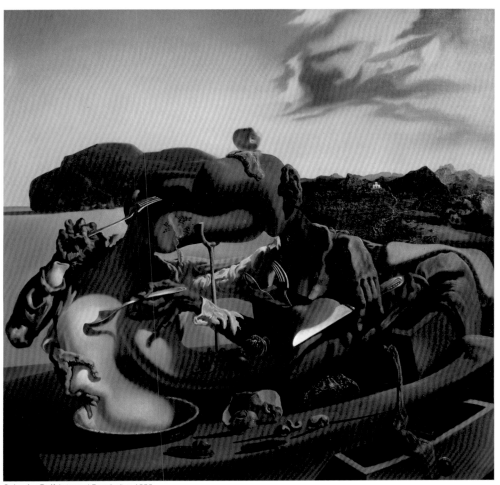

Salvador Dalí *Autumnal Cannibalism* 1936

Newman (see p.206) and Clyfford Still wanted to express a sense of the sublime, an idea associated with religious awe, vastness and natural magnificence. Although abstract, their works were seen at the time as expressing through their scale an aspect of the extraordinary landscapes of America. And it is true that a sense of place, and of nature's forms, influenced a number of American Abstract Expressionist painters. Arshile Gorky (see p.162), for example, took inspiration from flowers and grasses seen close-to; he projected feelings, memories and desires onto these botanical scenes, and created abstract but allusive images. By contrast, 'action painters' such as Jackson Pollock (see p.214) made their own vitality the prime content of their art. When asked about the relationship of his work to nature, Pollock reportedly commented, 'I am nature'.

In the decades following the Second World War art was influenced by the philosophies of existentialism, transcendentalism and phenomenology. It became overwhelmingly concerned with individual agency, consciousness and perception. Lucio Fontana's punctured and slit canvases (p.155) both recorded the gesture of the artist and invited the viewer to see the holes as emblems of infinite space. Inspired by the abstract landscapes of Helen Frankenthaler, Morris Louis used veils of pure colour to create non-figurative equivalents for the sensations of space and light in nature. These different approaches shared an idea of nature as something absolute and unchanging against which the individual can act – a view that was to be reassessed and challenged in the later twentieth century.

A pivotal figure in this reassessment was Joseph Beuys (see p.126). His fascination with natural morphology linked his work to earlier expressions of interest in the relationship of art and science, while his impassioned defence of the environment signalled a new approach to nature – one linked to the rise of the ecology movement in the 1970s. He developed a theory of what he called the expanded field of sculpture based initially on his study of bees, in particular their manufacture of honey and wax, and the hexagonal structures of their honeycombs. He worked with many materials but had a particular interest in wax, fat, felt and rock which he saw as symbolic of essential aspects of the natural world. He believed that beyond art and science lay the 'still larger concept' of creativity, and through his work he hoped to spread the idea that 'everyone is an artist' and to encourage people to believe that they could effect social and political change. In keeping with this, Beuys engaged in a number of projects that focused attention on issues relating to pollution and the destruction of areas of natural habitat. To highlight the loss of wetlands on the edge of the Zuider Zee in the Netherlands as a result of drainage projects, for example, he waded fully clothed into the marsh, until little more of him was visible than the top of his trademark hat. It was an action that was intended to demonstrate a conception of nature as a

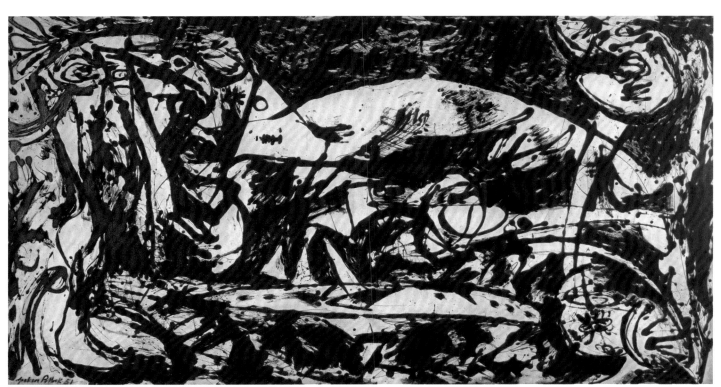

Jackson Pollock *Number 14* 1951

living system of which we are a part and which we modify, for better or worse, with our actions.

From the late 1960s the definition and role of art was challenged throughout the western world. As part of their programme of making art from ordinary, perishable materials, Arte Povera artists in Italy introduced fragments and emblems of nature into gallery spaces. In America a number of artists turned away from galleries and museums altogether to work directly in the natural landscape. The land art of such figures as Michael Heizer (who aimed, he said, to create 'an American art'), Robert Smithson and Walter de Maria saw the creation of monumental interventions – deep trenches, lines many miles long, fields of steel poles – in the deserts, plains and mountains of the American West. The geometry of their forms related to the aesthetics of contemporary Minimalism and also to the disciplines of surveying and mapping terrain. The works, most of which do not survive, articulated a heightened sense of the scale and qualities of the specific sites. The spiral form of Smithson's *Spiral Jetty* – a line of 1,500 feet of black basalt and limestone rocks curling into the Great Salt Lake, Utah – was inspired in part by the artist's sense of a 'spinning sensation without movement' when he looked from the site on the edge of the lake towards the horizon. It also alluded to the spiral structure of the salt crystals that he knew would adhere to rocks in the jetty, and to a local myth of a whirlpool in the lake.

The grandeur of many land art projects expressed an essentially pre-Romantic vision of nature as something to be dominated by man. This approach incurred the criticism of a later generation of artists who have preferred to work in and with nature. In Britain such artists as Richard Long (see p.191), Hamish Fulton and Andy Goldsworthy barely intrude upon the landscape at all, and express, rather, a consciousness of the fragility of the natural environment, and of the historical and spiritual interdependence of man and nature. Their walks in the countryside, 'mind maps' of place names, and impermanent sculptures of natural materials reflect a search for direct contact with the landscape, an immersion of the self in nature. Aiming, perhaps, to re-enchant the world, as it were, many of those practising this art in nature allude to the monuments and symbols of prehistoric art. Their work implies criticism of the exploitation of nature in the modern industrial world and evokes an ideal of the interaction of art and society.

Today the threat posed to the environment by modern technology and the growth of the human population has made the natural landscape a topical, even urgent, subject for art. Nature is no longer seen as an exhaustible resource or arena for man: if areas of wilderness survive in the future, it will be only as the result of man's careful stewardship. In this context, the contemporary artist might hope, as Smithson suggested, to act as a mediator between the ecologist and the industrialist. Attempting to articulate the significance of the landscape today, a number of artists have made the subject of their work the visual and cultural systems by which nature and

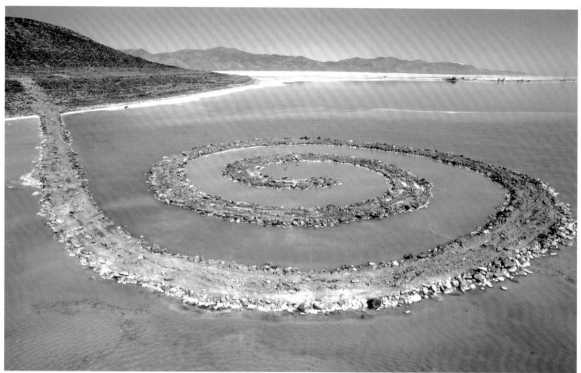

Robert Smithson *Spiral Jetty* 1970

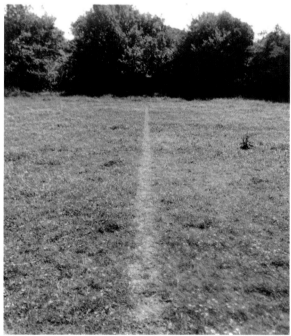

Richard Long *A Line Made by Walking* 1967

the landscape are represented. In many of his photographs and installations Lothar Baumgarten (see p.123) has used the names of places, plants and materials of the indigenous peoples of South America to reveal the cultural and political imperatives associated with the renaming of these things by early European explorers. His aim is not only to remind us of what has been obliterated by colonialism but also to explore the politics of naming and visualising whatever lies outside our own cultural systems. By contrast, such artists as Andreas Gursky and Thomas Struth (see p.224) have employed in their photographs of urban spaces the compositional devices of great landscape paintings of the past in order to highlight the continuities and disjunctures between past and present, between concept and reality. With such renewed interest in the interfaces between nature and culture, the landscape is once again a site of technical and theoretical innovation.

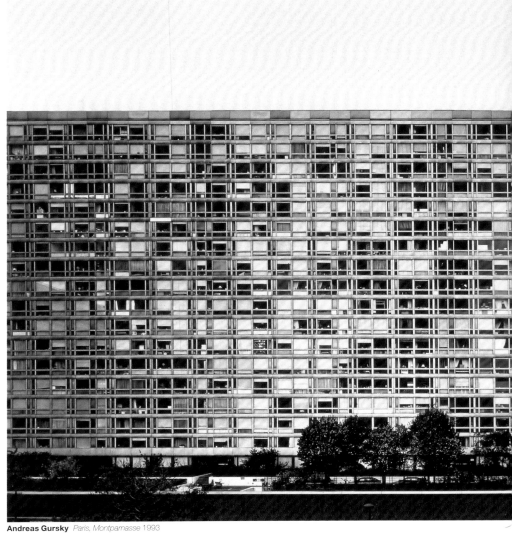

Andreas Gursky *Paris, Montparnasse* 1993

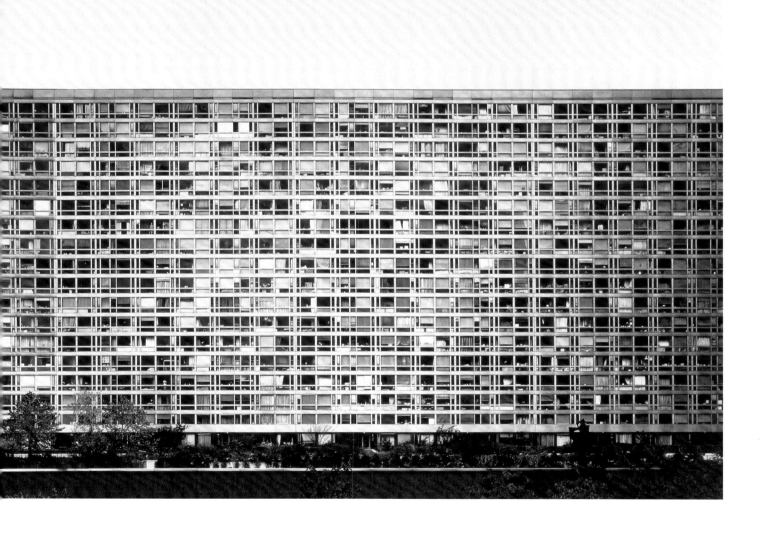

Then the sun rose and was so dazzling I found it impossible to see. The Thames was all gold. God it was beautiful, so fine that I began work in a frenzy, following the sun and its reflections on the water ...

... I can't begin to describe a day as wonderful as this. One marvel after another, each lasting less than five minutes, it was enough to drive one mad.

Claude Monet Letter to Alice Monet, London, 3 February 1901

I must tell you that as a painter I am becoming more clear-sighted before nature, but that with me the realization of my sensations is always painful. I cannot attain the intensity that is unfolded before my sense. I have not the magnificent richness of colouring that animates nature. Here on the bank of the river the motifs multiply, the same subject seen from a different angle offers subject for study of the most powerful interest and so varied that I think I could occupy myself for months without changing place, by turning now more to the right, now more to the left.

Paul Cézanne Letter to his son, Aix-en-Provence, 8 September 1906

The continual anxiety of the painter makes him observe nature constantly with all its cortege of details, of variations, of disinte-gration of objects ... The painter devours nature with his eyes and at the moment of painting he sees it only intuitively, nature appears on his canvas from the depths of his being which digests all this spiritual nourishment.

André Derain The notes of André Derain, 1920s

Physical nature in the true sense no longer exists. It has become the foundation of apartment blocks, and the asphalt of pavements and streets.

Physical nature is nothing but a memory, like a tale about something marvellous that has long since disappeared.

The Factory-Town dominates everything.

Perpetual movement, endless coming and going, nightmarish and confused visions of the city follow one after the other. In the daylight which is obscured by houses, in the light created by the electric suns of the night, life appears completely different to us ...

The world has been transformed into a monstrous, fantastic, perpetually moving machine; into an enormous automatic organism, inanimate, a gigantic whole constructed on a strict correspondence and balance of parts.

Alexander Shevchenko Neo-Primitivism: Its Theory, Its Potentials, Its Achievements, 1913

When one crosses a landscape by automobile or express train, it becomes fragmented; it loses in descriptive value but gains in synthetic value. The view through the door of the railroad car or the automobile windshield, in combination with the speed, has altered the habitual look of things. A modern man registers a hundred times more sensory impressions than an eighteenth-century artist ... The compression of the modern picture, its variety, its breaking up of forms, are the result of all this. It is certain that the evolution of the means of locomotion and their speed have a great deal to do with the new way of seeing.

Fernand Léger Contemporary Achievements in Painting, 1914

The art of Painting is the decomposition of nature's ready-made images into the distinctive properties of the common material found within them and the creation of different images by means of the interrelation of these properties; this interrelation is established by the Creator's individual attitude ... nature is a 'Subject' as much as any subject set for painting *in abstracto* and is the point of departure, the seed, from which a Work of Art develops.

Olga Rozanova The Bases of the New Creation, 1913

I expressed myself *by means* of nature. But if you carefully observe the sequence of my work, you will see that it progressively abandoned the naturalistic appearance of things and increasingly emphasized the plastic expression of relationships.

Piet Mondrian Dialogue on the New Plastic, 1919

The realization of our perceptions of the world in the forms of space and time is the only aim of our pictorial and plastic art ... The plumb-line in our hand, eyes as precise as a ruler, in a spirit as taut as a compass ... we construct our work as the universe constructs its own, as the engineer constructs his bridges, as the mathematician his formula of the orbits.

Naum Gabo and Antoine Pevsner The Realistic Manifesto, 1920

I believe that men will long continue to feel the need of following to its source the magical river flowing from their eyes, bathing with the same hallucinatory light and shade both the things that are and the things that are not. Not always quite knowing to what the disturbing discovery is due, they will place one of these springs high above the summit of any mountain. The region where the charming vapours of the as yet unknown, with which they are to fall in love, condense, will appear to them in a lightning-flash.

André Breton Surrealism and Painting, 1928

The consciousness and understanding of volume and mass, laws of gravity, contour of the earth under our feet, thrusts and stresses of internal structure, space displacement and space volume, the relation of man to a mountain and man's eye to the horizon, and all laws of movement and equilibrium – these are surely the very essence of life, the principles and laws which are the vitalization of our experience, and sculpture a vehicle for projecting our sensibility to the whole of existence.

Barbara Hepworth Sculpture, 1937

The man who wants to shoot a cloud down with an arrow will exhaust all his arrows in vain. Many sculptors are such strange hunters. What you have to do is fiddle something on a drum or drum something on a fiddle. Before long the cloud will descend, roll about on the ground in happiness, and at last complacently turn to stone.

Jean Arp The Man Who Wants to Shoot a Cloud Down, 1956

The 'sublime' ... is nowhere more pronounced than in Clyfford Still's vast canvases, whose jagged abstract shapes evoke awesome forms of nature: mountainous peaks, crevasses, torrential cataracts, and flaming holocausts.

Ellen H. Johnson American Artists on Art, 1982

Pollock's choice of enormous canvases served many purposes ... his mural-scale paintings ceased to become paintings and became environments. Before a painting, our size as spectators, in relation to the size of the picture, profoundly influenced how much we are willing to give up consciousness of our temporal existence while experiencing it. Pollock's choice of great sizes resulted in our being con-fronted, assaulted, sucked in.

Allan Kaprow The Legacy of Jackson Pollock, 1958

For me space is where I can feel all four horizons, not just the horizon in front of me and in back of me because then the experience of space exists only as volume ...

Anyone standing in front of my paintings must feel the vertical domelike vaults encompass him to awaken an awareness of his being alive in the sensation of complete space.

Barnett Newman Interview with Dorothy Gees Seckler, 1962

In the realm of the blue air more than anywhere else one feels that the world is accessible to the most unlimited reverie ... The world is ... on the far side of an unsilvered mirror, there is an imaginary beyond, a beyond pure and insubstantial, and that is the dwelling place of Bachelard's beautiful phrase: 'First there is nothing, next there is a depth of nothingness, then a profundity of blue.'

Yves Klein Sorbonne Lecture, 1959

The strata of the Earth is a jumbled museum. Embedded in the sediment is a text that contains limits and boundaries which evade the rational order, and social structures which confine art. In order to read the rocks we must become conscious of geologic time, and of the layers of pre-historic material that is entombed in the Earth's crust. When one scans the ruined sites of prehistory one sees a heap of wrecked maps that upsets our present art historical limits.

Robert Smithson A Sedimentation of the Mind: Earth Projects, 1968

The Fibonacci series ... is based on a very simple idea. Each number adds up with or involves the preceding number in the formation of the following one ...

Written in sequence, this makes 1,1,2,3. Then three adds up with two to form five; five with three to form the number eight. Thus, the sequence extends, while rapidly widening, like the growth of a living organism ... the microscopy of the dilation renews the organic ferment of development as proliferation. They pour space into a larger space which is infinite space.

Mario Merz The Fibonacci Series, 1971

There is no reason not to imagine a ... term ... that would be both *landscape* and *architecture* ...

The expanded field is ... generated by problematizing the set of oppositions between which the modernist category *sculpture* is suspended ... as we can see, sculpture is no longer the privileged middle term between two things that it isn't. *Sculpture* is rather only one term on the periphery of a field in which there are other, differently structured possibilities.

... the possible combination of *landscape* and *non-landscape* began to be explored in the late 1960s. The term *marked sites* is used to identify work like Smithson's *Spiral Jetty* (1970) ... and many others. But in addition to actual physical manipulations of sites, this term also refers to other forms of marking. These might operate through the application of impermanent marks ... or through the use of photography.

Rosalind Krauss Sculpture in the Expanded Field, 1979

If the only rule is that art must use what uses it, then one should not be put off by the generally high level of idiocy, politics and propaganda attached to public monuments – especially if one is in the business of erecting them. Should the government/ industry sponsorship of art as land reclamation be enthusiastically welcomed by artists? Every large strip mine could support an artist in residence. Flattened mountain tops await the aesthetic touch. Dank and noxious acres of spoil piles cry out for some redeeming sculptural shape. Bottomless industrial pits yawn for creative filling – or deepening.

Robert Morris Notes on Art as/and Land Reclamation, 1980

My art is about working in the wide world, wherever, on the surface of the earth.

My art has the themes of materials, ideas, movement, time. The beauty of objects, thoughts, places and actions.

My work is about my senses, my instinct, my own scale and my own physical commitment.

My work is real, not illusory or conceptual.
It is about real stones, real time, real actions ...

My outdoor sculptures and walking locations are not subject to possession and ownership. I like the fact that roads and mountains are common, public land.

My outdoor sculptures are places.
The material and the idea are of the place;
sculpture and place are one and the same.

Richard Long Five, Six, Pick Up Sticks, 1980

I think the tree is an element of regeneration which in itself is a concept of time. The oak is especially so because it is a slowly growing tree with a kind of really solid heartwood. It has always been a form of sculpture, a symbol for this planet ever since the druids, who are called after the oak. Druid means oak. They used their oaks to define their holy places. I can see such a use for the future as representing the really progressive character of the idea of understanding art when it is related to the life of humankind within the social body in the future. The tree planting enterprise provides a very simple but radical possibility for this when we start with the seven thousand oaks.

Joseph Beuys Interview with Richard Demarco, 1982

I make landscapes, or cityscapes as the case may be, to study the process of settlement as well as to work out for myself what the kind of picture (or photograph) we call a 'landscape' is. This permits me also to recognize the other kinds of picture with which it has necessary connections, or the other genres that a landscape might conceal within itself.

Jeff Wall About Making Landscapes, 1995

The rampant beauty of Gursky's photographs culminates in his interiors of factories or stock exchanges. That these places of labor, of alienation and of the most cynically disembodied business could provide an opportunity for unparalleled visual delight, even ahead of 'nature', is a paradox.

Jean-Pierre Criqui On the Melancholy of Vantage Points, 1995

Gardening activity is of five kinds, namely, sowing, planting, fixing, placing, maintaining. In so far as gardening is an Art, all these may be taken under the one head, composing.

Ian Hamilton Finlay More Detached Sentences on Gardening in the Manner of Shenstone, 1985

Still Life	**Object**	**Real Life**	
			Paul Moorhouse

Among the many radical developments in the visual arts during the last hundred years, one of the most significant has been the extraordinary growth and transformation of the genre known as still life. While the depiction of inanimate objects was known in Greek and Roman times, this type of subject only really emerged as an independent category in the seventeenth century. In the hierarchy of genres established at the same time still life came last, after history (religious, historical and mythological subjects), portraiture and landscape. Partly, this lowly status can be attributed to the main concern of the painter of still life with depicting ordinary, everyday things. Aside from the symbolic function of certain images called *vanitas* in which a skull, a spent candle or some other emblem of transience served as a reminder of mortality, the very familiarity of still life subjects precluded claims to more elevated content.

Yet, during the early years of this century, artists associated with the most advanced art movements demonstrated a new preoccupation with still life. The innovatory pictorial language of Cubism developed by George Braque and Pablo Picasso (see p.134, 212) between 1907 and 1912 could only take shape, it seems, by addressing subjects that were a recognisable part of everyday life. Their belief in the eloquence and validity of material things was continued and developed by subsequent movements from Dada and Surrealism to Pop. To the artistic resonance of inanimate objects these movements in turn added the subversion of aesthetic values, shock tactics and fetishism, and the seductive appeal of mass-produced consumer items. At the same time, the artists involved with these movements dramatically extended their visual vocabulary by making works of art which appropriated real things.

Since the 1960s, a growing engagement with the manifestations and meanings of material culture has sharpened the involvement of artists with objects. Paradoxically, however, much contemporary work has increasingly and in some instances, completely, disposed of the painted or sculpted depiction of these objects. Indeed, a principal trend of the art of the last forty years in particular has been an apparent desire to eliminate semblance, illusion and any trace of those virtual qualities that differentiate works of art from real things. Instead of creating a representation of an object the artist employs the object itself – an actual, found artefact. Alternatively, many artists have fabricated art objects that neither simulate the appearance of anything else, nor comprise found things, but exist in their own right and are 'real' in themselves, like other objects in the material world. The direct aim of such activity has been to close the gap between the artwork and other things in the world, and it can be argued that this aim has succeeded: still life has, as it were, reinvented itself as real life.

How did this transition from representational still life painting to an art grounded in the *actuality* of real life come about? The still lifes of Paul Cézanne stand at the beginning of this

Pablo Picasso *Bottle of Vieux Marc, Glass, Guitar and Newspaper* 1913

process, and their importance cannot be overestimated. The search for structure and the desire to impose order are the complementary tensions which define Cézanne's engagement with this genre. In an arrangement of objects on a table top he found a fragment of the world that he could contemplate, and whose formal and structural complexities he could attempt to fathom. It is ironic, therefore, that in seeking a firm, essential substructure beneath the evanescent play of light, he should find its inevitable opposites: contingency, change and relativity. The paintings' multiple viewpoints and the progressive abandonment of perspective suggest his growing realisation that every look at the objects before him yielded a fresh relationship with those things.

As if to compensate for the elusiveness of this natural structure, Cézanne's still lifes achieve a profound *pictorial* order. There is an overt sense of relationship between the painted objects, arising from the way they are arranged but also drawn into a satisfying compositional unity. This is so even though the means of depiction is frequently illogical when judged in relation to conventional perspective. For example, we see the side of a jug but also its top as if from above. In this apparent incoherence we have the first complex denial of pictorial illusion: the first tacit admission that traditional representational means, using an unchanging viewpoint, do not show the way things really are. In its place we have an assertion that while a painting stands in relation to the world, it is nevertheless a thing in itself, with its own inner order, structure and reality.

Responding to Cézanne's example, Cubism was formulated by Picasso and Braque principally in terms of still life subjects. The inertness of such objects as a glass, a bottle, a pipe or a newspaper provided a perfect vehicle for evoking the complex phenomenological relationships between such artefacts, the surrounding space and the viewer perceiving them. Moreover, by avoiding subject matter with a strong emotional or narrative content, they were able to give the greatest prominence to the innovative formal aspects of the visual language they were advancing. After 1912, Picasso's and Braque's incorporation within the picture image of 'real' materials, such as fragments of newsprint and wallpaper, is complex and in some ways paradoxical. The pieces of collage introduce elements of the material world into the picture, bridging the gap between art and real life. Simultaneously, such elements draw attention to the autonomous reality of the work of art, emphasising the physical, surface facts of the pictorial structure over and above its depicted subject.

This notion that a work of art should assert its independent reality is central to the approach advanced by Cézanne and the Cubists, and has its roots in earlier philosophical ideas. In a telling passage in *The Critique of Judgement*, Immanuel Kant observed: 'a work of art is an individual and distinct thing. Something self-contained and possessing its own purpose within itself; yet there is at the same time represented in it a new "whole", a new total image of reality.'

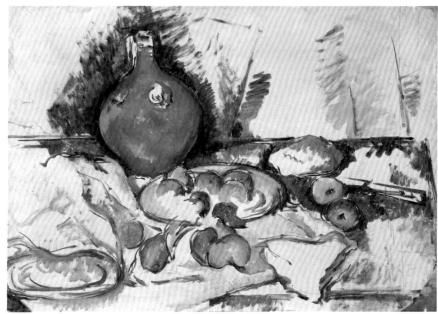

Paul Cézanne *Still Life With Water Jug* c.1892–3

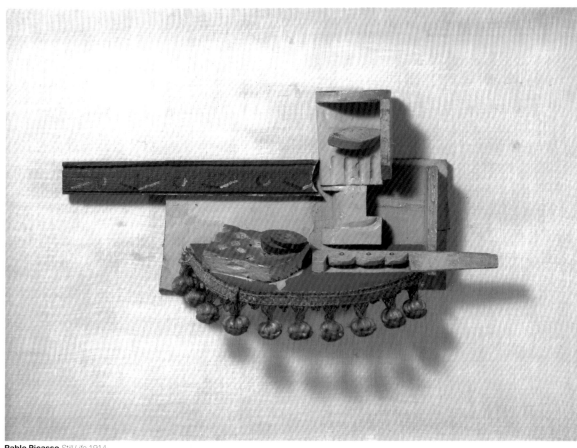

Pablo Picasso *Still Life* 1914

Kant's words capture precisely the ambiguity inherent in the modernist idea of investing a work of art with its own autonomous 'reality'. By playing down its representational function and asserting its physical components, the work of art certainly becomes more of an object in its own right. But the visual language employed by the modernist work of art also defines an object like no other: one which relates analogously to the real world but nevertheless remains separate from it.

It is illuminating to see Marcel Duchamp's radical introduction of the 'readymade' in the context of these issues (see p.148). In a primary sense, Duchamp's designation of a bicycle wheel, a bottlerack and other prefabricated, mass-produced objects as works of art was part of the Dada mission to subvert existing aesthetic standards. For this reason, the readymades have been seen as paradigms of anti-art. However, Duchamp's agenda was not simply anarchic and there is a deeper significance. By specifying certain ordinary objects – either individually or in combination – as art, Duchamp was attacking the idea of autonomy which had brought Cubist works of art to the brink of abstraction. Duchamp's *Bottlerack* (1914) removes entirely those qualities of representation which made Cubist still lifes increasingly difficult to read. In their place, an actual object functions as art, removing any need for representation. The implication is that the boundary between art and real life has been dissolved.

In practice, however, Duchamp's readymades could rarely – if ever – be mistaken for everyday objects. Even though they comprise elements taken from the real world, the context in which these things are displayed, and their strangeness, mark them out as functionless objects for contemplation. Later 'assisted' readymades such as *Why not Sneeze Rose Sélavy*? have an enigmatic quality which in the case of that work, arises from the bizarre combination of marble cubes masquerading as sugar lumps, a thermometer and a piece of cuttle fish within a bird cage. Moreover, the work's title hints at some cryptic meaning. Such works were a significant development in the evolution of the modern still life for, as the Surrealists grasped, they demonstrated the potential of using an *arrangement* of ordinary objects – albeit in a perverse way – to generate poetic meaning.

The Surrealists' campaign to court irrationality and subvert reason drew, in part, on notions of chance and fantastic coincidence, ideas which drew inspiration from 'the chance encounter of a sewing machine and an umbrella on a dissecting table' as conceived and declared 'beautiful', by the poet, Isidore Ducasse, whom the Surrealists hailed as a precursor. In their hands, still life was reborn as the Surrealist object: usually a three-dimensional arrangement of found artefacts forming a physical equivalent for the kind of collision envisaged by Ducasse. Salvador Dalí's *Lobster Telephone*, for example (p.141), provides startling evidence of the way ordinary things can be made to appear utterly alien, and to suggest abnormal perceptions and

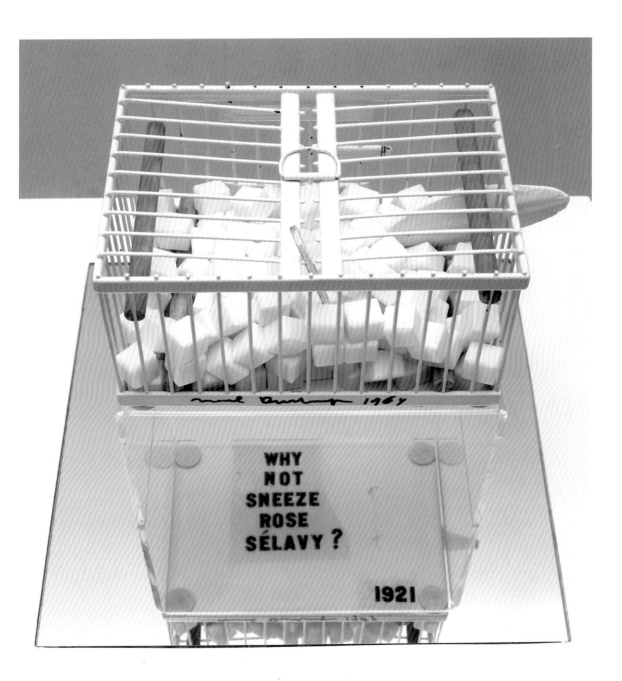

WHY
NOT
SNEEZE
ROSE
SÉLAVY ?

1921

Marcel Duchamp *Why Not Sneeze Rose Sélavy?* 1921

fetish-like desires, simply by combining two previously unrelated artefacts. It also suggests the new complexity which Surrealist objects brought to bear on the modernist preoccupation with emphasising the reality of the work of art. The work combines a virtual element (the imitation lobster) with a 'real' one (the telephone). Of course, if we allow that the imitation lobster has been appropriated from a fishmonger's window, it can also be seen as a found, or real, artefact. The object is actual, illusory and fantastic, confounding our ideas about what can be considered 'real'.

It would be misleading to suggest that this investigation of the boundaries of art and life constitutes the only line of development taken by the genre of still life during this century. Alongside these avant-garde tendencies many artists continued an engagement with still life predicated on the representation of arrangements of objects in domestic settings. In so doing, such painters as Pierre Bonnard, Giorgio Morandi, Braque, Picasso, Edouard Vuillard, André Derain and – more recently – Patrick Caulfield, have preserved an approach to still life in which representation by virtual means is central. The arrangement and depiction of objects has also been exploited by such artists as Helen Chadwick and Tim Head who have used photography as a vehicle for still life subjects. Both these artists have used photographs of inanimate objects as images of mortality, thus revisiting and extending the still life *vanitas* tradition.

Notwithstanding the continuation of the still life painting and the advancement of photography, the period since 1960 has, as noted above, seen the expansion of an artistic ethos whose principal aim has been to abolish semblance or depiction in art. The reasons for this are complex, but arise perhaps from a sense that virtual, illusionistic qualities are artificial and should be replaced by art whose physical characteristics are truer by being actual and real in themselves. Alternatively, it could be argued that some artists feel that by making art more 'real', it can be made to relate more directly and relevantly to its audience. Whatever the causes, the effect of this philosophical stance has been to produce a proliferation of different manifestations each dedicated to removing the difference between works of art and other objects in the world. Because of this focus on the veracity and material status of objects, issues deriving from still life – arrangement, classification and symbolism – have coloured the debate, ensuring the survival and development of the genre.

Within this vast field of activity, two principal strands can be discerned. The first of these has been a concern with fabricating works of art which do not represent any other thing and whose intrinsic physical characteristics constitute their own reality. During the 1960s the constructed sculpture pioneered in Britain by Anthony Caro and others, the minimal sculpture of Donald Judd, Carl Andre, Dan Flavin and Robert Morris (see p.180, 114 and 203), kinetic art, geometric abstraction, and the abstraction of painters such as Frank Stella, Morris Louis and Bridget Riley can all be

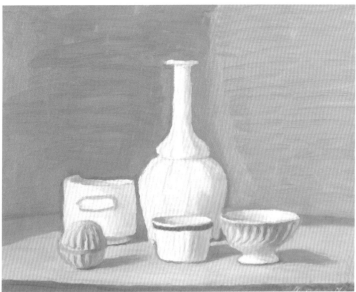

Giorgio Morandi *Still Life* 1946

Patrick Caulfield *Interior with a Picture* 1985–6

seen as having developed within this rubrik. In each case there is an emphasis on the factual, perceptual qualities of the work itself or, as Stella put it, 'what you see is what you see'.

A second major trend has been an ever growing involvement with using pre-existing real objects as the actual constituents of art. Pop in the USA and Britain, and also Nouveau Réalisme and Arte Povera in Europe, all reflected a fascination with the material fabric of the real world and a determination to make art that responded directly to, and grew out of, a global cultural obsession with objects and commodities: mass-produced, anonymous and disposable. In using real objects as the stuff of art, such artists as Robert Rauschenberg, Jasper Johns, Louise Nevelson, Christo, Daniel Spoerri and Marcel Broodthaers were, in one way, extending the legacy of Dada. However, as Duchamp observed, there was a crucial difference: 'I thought to discourage aesthetics. In neo-Dada they have taken my readymades and found aesthetic beauty in them.'

If such artists espoused a positive interest in the physical character and presence of everyday objects, in the last twenty years the focus has turned increasingly to addressing and exploring the *meanings* which attach to material things. The immediate antecedents of such developments can be found in the spread of Conceptual art during the late 1960s and 1970s. During that time, for certain artists the object ceased to have relevance except as a document, record or reference for an idea or process. Michael Craig-Martin's *An Oak Tree*, which features a glass of water on a shelf, is an extreme example. The notion that ephemera could embody and evoke complex conceptual content is central to the resurgence of interest in much object-based art today. This position is revealed in Tony Cragg's observation: 'any material that comes near to us, any material that we even see, automatically becomes more intelligent because it assumes metaphysical qualities in addition to its physical qualities. The material starts to have information attached to it, to have a history, to assume poetic qualities.'

Having abolished virtual references to other things, the concern among many artists now is that the objects they make should take their place in the real world *and* that these things should be charged metaphorically, embodying symbolic meaning. Rachel Whiteread, Susan Hiller and Damien Hirst (see p.231, 171) have in their different ways provided exemplars of this sensibility: Whiteread with her casts of objects constituting poignant reflections on absence and loss; Hiller, whose evocative deployment of found objects evokes a sense of their history and the lives they have touched; and Hirst in his use of dead creatures as emblems of mortality. This fusion of the actual and the symbolic has created the conditions for a remarkable vitality and diversity in contemporary art. In a fast changing world which insistently challenges our assumptions about what is virtual and what is real, and raises questions about the way objects carry meaning, art that is capable of addressing these issues is both relevant and necessary.

Daniel Spoerri *Prose Poems* 1959–60

Rachel Whiteread *Untitled (Air Bed II)* 1992

Still life can be said to unfold at the interface between these three cultural zones:

1. The life of the table, of the household interior, of the basic creaturely acts of eating and drinking, of the artefacts which surround the subject in her or his domestic space, of the everyday world of routine and repetition, at a level of existence where events are not at all the large-scale, momentous events of History, but the small-scale, trivial, forgettable acts of bodily survival and self-maintenance.

2. The domain of sign systems which *code* the life of the table and 'low plane reality' through discourses which relate it to other cultural concerns in other domains (for example those of ideology, sexuality, economics, class).

3. The technology of painting, as a material practice with its own specificities of method, its own developmental series, its own economic constraints and semiotic processes.

Norman Bryson Looking at the Overlooked, 1990

Treat nature by means of the cylinder, the sphere, the cone, everything brought into proper perspective so that each side of an object or a plane is directed towards a central point.

Paul Cézanne Letter to Emile Bernard, Aix-en-Provence, 15 April 1904

The object is not interesting in itself. It's the environment which creates the object … A glass of water with a flower is different from a glass of water and a lemon. The object is an actor: a good actor can have a part in ten different plays; an object can play a different role in ten different pictures. The object is not taken alone, it evokes an ensemble of elements.

Henri Matisse Testimonial, 1951

How often have we not seen upon the cheek of the person with whom we are talking the horse which passes at the end of the street.

Our bodies penetrate the sofas upon which we sit, and the sofas penetrate our bodies. The motor bus rushes into the houses which it passes, and in their turn the houses throw themselves upon the motor bus and are blended with it.

The construction of pictures has hitherto been foolishly traditional. Painters have shown us the objects and the people placed before us. We shall hence-forward put the spectator in the centre of the picture.

… We would at any price re-enter into life.

Umberto Boccioni et al. Futurist Painting: Technical Manifesto, 1910

To compose, to construct, to design, reduces itself to this: to determine by our own activity the dynamism of form.

We are neither geometers nor sculptors; for us, lines, surfaces, and volumes are only nuances of the notion of fullness.

Albert Gleizes and Jean Metzinger Cubism, 1912

The Impressionists were the first to reject the *absolute value of the subject and to consider its value to be merely relative*

… For the Impressionists a green apple on a red rug is no longer the relationship between two objects, but the relationship between two tones, a green and a red.

Fernand Léger The Origins of Painting and its Representational Value, 1913

What were the grounds for refusing Mr Mutt's fountain:

1. Some contended it was immoral, vulgar.

2. Others, it was plagiarism, a plain piece of plumbing.

Now Mr Mutt's fountain is not immoral, that is absurd, no more than a bathtub is immoral. It is a fixture that you see every day in plumbers' show windows.

Whether Mr Mutt with his own hands made the fountain or not has no importance. He CHOSE it. He took an ordinary article of life, placed it so that its useful significance disappeared under the new title and point of view – created a new thought for that object.

As for plumbing, that is absurd. The only works of art America has given are her plumbing and her bridges.

Marcel Duchamp The Richard Mutt Case, 1917

I think I am entitled to say without exaggeration that Surrealism has enabled painting to travel with seven-

league boots a long way from Renoir's three apples, Manet's four sticks of asparagus, Derain's little chocolate women, and the Cubists' tobacco-packet, and to open up for it a field of *vision* limited only by the *irritability capacity of the mind's powers*.

Max Ernst Beyond Painting, 1937

Collage is one of the more important additions to twentieth-century techniques. For me it is a form of inspired correction, a displacement of the banal by the fertile intervention of chance or coincidence … For it is a certain kind of sensitive chaos that is creative, and not sterile order. The revelation of the inexhaustible aspects of things is one of the great delights and one of the deepest charms of art.

The Surrealists have seen that the universe is at root a magical illusion, a strange, mysterious, fabulous game, and that is how they play it.

Eileen Agar A Look at My Life, 1988

playing cards, books, all objects of manipulation, referring to an exclusive, private world in which the individual is immobile, but free to enjoy his own moods and self stimulation. And finally, there are pictures in which the elements of professional artistic discrimination, present to some degree in all painting – the lines, spots of color, areas, textures, modelling – are disengaged from things and juxtaposed as 'pure' aesthetic objects.

Thus elements drawn from the professional surroundings and activity of the artist; situations in which we are consumers and spectators; objects which we confront intimately, but passively or accidentally, or manipulate idly and in isolation – these are typical subjects of modern painting.

Meyer Schapiro The Social Bases of Art, 1936

Where there is an avant-garde, generally we also find a rearguard. True enough – simultaneously with the entrance of the avant-garde, a second new cultural phenomenon appeared in the industrial

I defy any art lover to love a painting as much as a fetishist loves a shoe.

Georges Bataille The Solar Anus, 1927

The revolutionary strength of Dadaism lay in testing art for its authenticity. You made still-lifes out of tickets, spools of cotton, cigarette stubs, and mixed them with pictorial elements. You put a frame round the whole thing. And in this way you said to the public: look, your picture frame destroys time; the smallest authentic fragment of everyday life says more than painting. Just as a murderer's bloody fingerprint on a page says more than the words printed on it.

Walter Benjamin The Author as Producer, 1934

Although painters will say … content doesn't matter, they are curiously selective in their subjects … his studio and his intimate objects, his model posing, the fruit and flowers on his table, his window and the view from it; symbols of the artist's activity, individuals practising other arts, rehearsing, or in their privacy; instruments of art, especially of music, which suggest an abstract art and improvisation; isolated intimate fields, like a table covered with private instruments of idle sensation, drinking glasses, a pipe,

West: that thing to which the Germans give the wonderful name of *Kitsch*: popular, commercial art and literature with their chromeotypes, magazine covers, illustrations, ads, slick and pulp fiction, comics, Tin Pan Alley music, tap dancing, Hollywood movies, etc, etc …

Kitsch is mechanical and operates by formulas. Kitsch is vicarious experience and faked sensations. Kitsch changes according to style, but remains always the same. Kitsch is the epitome of all that is spurious in the life of our times. Kitsch pretends to demand nothing of its customers except their money – not even their time.

Clement Greenberg Avant-Garde and Kitsch, 1939

Painting Ensnared

'This is not painting! It's a line that you have drawn on the ground with your nail – and that? No better! It's soft fabric

like a curtain or a tapestry. As for this, it looks like a railway signal. This looks like housepainting! And this other one, which you've baked, it's not painting, it's pottery or pastry … You mix everything up. A skin specialist doesn't treat liver diseases. I need works that are mutually comparable, so I can classify them, give them a relative ranking, in a well-defined category. And then? Well, I fix the prices accordingly. That's it, it's all clear.' Too clear, I say. I'm in favour of confusion. Do not confine art, cut if off from the real world, keep it in a trap. I want painting to be full of life – decorations, swatches of colour, signs and placards, scratches on the ground. These are its native soil.

Jean Dubuffet Notes for the Well-Lettered, 1946

styling was a constant reproach to the Mooreish yokelry of British sculpture, or the affected Piperish gloom of British painting. To anyone with a scrap of sensibility or an eye to technique, the average Playtex or Maidenform ad in American Vogue was an instant deflater of most artists then in Arts Council vogue.

Reyner Banham Representations in Protest, 1977

This is not a composition. It is a place where things are, as on a table or on a town seen from the air: any one of them could be removed and another come into its place through circumstances analogous to birth and death, travel,

I am for an art that is political-erotical-mystical, that does something other than sit on its ass in a museum.
I am for an art that grows up not knowing it is art at all, an art given the chance of having a starting point of zero.
I am for an art that embroils itself with the everyday crap & still comes out on top.

I am for an art that imitates the human, that is comic, if necessary, or violent, or whatever is necessary.
I am for an art that takes its form from the lines of life itself, that twists and extends and accumulates and spits and drips, and is heavy and coarse and blunt and sweet and stupid as life itself.
I am for an art of underwear and the art of taxicabs. I am for the art of ice-cream cones dropped on concrete. I am for the majestic art of dog-turds, rising like cathedrals.

Claes Oldenburg I Am for an Art, 1961

It is important to realise how salutary a corrective to the sloppy, provincialism of most London art ten years ago, American design could be. The gusto and professionalism of widescreen movies or Detroit car

housecleaning, or cluttering.
… There is no more subject in a *combine* than there is in a page from a newspaper. Each thing that is there is a subject. It is a situation involving multiplicity.

John Cage On Robert Rauschenberg, Artist, and his Work, 1961

Three dimensions are real space. That gets rid of the problem of illusionism and of literal space, space in and around marks and colors – which is riddance of one of the salient and most objectionable relics of European art.

… The use of three dimensions makes it possible to use all sorts of materials and colors. Most of the work involves new materials, either recent inventions or things not used before in art. Little was done until lately with the wide range of industrial

I see myself more as a sorcerer than a sculptor, casting baroque spells with objects that embody good and evil, male and female, and suggest a place where our repressed desires can find release.

Cathy de Monchaux 1997

products … Materials vary greatly and are simply materials – formica, aluminum, cold-rolled steel, plexiglas, red and common brass, and so forth. They are specific. If they are used directly, they are more specific. Also, they are usually aggressive. There is an objectivity to the obdurate identity of a material. Also, of course, the qualities of materials – hard mass, soft mass, thickness of $\frac{1}{32}$, $\frac{1}{16}$, $\frac{1}{8}$ inch, pliability, slickness, translucency, dullness – have unobjective uses.

Donald Judd Specific Objects, 1965

Plastic (what a beautiful material and what extraordinary colours) is a pure, man-made material. I do not disregard other materials. I use everything but, preferably after they have been used by man … what interests me is the special critical appraisal which we apply to man made objects and his activities.

It is a realistic problem, the world is full of man-made objects. It is about time we stopped, started clarifying and re-evaluating the objects we have put into the world. This situation acquires a political dimension now, which no longer has anything to do with political structures but is related to the very nature of this *critical* search.

Tony Cragg Interview with Démosthènes Davvetas, 1985

When I first started using found domestic goods, it was in a way analogous to fossils – contemporary fossils … these items are material for me that is found in my environment, it's not recovered in any sense, it deals directly with my life and the majority of my experiences, whereas walks in the countryside and rural atmospherics don't play a very large part in my life.

Bill Woodrow 1981

If I wanted to make a ready-made today, I would make the pissoir, but one you could really piss into, in a museum. Recently I made something for the kitchen, a sieve, but you can use it, and then put it back on the plinth. And a shopping bag, with a very beautiful design … It's about searching for the art, somewhere between the artist and the technician.

Franz West Interview with Iwona Blazwick, James Lingwood and Andrea Schlieker, 1990

Objects can provide me with knowledges of various kinds that I can translate. I'm not talking about object theory but art, about getting your hands dirty, maybe stuck at that stage – material practices. Words come into it too, as in dream memories. I can't say what a dream is, but a dream memory or construction might be a word, a fragment of music, the memory of a colour or a touch, a flavour – but we can't dream without bodies, as you know. And it's that level of embodiment I want to emphasize when I say 'working through objects'. Objects embody meanings.

Susan Hiller Working Through Objects, 1994

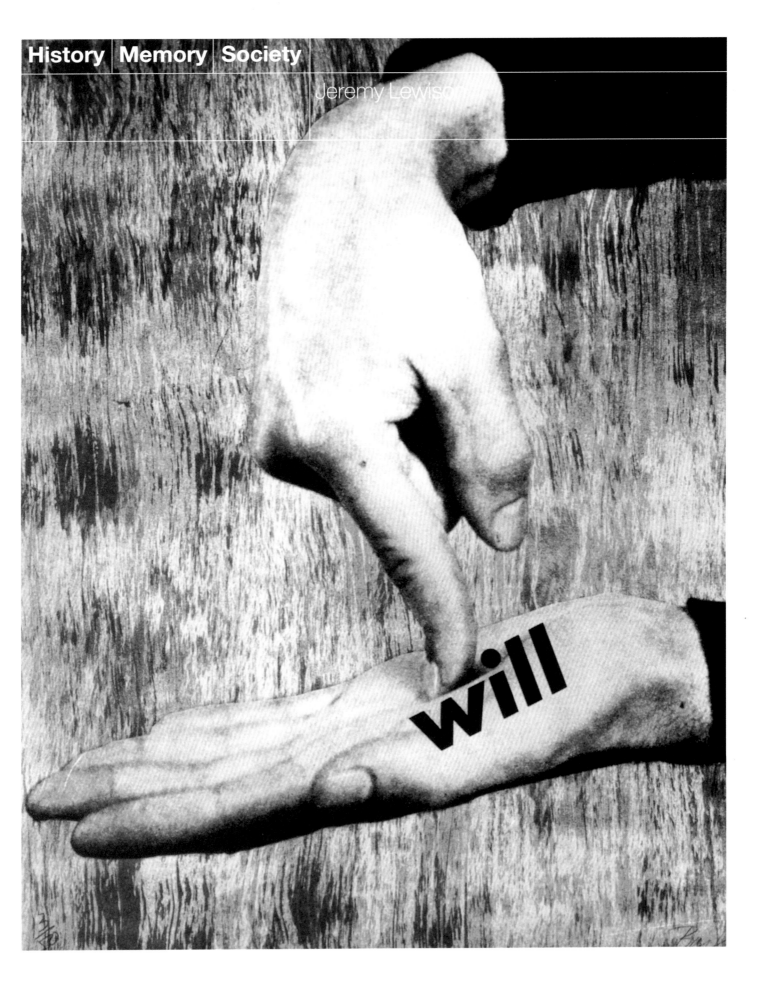

Jeremy Lewison

Leon Battista Alberti, whose *de Pictura* (1435) was the foundation of all thinking on the visual arts in the Renaissance, adumbrated the concept of history painting. Alberti employed the word *historia* (Latin for story) to describe a narrative picture with many figures. He attempted to raise the standard of Italian painting by suggesting a framework analogous to the Classical rhetoric propounded by Cicero and Quintilian. Through compositional discipline, he maintained, the artist should represent and interpret human emotions. Figures should be as near life-size as possible. Over the next four centuries Alberti's ideas were developed further to the point where history painting became the highest in the hierarchy of genres and the one by which an artist's greatness was measured. For Sir Joshua Reynolds, not himself a practitioner of what he called 'the grand manner' except as a portraitist, nothing was so worthy as history painting. In France, simultaneously, the critics La Font de Saint Yenne and Denis Diderot called for a painting of moral virtue in the face of the frivolity of Rococo painting, and it arrived shortly thereafter in the guise of the Neoclassicism of Jacques Louis David, whose celebrated *Oath of the Horatii* (1784) became a paradigmatic work. This painting depicts three brothers swearing an oath of allegiance to Rome before departing for combat against their cousins, representatives of Alba. In the background their wives and families sit in grief. Its themes were love, terror, pathetic sentiment, stoicism, moral virtue and civic duty, all of which were considered appropriate subjects for history painting. Civic duty was prized above family bond. Moral rigour was a defining characteristic of the genre. The theme of a history painting was derived from Greco-Roman history, religion or ancient myth and the illusion of archaeological accuracy was imperative. Temporal distance was a necessary precondition of the elevation of the subject to a state of universality, and was considered essential if painting was to take on some form of didactic function.

The French Revolution of 1789, however, saw the temporary abandonment by David of themes from ancient history in favour of the depiction of those normally confined to journalism. His *Oath of the Tennis Court* (1791) and *Death of Marat* (1793) endowed contemporary events with a mythological and religious status respectively, and built on the example of Benjamin West, the London-based American painter, whose *Death of General Wolfe* (1771) so incensed Reynolds for its depiction, on a grand scale, of a contemporary scene in modern costume.

The Neoclassical era was the high point of history painting and although the genre continued well into the nineteenth century, the relevance of the past to the conduct of contemporary life diminished. David's elevation of the contemporary to the level of history was perpetuated not only in his own idolisation of Napoleon but in that of his pupils Baron Gros and Jean Auguste Dominique Ingres. The concept of contemporary reportage was to be found in Gros's sanctification of Napoleon on the battlefield of Eylau and in the pest-house of Jaffa (1808 and

Georg Grosz *Suicide* 1916

1804) and Théodore Géricault's grandiose *Raft of the Medusa* (1819), where an account of a contemporary shipwreck was raised to the condition of universality by its grand scale and reliance on historical models for the depiction of human form, in this case the work of Michelangelo. Monumentality was another prerequisite of history painting. It was painting on a public scale. Although allegory continued to play a role in early nineteenth-century painting, ancient history, which had been so closely associated with the spirit of the French Revolution, was gradually replaced by an interest in the medieval and then with the modern. History painting and genre painting were conflated in the first half of the century when 'modern' subjects, for example *The Execution of Lady Jane Grey* by Paul Delaroche (1834), were painted on a large scale. Simultaneously, the emphasis began to shift from people of high standing to the general populus. Thus Eugène Delacroix's *Liberty Leading the People* (1830) celebrates the heroism of ordinary Parisians and not a public figure.

After the momentous events of the first half of the nineteenth century, when history was perceived to be in the making, it seemed impossible for some artists to return to the depiction of ancient times. While this kind of art slipped down the hierarchy into 'genre painting', Gustave Courbet, the Realist painter, argued that 'All history painting must, in essence, be contemporary.' Courbet stated that an artist can only reproduce his own era and his view became the foundation of art from 1850 onwards. Since then, artists have rarely returned to depict events of the distant past, and where they have wished to engage with some of the themes central to the concept of history painting they have done so by depicting the contemporary. Georg Grosz's *Suicide* (1916) satirises the lack of moral virtue in Germany during the First World War by highlighting depravity and corruption in Berlin. It is a modern permutation of a Dantesque descent into hell. A contemporary equivalent of David's *Death of Marat* might be found in Richard Hamilton's *The citizen* (p. 167) which has overtones of a Christian martyrdom in spite of its sense of moral ambiguity. Today's version of Rembrandt's *The Night Watch* (1642), arguably one of the first 'modern history' paintings and a model for Courbet's *Firemen Going to a Fire* (1850–1), is Gillian Wearing's *Sixty Minute Silence* (1996).

The concept of the heroic has essentially been discredited. If in the late eighteenth and nineteenth centuries a hero was defined as a man or woman of public virtue, who acted for the public good and was memorialised in monumental sculpture and painting, in the late twentieth century the idols are the rich and famous. The cult of celebrity and opulence, as exemplified by Andy Warhol's portraits, has replaced moral example as the determining factor in the choice of subject. In the case of Georg Baselitz (see p. 122) in the 1960s, the anti-heroic replaced the heroic. Baselitz's rebels are rebels without a cause, disenfranchised and deracinated. They lack

Baselitz *Rebel* 1965

a historical identity, because Germanic mythology and history had been appropriated by the Nazis. Christian Boltanski's works on the theme of the *Dead Swiss* are not so much memorials to the Holocaust, as they have often been interpreted, but ironic comments on anonymity and the lack of heroism in death. No information is known about the victims since their photographs have been divorced from their obituaries. They have been memorialised but without memory. Nevertheless Boltanski employs the strategies of the traditional apotheosis and memorial. Similarly, the gravestones of the Jewish cemetery in Warsaw, photographed by Hannah Collins (see p.137), speak of anonymity and erasure. In death there is no glory.

The traditions of history painting in their purest form have migrated to film. Abel Gance's *Napoleon* (1927) which lionised its eponymous hero and, later, the Hollywood productions of *The Ten Commandments* (1956), *Ben Hur* (1959) and *El Cid* (1961), exemplify the use of history to encode moral virtue, stoicism and other characteristics of history painting. The epic film replaced the epic painting. In the contemporary era such films as *Gandhi* (1982) and *Saving Private Ryan* (1998) indicate that the public still has a thirst for high moral example and heroism.

Some of the functions of history painting, however, have remained intact into the twentieth century. Such a painting as David's *Oath of the Horatii* was intended to address a wide public and to put over a particular point of view in the most direct way possible. The murals of the Mexican artists José Clemente Orozco, Diego Rivera and David Alfaro Siqueiros were similarly intended. By and large, however, artists have developed other strategies to address a mass audience. It is perhaps an indication of the increase of literacy in early twentieth-century Europe that they have chosen to announce their views in manifestos, often published in mass-circulation newspapers. The Futurists published theirs in *Le Figaro*, Paul Nash announced the formation of Unit One in *The Times*, while Antoine Pevsner and Naum Gabo issued their *Realistic Manifesto* as a poster to accompany their joint open-air exhibition on the Tverskoie Boulevard in Moscow. The fashion for manifestos was an indication that art was no longer intended to decorate apartments or palaces but, in the words of Picasso, in a statement of 1945, 'It is an instrument for offensive and defensive war against the enemy'. Picasso had painted *Guernica* and all the *Weeping Woman* paintings in 1937 following the bombardment of the village of Guernica in the Basque country during the Spanish Civil War. *Guernica* is executed on the scale of an eighteenth-century history painting and its moral stance is transparently obvious. It protested against an immoral act. The *Weeping Woman* is an allegory for the plight of Republican Spain. Similarly, Boris Taslitzky's *Riposte* (1951) was painted in protest at the treatment of strikers in the docks of Port Bouc in Algeria, who had refused to load armaments to be used in the conflict in French Indochina. Taslitzky's painting, like many social realist works, particularly those of the

Christian Boltanski *The Reserve of Dead Swiss* 1990

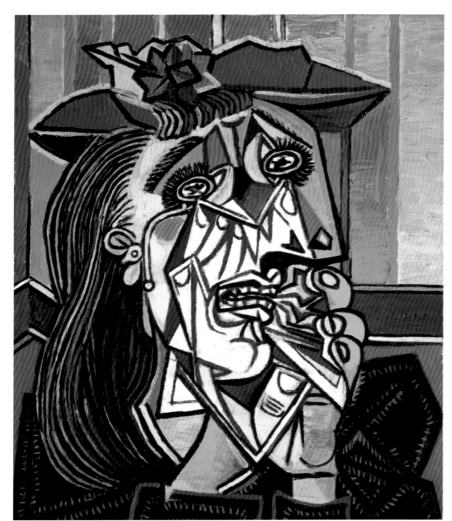

Pablo Picasso *Weeping Woman* 1937

fascist era, adopts the traditional forms of history painting. However, unlike Russian and German social realism, it was intended to be subversive rather than authoritarian. Indeed so subversive was this work that it was removed from the 1951 Salon d'Automne at the order of the Chief of Police in Paris. The political commitment shown by Taslitzky and Picasso is ostensibly absent from Roy Lichtenstein's 1963 painting *Whaam!* (p.190) which in scale and subject is an archetypal modern-day history painting. Executed in the year of President John F. Kennedy's assassination and as American involvement in the Vietnam war was beginning to escalate (bombing began in 1964), Lichtenstein adopts a deadpan comic book style which belies implicit criticism of the glorification of war.

The emphasis of all the major manifestos of the twentieth century was on the central importance of the present and the abandonment, if not the destruction, of the past. An idealistic sense of progress was enshrined in these documents. Thus the Vorticists 'blasted' the Victorian era, while the Futurist Filippo Tommaso Marinetti declared that 'Time and Space died yesterday' and vowed destruction on the guardians of the past, 'museums, libraries and academies of every kind'. The manifesto format, which was essentially appropriated from the political sphere, was a way of circulating in an imperious fashion a synthetic overview of ideological, ethical and political values. Its language was simple, direct and assertive and its content was by and large utopian, setting out a vision for a better society.

In successive manifestos between 1910 and 1939 artists preached social revolution and in certain cases allied themselves to workers' movements. The language of art, particularly of abstraction, was intended to be universally understood, requiring no knowledge of literature or history but an appreciation of colour and form. To this extent modernism was intended to be anti-elitist although for many people its obscurity and opacity had precisely the opposite effect. The utopianism of Suprematism, Constructivism and *L'Esprit Nouveau*, Le Corbusier and Ozenfant's magazine where art, architecture and industrial production were intended to be harnessed together to create the appropriate conditions for a harmonious life, was a manifestation of the drive for social reform and change expressed in schemes for public buildings, garden cities and an art of pure, abstract form. It coincided with government policies of slum clearance and rationalisation and a growing awareness of a need for social reform.

Utopia was a major theme in the first half of the twentieth century. While the Futurists and the Vorticists idolised the machine itself, the machine ethic underpinned attitudes towards life and art for decades. Suprematism, De Stijl, Constructivism, *L'Esprit Nouveau* and the work of Fernand Léger (see p.188) are all in one form or another optimistic manifestations of the celebration of the machine aesthetic encapsulated in the concept of Fordism which, as Peter Wollen

Boris Taslitzky *Riposte* 1951

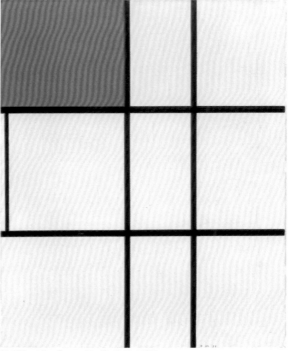

Piet Mondrian *Composition B with Red* 1935

has written, 'became a vision not only of greater productivity, necessary for the development of capitalism, but also of a new model of social organisation with universal implications'. Fordism (named after Henry Ford, who automated the car manufacturing industry) was embraced by capitalist, communist and fascist thinkers as the guiding principle for the future. Mass production and standardisation were its central tenets, Andy Warhol's paintings its logical outcome. Reactions against standardisation came in the form of the return to the 'primitive', the interest in African art at various times in the century whether in the first decade in Picasso's *Demoiselles d'Avignon* (1907) or in the 1980s with the *Magiciens de la Terre* exhibition held in Paris in 1989. Reactions against capitalism were manifested by the Fluxus movement which sought to circumvent the art market by its emphasis on the ephemeral.

To counterbalance the (over)emphasis on the utopian, artists have also dwelt on the dystopian. In the field of literature George Orwell and Aldous Huxley are the most celebrated exemplars of this tradition. In fine art Hans Bellmer's robotic dolls, the logical product of Fordism, highlight the dystopic characteristics of a regulated society, while Francis Bacon's screaming Popes are a clear sign that religion cannot bring salvation in a godless world. The dysfunctional world has led artists to turn inwards and to withdraw from society. Thus in 1992 Absalon constructed *Cells* (p.113) pared down to a minimum in which to seek refuge from the outside. These buildings, intended for the artist's own use, could be erected anywhere. They were purified environments, painted brilliant white, purged of disease and dirt. They were in themselves utopian dwellings in which the artist could isolate himself from the degradation of life. Mario Merz's igloos (p.197) are emblems of survival and nomadic existence, constructed with materials determined by locations and contexts. They are monuments to impermanence and, in the context of the political revolutions of 1968 which formed the backdrop for their creation, they symbolise reconstruction from primal beginnings.

The 1968 student and workers' protests had a profound effect on art. In Germany, where students revolted against the post-war generation of politicians who effectively wrote the Nazi episode out of history by ignoring it, such artists as Anselm Kiefer sought to question the concept of the Germanic by opening up the scars of the Nazi era. In his photographs and paintings of the 1970s Kiefer identified with the cultural and spiritual heroes of Germany who had also been adopted by the Nazi regime. If this identification was ironic and subversive it was nevertheless uncomfortably ambiguous. The association of the myth of Parsifal with the exploits of the Baader-Meinhof group by the incorporation of the names of its core members in Kiefer's paintings of that name recalls the appropriation of Wagnerian mythology by the Nazis, who saw their own exploits as an echo of the redemptive actions of Parsifal. While there is no attempt to depict

Andy Warhol *Electric Chair* 1964

Anselm Kiefer *Parsifal I* 1973

Anselm Kiefer *Parsifal II* 1973

the personages of ancient myth, by verbal allusion Kiefer keeps alive the mythological subject so commonly found in history painting.

In America, rebellion against authority took multiple forms. On the one hand such artists as Sol LeWitt circumvented the system by creating Conceptual art where effectively the only thing which could be traded was a concept, not an object. The object was, so to speak, dematerialised and democratised since it could be created by anyone who followed LeWitt's instructions. Minimal artists, for example Donald Judd (see p.180) or Dan Flavin, made works from industrial materials. Judd had his sculptures manufactured by others just as Warhol's screenprinted paintings were executed by his 'factory' assistants. This was another manifestation of the Fordist ethic. Similarly the grid became a feature of New York painting in the 1960s and 1970s. The notion of seriality was common both to art and industrial manufacture. The grid's non-hierarchical structure was an expression of democracy although its regulatory authority was perhaps a manifestation of underlying repression and control.

Hans Haacke, on the other hand, sought to subvert capitalist structures and political authority, which generally were closely linked, by exposing censorship and violations of democratic principles. *A Breed Apart* (1978) indicates the hidden links between British Leyland, Britain's nationalised flagship motor manufacturer, and South Africa's former apartheid regime, pointing up the irony of British Leyland's advertising campaign slogan aimed at selling Jaguars and Land Rovers. Using the techniques of investigative journalism, Haacke addresses the political issues of his day.

Just as artists appropriated journalistic devices to launch their manifestos, so in recent years they have employed advertising techniques to make art. Jenny Holzer's *Truisms* (1984) and *Inflammatory Essays* (1979–82) consist of slogans that echo the rhetoric of advertising as well as of the political manifesto (see p.175). These half-appealing, half-revolting clichés, whose voice is unidentifiable, were conceived to be located in the city, pasted up on street corners or emblazoned across the LED displays of Times Square. They are in effect emblems of guerilla warfare intended to shock, surprise and discomfort. Barbara Kruger has appropriated advertising strategies more overtly in her use of slogans that look critically at patriarchal values.

Kruger and Holzer's work emerged after a decade in which power relationships were questioned and deconstructed. The birth of the feminist movement in the USA had wide-reaching repercussions in the art world. With the reclamations of the lost histories of women artists, who had for centuries been excluded from the walls of museums and the narrative of art, the focus of contemporary feminist art changed. The female form or persona was no longer a male subject; indeed it was not even neutral, but began to be explored by such artists as Judy

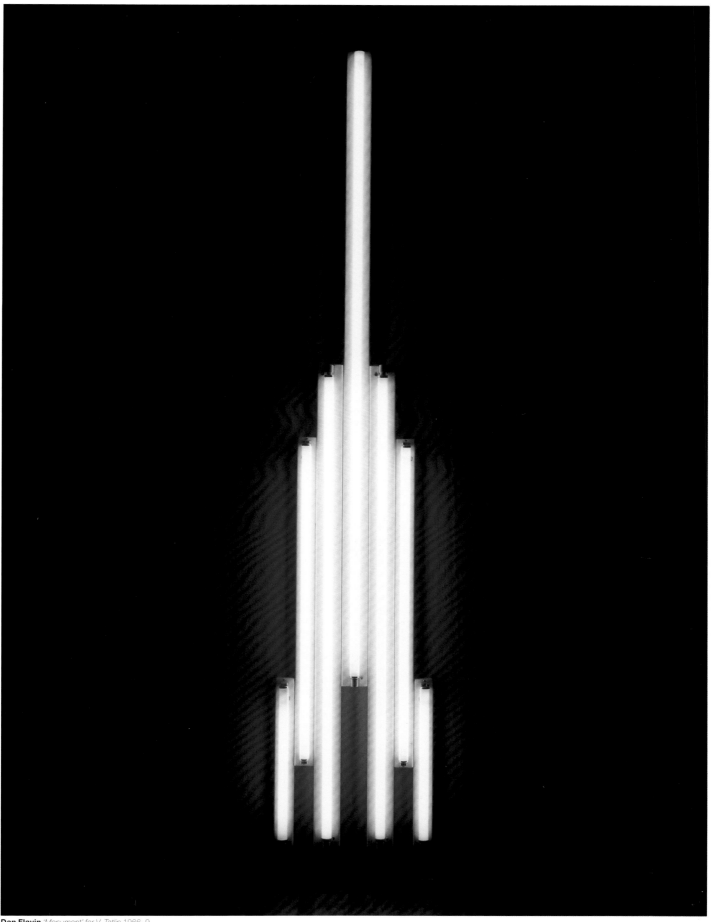

Dan Flavin *'Monument' for V. Tatlin* 1966–9

Chicago, Louise Bourgeois (see p.130) and later, Helen Chadwick, as a site for biological, psychological and social investigation. The erotic was not surpressed, but often reappeared as a threat to male dominance. Rather than being the subject of voyeuristic male pleasure, the female body and psyche became a subject of almost scientific enquiry. The sentimentality of the traditional (male) view of the mother and child relationship found in, for example, the sculpture of Henry Moore, was replaced by the detailed sociological and anthropological approach of, for example, Mary Kelly (see p.184).

From the 1970s onwards, after the machismo of Abstract Expressionism, and the powerfully masculine structures of such Minimalist artists as Donald Judd, women artists established themselves as both a parallel and intersecting stream within the history of art; one which sought alternative strategies and viewpoints to those of the dominant male. Female identity, however, was but one debate among many surrounding the exclusive nature of the canon, as the issue of identity came to the fore. Class, ethnicity and cultural background suddenly became the focus for artists who had hitherto been unheard. History was no longer the preserve of the Anglo-Saxon male.

If history painting barely survived the turn of the eighteenth into the nineteenth century in its grandiloquent and grandiose form, many of its preoccupations continued or re-emerged in later years. Public morality, politics, ideology, idealism and suffering among other themes still preoccupy artists today. But the manner in which they address them has changed, just as the study of history itself has changed. As Norman Davies has written: 'Historical research has greatly benefited from the use of techniques and concepts derived from the social and human sciences … New academic fields such as oral history, historical psychiatry, or family history, or the history of manners, are now well established.' The study of history has descended to the micro level. It has in a sense been democratised. History is not made by heroes and leaders but by ordinary people. Artists' engagement with history has followed the same course and by employing the same strategies, by opening themselves to techniques and concepts derived from the human and social sciences, artists today address issues relevant to contemporary life.

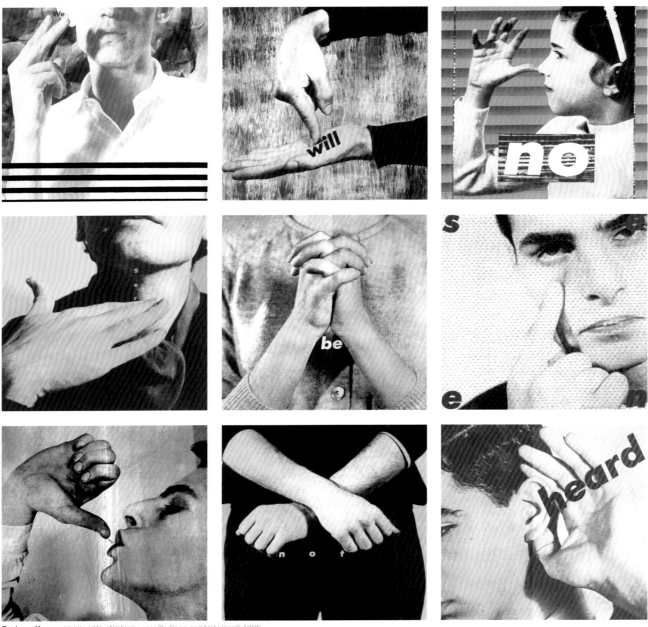

Barbara Kruger *Untitled (We Will No Longer Be Seen and Not Heard)* 1985

History Memory Society in quotation

We must shake the gates of life, test the bolts and hinges. Let's go! Look there, on the earth, the very first dawn! There's nothing to match the splendour of the sun's red sword, slashing for the first time through our millennial gloom! ...

So let them come, the gay incendiaries with charred fingers! Here they are! Here they are! ... Come on! Set fire to the library shelves! Turn aside the canals to flood the museums! ... Oh, the joy of seeing the glorious old canvases bobbing adrift on those waters, discoloured and shredded! ... Take up your pickaxes, your axes and hammers and wreck, wreck the venerable cities, pitilessly!

Filippo Tommaso Marinetti The Foundation and Manifesto of Futurism, 1909

The Staatliche Bauhaus, founded after the catastrophe of the war, in the chaos of the revolution and in the era of the flowering of an emotion-laden, explosive art, becomes the rallying-point of all those who, with belief in the future and with sky-storming enthusiasm, wish to build the 'cathedral of socialism'.

Oskar Schlemmer Manifesto, 1923

Now that art, thanks to Suprematism, has come into its own – that is, attained its pure, unapplied form – and has recognised the infallibility of non-objective feeling, it is attempting to set up a genuine world order, a new philosophy of life. It recognizes the nonobjectivity of the

Our vortex is not afraid of the Past: it has forgotten its existence.

Wyndham Lewis Our Vortex, 1914

1 Dadaism demands:
1) The international revolutionary union of all creative and intellectual men and women on the basis of radical Communism;
2) The introduction of progressive unemployment through comprehensive mechanization of every field of activity …
3) The immediate expropriation of property (socialization) and the communal feeding of all; further, the erection of cities of light, and gardens which will belong to society as a whole and prepare man for a state of freedom.

2 The Central Council demands …
b) Compulsory adherence of all clergymen and teachers to the Dadaist articles of faith …
d) The immediate erection of a state art center, elimination of concepts of property in the new art (expressionism); the concept of property is entirely excluded from the super-individual movement of Dadaism which liberates all mankind …
h) Immediate regulation of all sexual relations according to the views of international Dadaism through establishment of a Dadaist sexual center.

Richard Hülsenbeck and Raoul Hausmann What is Dadaism and what does it want in Germany, 1919

world and is no longer concerned with providing illustrations of the history of manners.

Kasimir Malevich Suprematism, 1927

American artists have discovered that they have work to do in the world. Awareness of society's need and desire for what they can produce has given them a new sense of continuity and assurance. This awareness has served to enhance the already apparent trend toward social content in art … the search for social content has taken the form of an illustrative approach to certain aspects of the contemporary American scene – a swing back to the point of view of the genre painters of the nineteenth century …

Surely art is not merely decorative, a sort of unrelated accompaniment to life. In a genuine sense it should have use; it should be interwoven with the very stuff and texture of human experience, intensifying that experience, making it more profound, rich, clear and coherent.

Stuart Davis The Artist Today, 1935

What kind of representational art, may I ask, would you impose upon the masses, to compete with the daily allurements of the movies, the radio, large-

scale photography and advertising? How enter into competition with the tremendous resources of modern mechanics, which provide an art popularized to a very high degree?

... In this domain, where it is a question of manifesting life's intensity under all its aspects, there are some wholly new possibilities – scenic, musical, in the way of colour, movement, light, and chant – that have not as yet been grouped and orchestrated to their fullest extent.

Fernand Léger The New Realism Goes On, 1937

alive to heartrending, fiery, or happy events, to which he responds in every way. How would it be possible to feel no interest in other people and by virtue of an ivory indifference to detach yourself from the life which they so copiously bring you? No, painting is not done to decorate apartments. It is an instrument of war for attack and defence against the enemy.

Pablo Picasso Interview with Simone Tery, 1945

Only art is capable of dismantling the repressive effects of a senile social system that continues to totter along the deathline: to dismantle in order to build A SOCIAL

Blasphemy, obscenity, charlatanism, sadistic excess, orgies and the aesthetics of the gutter, these are our moral expedients against stupidity, satiety, intolerance, provincialism, dullness, against the cowardice to bear responsibility, against the sack that eats at the front and shits behind.

Otto Mühl Letter to Erika Stocker, 26 January 1962

True art, which is not content to play variations on ready-made models but rather insists on expressing the inner needs of man and of mankind in its time – true art is unable *not* to be revolutionary, *not* to aspire to a complete and radical reconstruction of society.

André Breton and Leon Trotsky Towards a Free Revolutionary Art, 1938

What do you think an artist is? An imbecile who has only his eyes if he's a painter, or ears if he's a musician, or a lyre at every level of his heart if he's a poet, or even, if he's a boxer, just his muscles? On the contrary, he's at the same time a political being, constantly

ORGANISM AS A WORK OF ART.

This most modern art discipline – Social Sculpture/Social Architecture – will only reach fruition when every living person becomes a creator, a sculptor, or architect of the social organism. Only then would the insistence on participation of the action art of FLUXUS and Happening be fulfilled; only then would democracy be fully realised. Only a conception of art revolutionised to this degree can turn into a politically productive force, coursing through each person, and shaping history.

Joseph Beuys I am searching for a field character, 1973

The historical, aesthetic avant-garde was itself in the grip of various kinds of utopian social, political, revolutionary experiments. The notion of originality was linked to the idea of reinventing a self, a lifestyle, a society, through various kinds of acts, probably aggressive ones. The idea that there could be an easy accommodation with fashion, with the power of mass dissemination of consumer goods and mass taste, was simply not possible for that avant-garde …The avant-garde is a function of a historical period which is itself closed.

Rosalind Krauss Reflecting on Postmodernism – An Interview with Lisa Appignanesi, 1982

the one we are actually living. As a result, we often feel humiliated when we observe soberly the way we do live.

Jeff Wall Interview with Jean François Chevrier, 1990

It seems to me that the general programme of the painting of modern life … is somehow the most significant evolutionary development in Western modern art, and the avant-garde's assault on it oscillates around it as a counter-problematic which cannot found a new overall programme.

Jeff Wall Representation, Suspicions and Critical Transparency, 1990

The artist works in an entirely irresponsible manner. His relation to society is anti-social, and his only duty is to maintain his composure, in respect of himself and his work.

Georg Baselitz Four Walls and Skylight or Rather No Picture on the Wall at All, 1979

Every identity is placed, positioned, in a culture, a language, a history. Every statement comes from somewhere, from somebody in particular. It insists on specificity, on conjuncture. But it is not necessarily armour-plated against other identities. It is not tied to fixed, permanent, unalterable oppositions.

Stuart Hall Minimal Selves, 1987

History painting is storytelling … and storytelling is a way of building ethical worlds based, as Benjamin taught, on memory and dialogue … an utterance derives not from one isolated individual but is already a response to the words of others. Thus the storyteller is not a hero separated from others by a special relation to language … I feel that my work is in fact both classical and grotesque. Ancient art imagined the good society but was also open to the concept of the deformed. That is, it was able to recognise that it was not the society it could imagine. Now we are living at a moment when we have already imagined, and even in great and excessive detail, better ways of life than

It is an impossibly painful thing to realise that the lives, the very existence of people one loves are of the same matter as their fathers and mothers, and generations before. This is not an easy thing to live with. To embrace such an understanding of history forces us to confront what I might call the genealogical, the matter of our own being in relation to the physical matter of our friends. And that history exists in this most visceral, most sensational of ways. And it lessens us of course. It no longer says that I am the centre, and the future is all that awaits me, it says that I am of a piece and of a kind and of a kind with those who were my forebears. Photography may precisely engage with that apprehension. This is what makes it uncomfortable.

Craigie Horsfield 1991

When I say I'm interested in coupling the ingratiation of wishful thinking with the criticality of knowing better, I think that there's this kind of flux that's part of the seduction. I am making something to be looked at; there's a retinal address. You make something

people want to look at and then you deliver a message …

I am not concerned with issues if they are not going to be anchored by some kind of analysis or consideration of class. Any questioning or displacement of the subject within patriarchy that is going to change the strictures of that construction is going to be an attack on class. To change the dominant position of the subject is to change class.

Barbara Kruger Interview with John Roberts, 1983

We can argue for the necessity of a continuing commitment to a revolution that can not only accommodate women but be made by the dissidence of the feminine, providing a framework in which art, politics and sex conjoin … we can understand art as a practice both in and on, shifting the current symbolic; politics, as the radical transformation of the borderlines of meaning and subjectivity; sex, as the unfixing rather than final designating marker of difference and loss; and sexual difference, as one of the questions of the last quarter of this modernist century. Thus after modernism, we pose feminism.

Griselda Pollock Inscriptions in the Feminine, 1995

The exclusion of non-white peoples as historical subjects from the grand narratives of modernism is understandable within the context of colonialism, but how do we justify this exclusion in the context of postcolonial freedom and the presence of others as historical subjects within the modern metropolis? Why has the history of art of the twentieth century remained a white monopoly?

Rasheed Araeen New Internationalism. Or the Multiculturalism of Global Bantustans, 1994

Postmodern pluralism can be seen as one of the chief cultural currents unleashed by the simultaneous 'death of the author' and fall of the West as universal subject of history … From the ashes of this double demise sprang the gaudy bird of Difference. Yet… the postmodern account of difference tended to re-center the … Western, white male subject, who retained his previous unilateral power to name, gaze at, and thereby constrain Others …

Postcolonialism disrupts this epistemological tyranny by historicizing 'the West' … detecting West/rest interdependency in both its material and symbolic forms … postcolonial theory at its best puts meat on the bones of 'hegemony' by demonstrating the unstable, ambivalent, perpetually equivocal nature of dominance.

Judith Wilson New (Art) Histories: Global Shifts, Uneasy Exchanges, 1996

When people ask 'How much of herself can she keep digging out?', I say 'You've only seen the tip of the iceberg, mate' … I want to take from life. What travels through me is what I make. Something comes into me, spirals out, and as it spirals I pull it in, create something, then throw it back into the world.

Tracey Emin The History of I, 1997

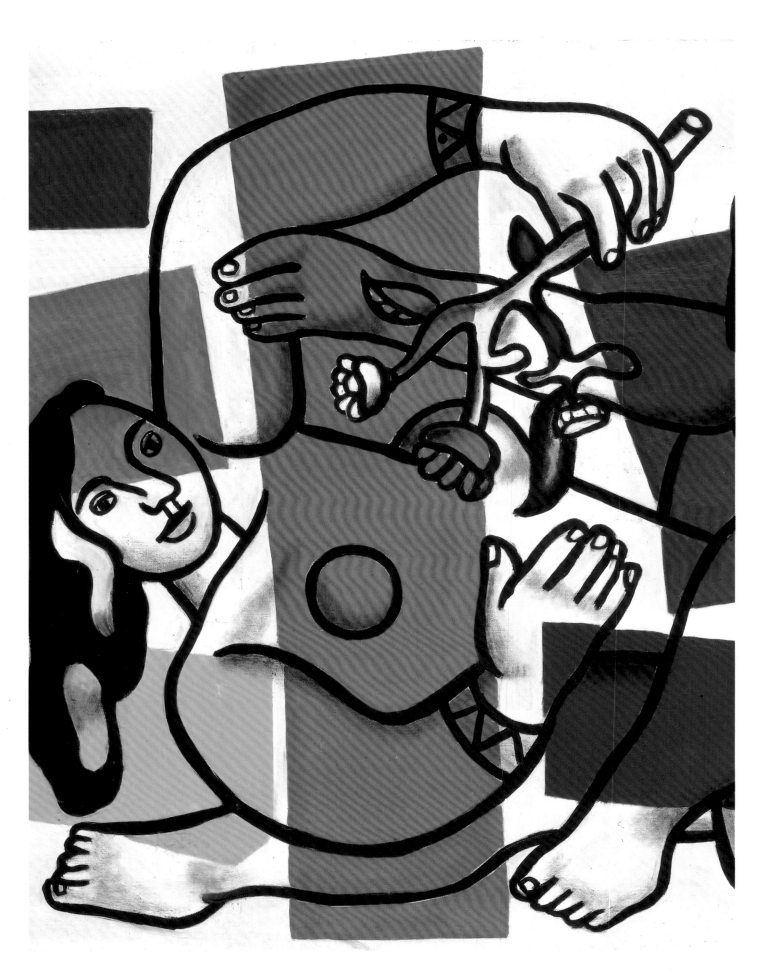

Simon Wilson

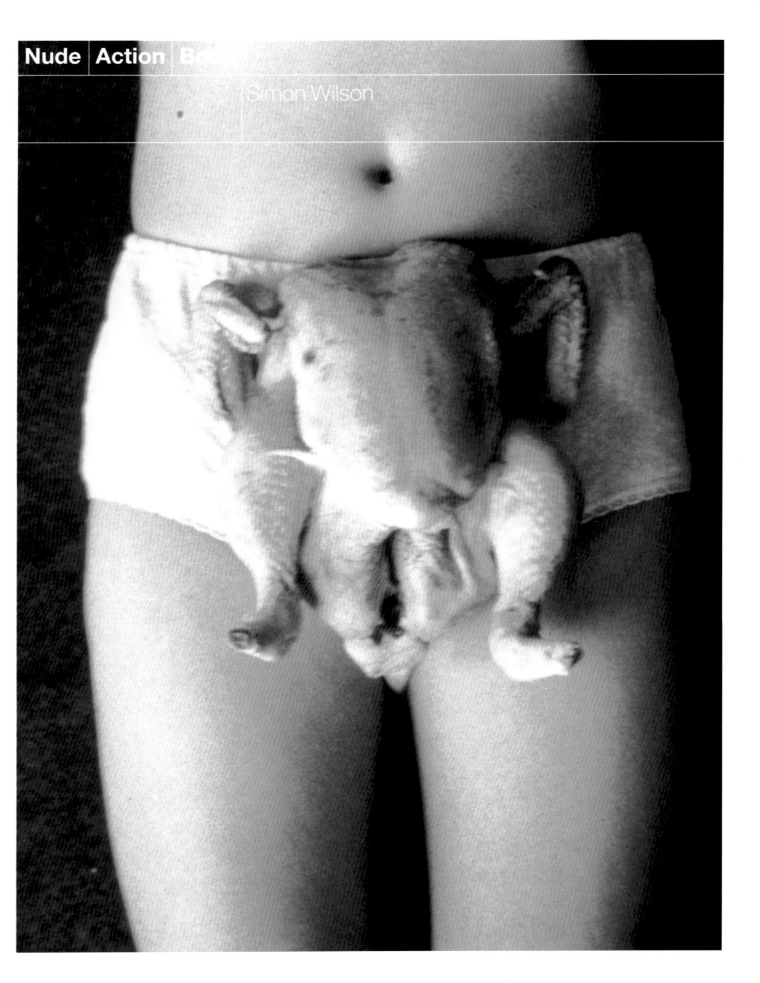

Among the most ancient man-made objects recognisable as belonging to the category that we call art are small naked human figures carved from stone or ivory. Female, with bulbous breasts and buttocks, they date from the Upper Paleolithic period and may be as much as forty thousand years old. The most famous of them, discovered in Austria in 1908, is known as the *Venus of Willendorf*. Clearly not naturalistic, these figures are assumed from their characteristics to be images of fertility. They stand at the beginning of the central tradition of Western art, the creation of representations of the human body, particularly but not invariably nude, formed in such a way as to express or embody ideas, ideals, emotions or experiences.

In the seventeenth century admiration for the art of ancient Greece and Rome, and for the achievements of the Italian Renaissance that it in turn inspired, combined with the appearance of powerful academies of art, led to a codification of the centrality of the human figure. A hierarchy of genres was established, with 'history' at the top. This term embraced not only history, but the Bible and ancient myth. Subjects were to be illustrated by means of the human figure, singly or in groups. History, also known as 'high art', was followed in order of importance by portraiture, scenes of everyday life, landscape and still life.

In the hands of the academies, painting and sculpture of the body in the classical tradition became deadened or debased while still being oppressively advocated as the highest form of art. Rodin's *The Kiss* is one of the last great manifestations of the academic nude. At first sight it appears to be a timeless, contextless, idealised image of human love. However, this reading, and the conventional forms of the work, are subverted by its eroticism, and especially by its real subject, the first embrace of the adulterous couple Paolo and Francesca, from Dante's *Inferno*, as well as by the force and unconventionality of Rodin's conception, in which it is Francesca who appears to have taken the initiative. But by the time of *The Kiss* a shift had already taken place in favour of the humbler genres. This shift was one of the key factors in the emergence of what became known as modern art, and the human figure in art in particular began a journey of transformation, a journey that rapidly accelerated as the new century dawned, in which the figure was to suffer often violent disruption and even near complete dissolution.

However, through the twentieth century and into the twenty-first a strand of practice continues that has maintained, in forms that avoided the most radical disruptions of modernism and indeed embraced the extremes of realism, a specific tradition, which emerged within the context of history painting: that of the individual nude female figure painted for its own sake, often with a history subject as the thinnest of excuses. John Berger was one of the earliest to point out, in *Ways of Seeing* in 1972, that the vast majority of such works suffered the moral deficiency of having been made by men for the delectation of other men – the unseen spectator/owner.

Auguste Rodin *The Kiss* 1901–4

Rarely, (Berger cites works by Rembrandt and Rubens) they offer more profound expressions of the personality of the model, the nature of desire, sexuality and mortality, the artist's relationship to the model, or more truthful accounts of the human body.

In the twentieth century this tradition of the nude, in the latter mode, with the pretext of the history subject abandoned and including the male body, can continue to be traced. Also increasingly challenged has been another key component of the pre-modern nude, the idealisation and censorship that permitted a distinction to be drawn between the naked and the nude, between that is, the erotic and the aesthetic, enabling the nude to survive as a major form of public art in a puritanical age. Abandonment of this distinction was in fact very gradual. In 1910 the British artist Walter Richard Sickert published an essay 'The Naked and the Nude' (*The New Age*, 21 July 1910) in which he summarised the position: 'An inconsistent and prurient puritanism has succeeded in evolving an ideal which it seeks to dignify by calling it the Nude with a capital N, and placing it in opposition to the naked.' Almost half a century later, in his milestone study *The Nude*, Kenneth Clark was still worrying about this issue, adopting Sickert's title for his own long opening chapter, and still taking the side of idealisation. He did however, forcefully support the erotic as a valid, indeed essential element of the nude: 'no nude, however abstract, should fail to arouse in the spectator some vestige of erotic feeling … and if it does not do so it is bad art and false morals.'

The new bluntness of the modern nude was initially one of concept and context rather than anatomy (with the notable exception of the Austrian artist Egon Schiele). Sickert's own remarkable studies, known as the Camden Town nudes, produced around 1906, combine extreme naturalism of pose, a high degree of intimacy, and the evocation of a seedy and sexual situation, with a high degree of abstraction achieved by rendering the model in Impressionist terms of broken patches of light and colour. The nude, he wrote, 'is in the nature of a gleam – a gleam of light and warmth and life'.

Something similar happened in the work of the French painter Pierre Bonnard (see p.129), whose formal approach was also rooted in Impressionism. In 1893 in Paris he met Marthe de Méligny (whose real name was Maria Boursin) and formed a relationship which continued until her death half a century later. During that time he painted her some 380 times. Eventually Bonnard's obsessive broodings over his wife (as she finally became in 1925) found a climactic focus in the astonishing series of pictures of her in the bath, in which celebration of the erotic, and the simultaneous denial and recognition of mortality, come together in a shimmering haze of other worldly light and colour.

At the same moment, in England again, another obsession of an artist with his wife, or

Walter Richard Sickert *La Hollandaise* c. 1906

rather two wives, fuelled by a sacramental vision of sex, also resulted in a series of paintings, very different in their sharp focus and anatomical detail from the baths of Bonnard, but equally as exceptional. Between 1933 and 1936, Stanley Spencer painted seven nudes, one of his first wife Hilda Carline, four of his second wife Patricia Preece, and two in which he himself appears, also naked, with Preece. One of these two is the largest and most iconographically complex of the whole series, combining unblinking realism with an allegorisation of sexual love as analogous to the Christian sacrament of Communion.

Painted from life, Spencer's nudes were exceptions to his normal imaginative practice, and their frank nakedness and obsessive intimacy was also at odds with the climate of the time. It was not until thirty years later that another painter in England, Lucian Freud (see p.156), made a shift of style which, coinciding with the liberalisation of sexual attitudes in the 1960s, enabled him to bring about a complete conflation of the concepts of the naked and the nude. Freud's nudes are the outcome of prolonged observation, but they are nevertheless far from literal, expressing, rather, a distinctive vision, embracing both the physical and the psychological, of what it is to be human. As he has put it: 'When I look at a body I know it gives me choices of what to put in a painting ... there is a distinction between fact and truth. Truth has an element of revelation about it.'

There is no doubt that one of the most powerful influences on the evolution of modern art in general and on the appearance and meaning in it of the human figure in particular, was the complex phenomenon known as Primitivism. As artists in the second half of the nineteenth century increasingly took the view that the high art or history tradition had become over-sophisti-cated, exhausted and decadent, they began to seek cultural forms that appeared to be simpler, purer and more truthful in their depiction of human feeling and human life. They found these initially in European peasant societies and their folk arts, and abroad in the art of Japan. By the turn of the century, turning away from Japanese art as too sophisticated, they began increasingly to explore the art of tribal societies in Africa and elsewhere.

Primitivism also embraced a return to nature, exemplified in the German Brücke group's images of themselves and their friends and lovers, who were also their models, bathing nude at the Moritzburg lakes outside their Dresden base. Henri Matisse's explorations of the bather theme preceded those of the Brücke and reached a climax in his four sculptures of a standing bather, *The Backs*, whose primitivism is expressed also in their increasingly simplified and rough hewn forms.

For some artists the new emphasis on nature led to the abandonment of the human figure or more precisely, its substitution by animals. The sculptor Constantin Brancusi (see

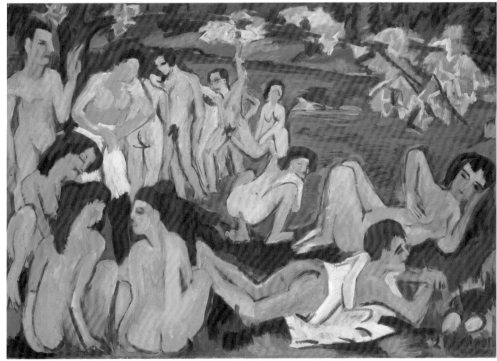

Ernst Ludwig Kirchner *Bathers at Moritzburg* 1909/26

Henri Matisse *Back I* c.1909–10, cast 1955–6

Henri Matisse *Back IV* 1930, cast 1955–6

p.132), dismissing the high art nude as 'beefsteak', focused on the bird to produce a long series of increasingly abstracted images whose simplifications, and refinement of polished bronze or marble surface, gave them a contemplative and spiritual dimension. Not neglecting the animal, in his series of copulating doves, but remaining largely loyal to the human, the British sculptor Jacob Epstein (see p.150) broke new ground with his emphatic depictions of pregnancy in powerful carvings such as *Figure in Flenite*, whose upper form is also foetus-like.

It was Pablo Picasso who drew the most shattering results from Primitivism. The stylistic character of African and other non-European or ancient art was crucial to his development (with Braque) of Cubism, the most revolutionary of all the forms of early modernism, in which by 1910 the human figure, though in theory still present, had effectively become invisible, dissolved into an overall structure of fragments. At this point Picasso reintroduced readable elements and, after the First World War, in common with many of the early twentieth-century avant-garde, returned to an overtly classicising human image. Then, from 1925, he began to use the freedoms of Cubism radically to remake the figure into images of lyrical or violent eroticism, and in *Guernica* and the series of weeping women that followed it, of horror and grief. Now it was the potential for emotional expression of tribal art that Picasso exploited, starting with the turning point *Three Dancers* (p.213), in which the *fin de siècle* fear of the destructive sexuality of the *femme fatale* is updated, evoked in a savage, mask-like face, its sharp toothed mouth a *vagina dentata*, and crudely schematic vulva.

The Second World War produced in Europe not a return to classicism but to a human image that, while more coherent and generally more naturalistic than those of Picasso, was submitted to distortion, metamorphosis and caricature to express a range of responses to the war and its aftermath of cold war and nuclear threat. Francis Bacon in painting and Alberto Giacometti (see p.158) in sculpture established archetypes of existential man, alone in a godless universe. Jean Fautrier and Germaine Richier (see p.153,216) added themes of torture and suffering, while Henry Moore and the younger British sculptors who emerged in the 1940s created the work characterised by the critic and philosopher Herbert Read as 'the geometry of fear'.

In America, away from direct experience of the war, human themes were sublimated in the grand and romantic forms of abstraction that became known as Abstract Expressionism. But certain titles of Barnett Newman's apparently utterly abstract paintings, for example the pair *Adam* and *Eve* (p.206), suggest that their signature vertical forms can be seen as even further attenuated equivalents of Giacometti's skeletal figures.

The example of Newman was undoubtedly important to the younger American artists

Francis Bacon *Study for a Portrait of Van Gogh IV* 1957

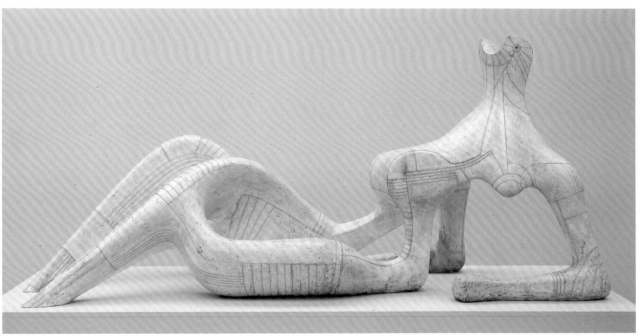

Henry Moore *Reclining Figure* 1951

who in the 1960s created the very pure forms of abstract art that became known as Minimalism. A key aspect of Minimal art was that its practitioners were influenced by the phenomenology of the French philosopher Maurice Merleau-Ponty, which emphasised the importance of the individual's perception of the object, irrespective of its reality as described by the laws of physical science. Consisting typically of simple geometric forms, Minimal art did away with internal compositional relationships of the art object. As the leading Mimimalist Robert Morris put it, such art 'takes relationships out of the work and makes them a function of space, light, and the viewer's field of vision'. Minimal art was thus constructed very much with the participation of the perceiving visitor in mind, and the body was brought into play in even the most rigorously non-figurative work. It was also Morris who in 1971 constructed at the Tate Gallery a kind of minimal gymnasium which invited the direct physical engagement of the spectator, whose presence completed the work. His untitled piece of the same time, consisting of four large mirrored cubes (p.203), offered a more contemplative experience of the ambiguities of perception.

In the final decades of the twentieth century three remarkable developments took place in the art of the human figure. First, artists began to use their own body as the expressive medium, initially creating necessarily ephemeral works in the form of what became known as Performance art. Then they adopted the media of film, video and still photography as a means of making permanent these ephemera. This led in turn to the creative use of these media to originate the work. An astonishing new art of the body appeared. Its most immediate origins lie in the extraordinary 'actions' of Joseph Beuys, created from 1963 onwards. Almost at once a younger generation of artists began to explore this new avenue. In 1965 Bruce Nauman (see p.205) created his first performance piece in California and the following year began to use film and a little later video. Since then he has pursued an often wry, even satirical, sometimes tragic examination of human behaviour and the human condition in these and a wide range of other media, to become one of the most influential artists of his time.

In 1969 Gilbert and George (see p.160) made the first of a compelling series of performance works that brought them wide recognition. They then turned to photography and video and quickly developed a highly original use of still photography as the means not only to give permanence to an art focused on their own bodies but to extend that art into new imaginative realms of the taboo, such as drunkenness or homoeroticism. At the same time artists such as Rebecca Horn adopted a slightly different approach, employing props that extended her body, metamorphosing into a fantastical beast. Kept by the artist, these prosthetics or body sculpture were relics of the performances, yet became works of art in their own right. Cindy Sherman has turned her own person into myriad personas, drawn from sources ranging from Hollywood to the

Cindy Sherman *Untitled C* 1975

history of art, in photographs whose formal beauty and technical accomplishment seduces the spectator irresistably into engagement with their imagery and content which often reaches subversively into the most Freudian recesses of the psyche.

Autobiography has been an important strand in modern figure art – much of Picasso's work for example rewards an autobiographical reading. In the mid 1970s the Viennese artist Arnulf Rainer made a series of photographic self-portraits in which he recreated aspects of the behaviour of mental patients – what he called their 'autotheatre'. He worked over the photographs, with oil paint to 'accentuate my bodily expression and graphically analyse movement and gesture'. In recent years a positively confessional art has appeared in a younger generation, often accompanied by confrontational social, political and sexual content. Artists such as Tracey Emin and Sarah Lucas (see p.95) use a range of media as well as video, photography and photo silkscreen to create disturbingly intimate self-portraits or sharp indictments of social attitudes. Gillian Wearing (see p.230) extracts from others rather than herself the most frank confessions in photographs and video. Nan Goldin (see p.161) has documented the lives of her friends, who include drug addicts and transsexuals, and who have revealed themselves with candour to her camera. This list of female artists reflects the rise and importance of feminism from the 1970s onwards. In *Post-Partum Document* (p.184) Mary Kelly created a 165-part artwork recording the first six years of her son's life, using diagrams, annotated letters, stained nappies, the child's drawings, feeding charts and analyses of the child's first utterances. However, as the critic Eleanor Hartney has pointed out, the work is as much about the often ignored experience of the mother.

The use of film and video has enabled artists to extend in striking ways the theme of the nude. In Sam Taylor-Wood's *Brontosaurus* we might be looking at a dionysian escapee from a Greek vase or a Poussin bacchanal, while Steve McQueen's *Bear* (p.196), in which two naked men ambiguously confront and spar with each other, seems to bring to life and extend the frozen moment of a multitude of male nudes in the classical tradition. With its echoes of, to choose examples almost at random, the Uffizi *Greek Wrestlers,* or the Munich *Barberini Faun* with its sprawlingly exposed genitalia, this brief but intense work brings full circle the story of the nude in art since the beginning of the modern era.

Arnulf Rainer *Two Flames (Body Language)* 1973

The majority of dream-symbols serve to represent persons, parts of the body and activities invested with erotic interest; in particular, the genitals are represented by a number of often very surprising symbols, and the greatest variety of objects are employed to denote them symbolically.

Sigmund Freud On Dreams, 1901

What interests me most is neither still life nor landscape, but the human figure. It is that which best permits me to express my almost religious awe towards life. I do not insist upon all the details of the face, on setting them down one-by-one with anatomical exactitude … I penetrate amid the lines of the face those which suggest the deep gravity which persists in every human being. A work of art must carry within itself its complete significance and impose that upon the beholder even before he recognizes the subject matter.

Henri Matisse Notes of a Painter, 1908

A painted or drawn hand, a grinning or weeping face, that is my confession of faith; if I have felt anything at all about life it can be found there.

Max Beckmann Creative Credo, 1920

Work!

 Ecstasy! Smash your brains! Chew, stuff yourself, gulp it down, mix it around! The bliss of giving birth! The crack of the brush, best of all as it stabs the canvas. Tubes of colour squeezed dry. And the body?

It doesn't matter … Paint! Dive into colours, roll around in tones! in the slush of chaos! Chew the broken off mouthpiece of your pipe, press your naked feet into the earth. Crayon and pen pierce sharply into the brain, they stab into every corner, furiously they press into the whiteness.

Max Pechstein Creative Credo, 1920

The two things which interest me most are the significance of human action, gesture and movement, in the particular circumstances of our contemporary life, and the relation of these human actions to forms which are eternal in their significance.

Barbara Hepworth 1952

The aura given out by a person or object is as much a part of them as their flesh. The effect that they make in space is as bound up with them as might be their colour or smell. The effect in space of two different human individuals can be as different as the effect of a candle and an electric light bulb.

Lucian Freud Some Thoughts on Painting, 1954

One has the desire to sculpt a living person but there is no doubt that as far as the life within them is concerned, what makes them alive is *le regard* – the looking of the eyes. It is very important. If the look, that is to say life, becomes the essential concern, then it is the head that is of primary importance. The rest of the body is reduced to the role of antennae making life possible for the person – the life that exists in the cranium.

Alberto Giacometti 1956

Only the body is alive, all-powerful, non-thinking. The head, the arms, the hands are only intellectual articulations around the bulk of flesh that is the body.

… pursuing the adventure of the immaterial, my work ceased to be tangible. My studio was empty. Even the monochromes were gone. At this moment, my models felt they had to help me. They rolled in the pigment and painted my monochromes with their bodies.

They became living brushes.

Yves Klein Truth becomes Reality, 1960

From 1960 onwards I have been selling prints of my right and left thumbs. In 1959 I thought of exhibiting a number of living people (I wanted to enclose and conserve other, dead, bodies in blocks of transparent plastic). In 1961 I began to sign people for exhibition. I give a certificate of authenticity to accompany these

Covered in paint, grease, chalk, ropes, plastic, I establish my body as visual territory. Not only am I an image maker, but I explore the image values of flesh as material I choose to work with. The body may remain erotic, sexual, desired, desiring, but it is as well votive: marked, written over in a text of stroke and gesture discovered by my creative female will.

Carolee Schneemann Eye Body, 1983

I dissever my left hand. Somewhere lies a foot. A suture on my wrist-joint bone. I press a drawing-pin into my spinal cord. I nail my large toe to my forefinger. Pubic, underarm and head hairs lie on a white plate. I slit open the aorta with a razor-blade (Smart). I slam a wire-tack into my ear. I split my head lengthwise into two halves. I insert barbed wire into my urethra and by turning it slightly try to cut the nerve (autosystoscopy). I bite open my pimple and suck on it. I have everything photographed and viewed.

Günter Brus Artist's Statement, 1965

Being living sculptures is our life blood, our destiny, our romance, our disaster, our light and life … Nothing can touch us or take us out of ourselves. It is a continuous sculpture. Our minds float off into time, visiting fragments of words heard, faces seen, feelings felt, faces loved. We take occasional sips from our water glasses.

Gilbert and George 1971

Of course, we are meat, we are potential carcasses. If I go into a butcher's shop I always think it's surprising that I wasn't there instead of the animal.

Francis Bacon Interview with David Sylvester, 1966

works. In January 1961 I also constructed the first 'magic base', as long as any person or any object stayed on this base he, or it, was a work of art … In the month of May 1961 I produced and tinned ninety tins of artist's shit … naturally preserved (made in Italy).

Piero Manzoni Some Experiments, Some Projects, 1962

Very shy people don't even want to take up the space that their body actually takes up, whereas very outgoing people want to take up as much space as they can … I've always had a conflict because I'm shy and yet I like to take up a lot of personal space. Mom always said, 'Don't be pushy, but

let everybody know you're around'. I wanted to command more space than I was commanding, but then I knew I was too shy to know what to do with the attention if I did manage to get it. That's why I feel that television is the media I'd most like to shine in.

Andy Warhol The Philosophy of Andy Warhol, 1975

Desire is embodied in the image which is equated with the woman who is reduced to the body which in turn is seen as the site of sexuality and the locus of desire … a familiar elision …

The woman artist sees her experience as a woman particularly in terms of the 'feminine position', that is, as the object of the look, but she must also account for the 'feeling' she experiences as the artist, occupying what could be called the 'masculine position' as subject of the look … Yet, there is a dilemma: the impossibility of being, at once, both subject and object of desire.

Mary Kelly Desiring Images/Imaging Desire, 1984

By the late twentieth century, our time, a mythic time, we are all chimeras, theorized and fabricated hybrids of machine and organism; in short, we are cyborgs … The cyborg is a creature in a post-gender world; it has no truck with bisexuality, pre-oedipal symbiosis, unalienated labour, or other seductions to organic wholeness through a final appropriation of all the powers of the parts into a higher unity …

Late twentieth-century machines have made thoroughly ambiguous the difference between natural and artificial, mind and body, self-developing and externally designed, and many other distinctions that used to apply to organisms and machines. Our machines are disturbingly lively, and we ourselves frighteningly inert.

Donna Haraway A Cyborg Manifesto, 1985

The body … is the meeting-place of the *individual* (or one's biography and unconscious) and the *collective* (or the programming of the roles of identity according to the norms of social discipline) … The threshold of pain enables the mutilated subject to enter areas of collective identification, sharing in one's own flesh the same signs of social disadvantage as the other unfortunates. Voluntary pain simply legitimates one's incorporation into the community of those who have been harmed in some way – as if the self-inflicted marks of chastisement in the artist's body and the marks of suffering in the national body, as if pain and its subject could unite in the same scar.

Nelly Richard The Rhetoric of the Body, 1986

Photography is my skin. As membrane separating this from that, it fixes the point between, establishing my limit, the envelope in which I am. My skin is image, surface, medium of recognition. Existing out there, the photograph appears to duplicate the world, disclosing me within its virtual space.

Helen Chadwick Soliloquy to Flesh, 1989

No one wants – it would seem – to represent the female sexual organ. And so representation goes through the phallus. This amounts to a masculine identification. We cannot have other representations except through this intermediary and by turning away from ourselves and our bodies.

I vehemently protest this – and I'm not the only one. Why are we not representable? Why should this uterus that carries life, that gives life, pleasure, and suffering, that is eminently anchored in life, not be representable?

Chantal Chawaf Interview with Alice A. Jardine and Anne M. Mencke, 1991

When you are very isolated or alone, you have this tremendous longing for communication, and also this strong desire to communicate through the body. Looking back at my first pieces you always see a kind of cocoon, which I used to protect myself. Like the fans where I can lock myself in, enclose myself, then open and integrate another person into an intimate ritual. This intimacy of feeling and communication was a central part of the performances.

Rebecca Horn Interview with Germano Celant, 1993

My attitude toward the space, place and human body in my art is defined by the relationship between myself and the place where I work … I work in a deserted room where once somebody lived and died. This room has its own atmosphere and its own definite dimensions. My body has definite dimensions, there are relationships between my body and the room, between myself and the corners in this particular interior…

I took an interest in the forms that accompany the body and in the traces the body leaves: a bed, a coffin, a funeral urn.

Miroslaw Balka Conversation with Jaromir Jedlinski, 1994

Funnily enough, as it turns out, a dick with two balls is a really convenient object. You can make it and it's already whole. It can already stand up and do all those things that you'd expect any sculpture to do. In that way it's really handy, I mean I could start thinking about making vulvas, but then I'd have to start thinking about where the edges are going to be.

Sarah Lucas Interview with Carl Freedman, 1994

If the regalia of the male figure in Barney's performances was sportsmanlike and heroic, with swimming, baseball, rock-climbing and gymnastics merging into one activity, his female counterpart, played by Barney posing in a white robe, toque and 1950s swimsuit, seemed the epitome of nimbleness and grace … Shifts between conventional sexual roles, between states and conditions (hard and soft, frozen and liquid, captivity and freedom); the references to protection by coated surfaces (Pyrex, Teflon, Silicon): above all the use of materials such as 'human chorionic gonadotropin', relate to the sex act. But *which* sex act, exactly?

Stuart Morgan Matthew Barney: Of Goats and Men, 1995

Body ego can be experienced two ways: first through appeal, the desire to caress, to be caught up in the feel and rhythms of a work; second, through repulsion, the immediate reaction against certain forms and surfaces which take longer to comprehend.

Lucy R. Lippard Eccentric Abstraction, 1966

For me, the embodiment of an artwork is within the physical realm; the body is the axis of our perceptions, so how can art afford not take that as a starting point? We relate to the world through our senses. You first experience an artwork physically. I like the work to operate on both sensual and intellectual levels. Meanings, connotations and associations come after the initial physical experience as your imagination, intellect, psyche are fired off by what you've seen.

Mona Hatoum Conversation with Michael Archer, 1997

Sculpture allows me to re-experience the past, to see the past in its objective, realistic proportion … Since the fears of the past were connected with the functions of the body, they reappear through the body. For my sculpture is the body. My body is my sculpture.

Louise Bourgeois Self-Expression is Sacred and Fatal. Statements, 1992

100 Artists A-Z

Tanya Barson, David Batchelor, Kirsten Berkeley, Carl Freedman
Matthew Gale, Mary Horlock, Jemima Montagu, Anna Moszynska
Andrew Wilson, Simon Wilson, Rachel Withers

ABSALON (b.Israel 1964–1993) Absalon's all-white architectural constructions are a hybrid of model making and minimalist sculpture. Fabricated out of polystyrene and cardboard, *Cell No. 1* is one of a series of six similar structures based on the concept of a single-occupancy, self-contained home. Measured to fit Absalon's specific body dimensions, *Cell No. 1* has everything a home could want: a door, a window, a table, chair, bed, book shelf and kitchen area.

Geometrically pure, ice-cool and silent, *Cell No. 1* is a futuristic dream house, perhaps a solitary astronaut's module, or a cell for a space-age monk. Yet the restricted scale and claustrophobic design suggests the work is as much about existential isolation and imprisonment as about creating an ideal home.

Absalon's other sculptural work is similarly concerned with the relationship between architecture and design, and the way they affect and control our lives. The titles of these works – *Arrangement*, *Order*, *Compartments*, *Departments*, and *Proposals for Everyday Objects* – indicate formal, bureaucratic procedures, while their use of flimsy materials and prototype status give them an unsettled, fragile quality.

This sense of uneasiness is more forcibly present in Absalon's video work. In the videos he interacts with his cells and sculptural installations, leaning on them, moulding and bending his body to fit them, nervously pacing to and fro around them. In a video made in 1993, the year of his premature death aged twenty-nine, Absalon forgoes all restraint, letting out a primal scream with his head stuck in a large hole he has dug in the ground.

Cell No. 1 1992, wood, cardboard, fabric and neon lights 245 x 420 x 220 cm

CARL ANDRE (b.USA 1935) American artist Andre is best known in Britain for the infamous 'Bricks'. First made in 1966, and acquired by the Tate in 1972, the work, whose correct title is *Equivalent VIII*, was seen by some journalists as evidence of the meaninglessness of modern art. After all, the 120 firebricks that constitute the work seemed no different from any which could be bought from a commercial brickyard. They had not been altered or added to, just stacked two high in a regular, rectangular, apparently artless arrangement. At the same time, Andre's work had also long been considered by artists and other commentators as some of the most serious, adventurous and challenging of the 1960s.

Almost all of Andre's sculptures are made from regular repeated units of unmodified industrial materials – bricks, timber, metals or plastics. These are placed directly on the gallery floor, usually in uncomplicated linear, square or rectangular arrangements. There is no intervening plinth to elevate or otherwise distinguish the work from its surroundings. For these reasons Andre's work has been seen as exemplifying Minimal art. Minimalism in general, and Andre's work in particular, employs the physical materials common to modern industrial societies. At one level the work exists as an invitation to the viewer to look more closely at these often overlooked elements of our everyday lives. But the work is also a contribution to the idea that art can exist without illustration, imagery or illusionism. For Andre it is unnecessary to 'impose properties upon materials'; rather, 'you have to reveal the properties of the material.' Thus the material is never welded,

glued or bolted in place. It is never polished or tidied up or manipulated or made to resemble anything. When made in metal, as in *144 Magnesium Square*, the viewer is invited to experience the quality of the material by walking across it. Very occasionally, as in *Venus Forge*, two or more metals – in this case steel and copper plates – are combined in a single work.

The titles of Andre's works are sometimes literal, as in *144 Magnesium Square*, and sometimes allusive, as in *Equivalent VIII* and *Venus Forge*. *Equivalent VIII* was one of eight works exhibited together as a group in 1966. All the works were made from the same quantity of the same materials. Each individual work, however, was arranged into a different rectangular shape. Thus each was equivalent to but not exactly the same as every other work. In addition, variations in colour, texture and surface wear were visible among the components of each individual work. Each brick is thus equivalent to but not the same as every other. Clearly we would not normally notice such apparently slight variations. But perhaps this is the point: when the materials Andre uses are taken out of their normal context, we begin to look at them rather differently. Where we assume there is sameness, we find difference. Furthermore, Andre's work invites us to look at these non-artistic materials such as bricks or steel with the same kind of attention that we might normally reserve for, say, bronze or marble. That is to say, such work invites us to look at all materials – expensive or cheap, exotic or plain, artistic or non-artistic – as if they were equivalent.

Equivalent VIII 1966, firebricks 12.7 x 68.6 x 229.2 cm

144 Magnesium Square 1969, magnesium 1 x 365.8 x 365.8 cm

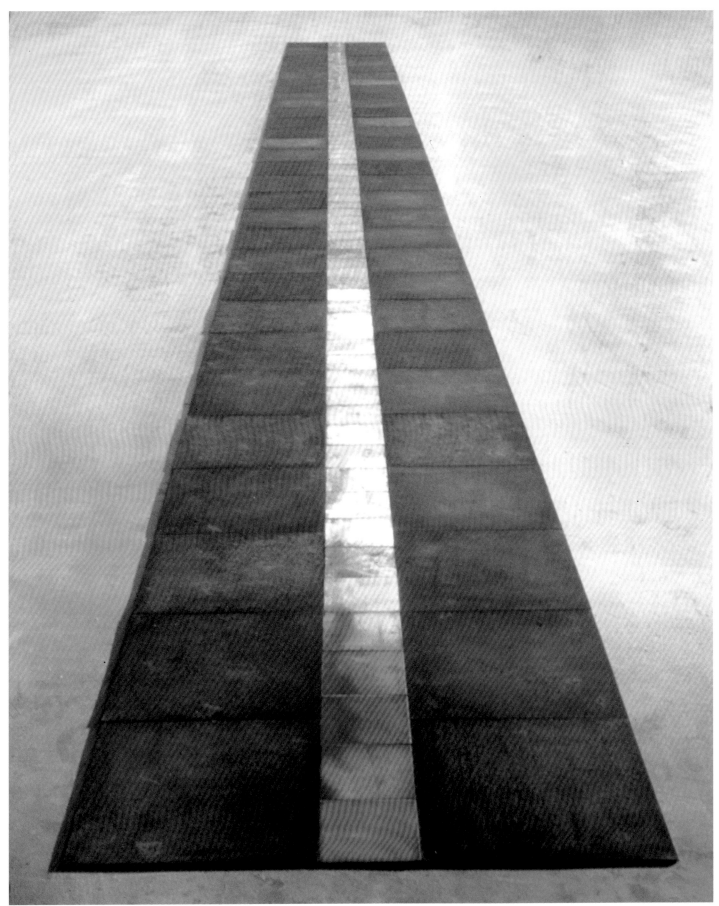

Venus Forge 1980, steel and copper plates 0.5 x 120 x 1555 cm

JEAN ARP (b.France 1886–1966) Chance in art promises the unravelling of the rational. A founder of the Dada movement in Zurich in 1916, Arp used the 'laws of chance' to determine his collages, after recognising an unexpected harmony in the remains of a work he had torn up. He closed his eyes while underlining words in the newspaper to make poems, and left deliberately flexible instructions for the carpenter building his reliefs. For Arp, chance suggested a universal order of a kind embraced by Eastern philosophies but incomprehensible to the Western rationalism which had resulted in the First World War. *Constellation According to the Laws of Chance* shows his continued use of this practice.

Arp's origins in disputed Alsace (his German poetry is signed Hans Arp) left him officially 'stateless' in the 1920s, although he was active in Switzerland and Germany. Only in 1925 were he and his artist wife Sophie Taeuber admitted to France where they built a studio-house outside Paris. Friendly with Surrealists and Constructivists, Arp made sculptures there that he distinguished from abstraction by terming them 'concrete', being forms in their own right. This is also true of the organic wooden blocks and painted forms of this shallow relief. The play between block and plane, black and white, establishes such a finely balanced composition that the role of chance is impossible to identify. A sense of the artist's creativity as paralleling natural processes underpinned Arp's work and encouraged its perception as inherently innocent and playful. *Pagoda Fruit* exemplifies these qualities. After the Second World War, and Taeuber's accidental death in 1943, Arp was acclaimed as one of the most imaginatively fertile artists of his generation.

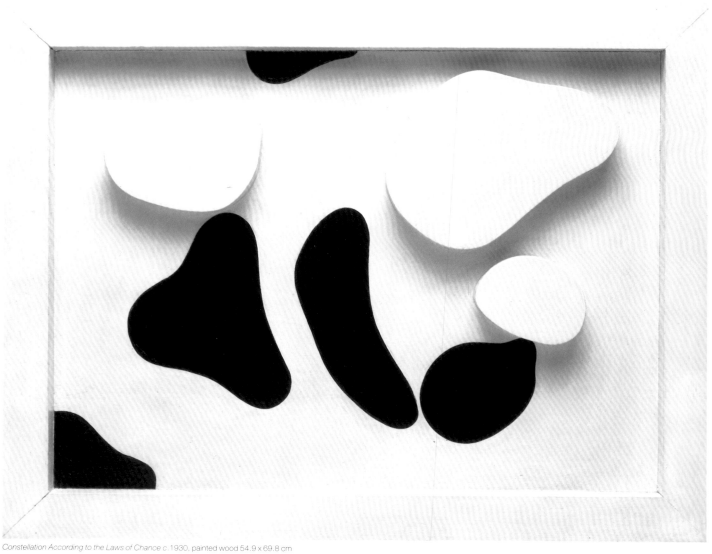

*Constellation According to the Laws of Chance c.*1930, painted wood 54.9 x 69.8 cm

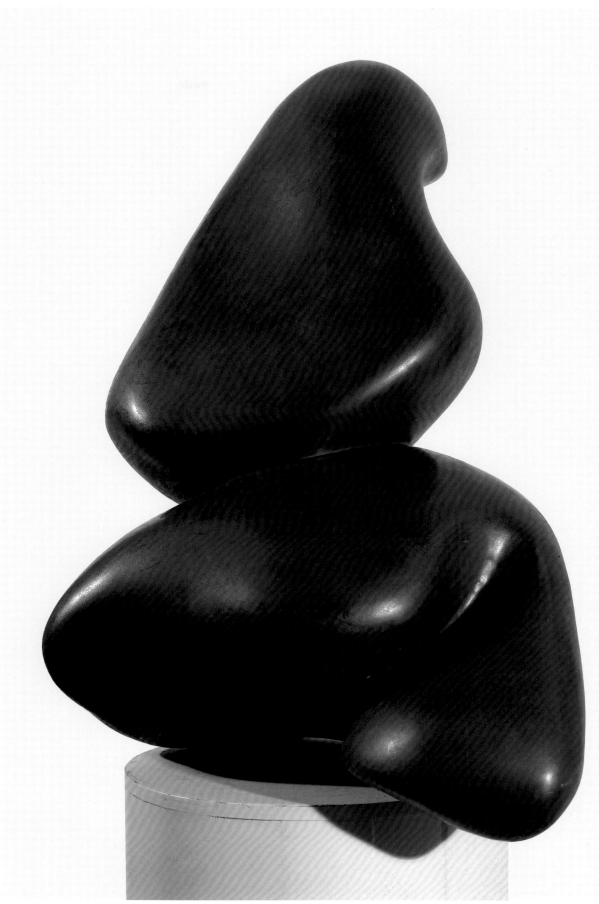

Pagoda Fruit 1949, bronze 88.9 x 67.9 x 76.2 cm

FRANCIS BACON (b.Ireland 1909–1992) Bacon is acknowledged as one of the most important painters of the figure in the twentieth century. His work reveals the tragedy of the isolated individual while simultaneously suggesting a wider human condition. Bacon practiced interior design around 1930 before beginning to paint under Picasso's influence and the guidance of the painter Roy de Maistre. He destroyed many early works, and even *Three Studies for Figures at the Base of a Crucifixion*, which he considered his first major painting, shows signs of tentativeness. When exhibited in 1945 alongside the work of Henry Moore (see p.202) and Graham Sutherland, this triptych caused consternation which catapulted Bacon to public attention. The semi-human figures in their hot orange setting appear prophetic of the revelations of the concentration camps reported shortly after. In fact Bacon was partly inspired by photographs of Nazi leaders – the bared teeth deriving from the haranguing speech-makers. The distillation of emotion in the mouth would be a recurring theme, and here suggests the suffering appropriate to the great tragic image of the Western tradition significantly universalised as a Crucifixion. Bacon later identified the three figures as Eumenides, the vengeful furies of Greek myth, and acknowledged the importance of the Greek poet Aeschylus and of T.S. Eliot for his work.

Contemporary Existentialist ideas about the impossibility of communication between individuals appear to be reflected in Bacon's work, particularly in his 1950s series of screaming Popes (based on Velazquez's *Pope Innocent X*). In 1957 the painter's rather haphazard lifestyle brought on the crisis reflected in an unusual series of energetically worked canvases based upon a van Gogh self-portrait (see p.103).

It was in reverting to the controversial treatment of the Crucifixion in 1962 that Bacon returned to the triptych format. Although he made many portraits, the triptych became the vehicle for his most important works. A consistent style emerged: the figure – most often derived from photographs – was the central focus of painterly activity and set against a flatly painted ground. More of the figures were now male nudes, reflecting the gradual public acceptance of homosexuality, their flesh luscious in its contortions. Bacon's pessimism seemed to be confirmed with the death of his long time lover and model George Dyer in 1971. Although the painter consistently avoided narrative, a series of triptychs memorialised Dyer with startling honesty. In *Triptych – August 1972* the eroded bodies of the painter and his lover occupy the outer panels between which their sexual coupling turns to combat. There is an austerity in the reduced colours, the stark composition and the material presence of the paint, which marks these paintings with profound emotion. Bacon continued to experiment with new techniques (Letraset, spray-paint), but the concentration in the application of paint of the Dyer triptychs was rarely surpassed.

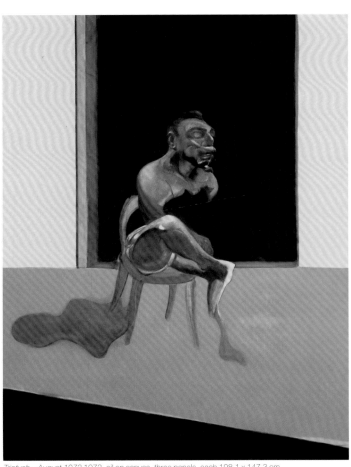

Triptych – August 1972 1972, oil on canvas, three panels, each 198.1 x 147.3 cm

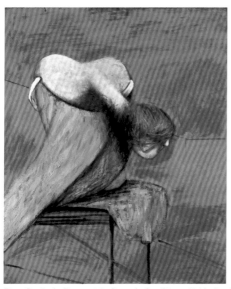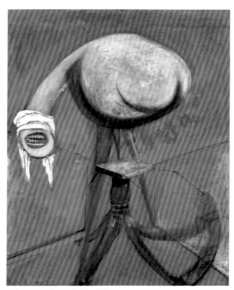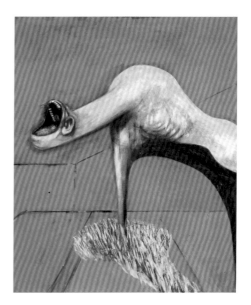

Three Studies for Figures at the Base of a Crucifixion c.1944, oil on board, three panels, each 94 x 73.7 cm

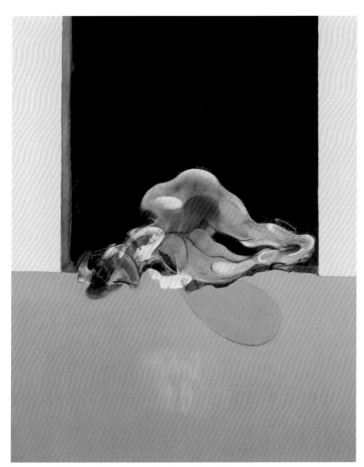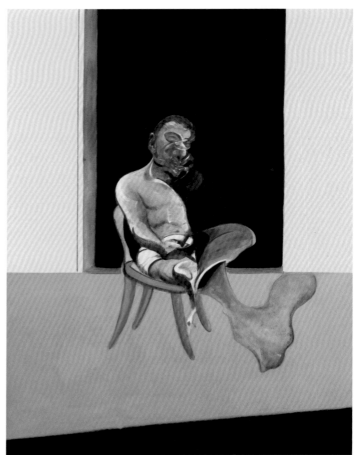

MIROSLAW BALKA (b.Poland 1958) Balka began working as an artist in the mid-1980s, just as Poland's period of martial law was ending. Prior to this time, Poland's artistic scene had been one of the most liberal of the Eastern Bloc countries, but with the advent of martial law artists boycotted the state's cultural institutions en masse, showing work clandestinely in private homes or churches. Dissatisfied with the choice of alignment either to church or state, a number of younger artists turned inwards for inspiration, developing working practices that privileged bodily experience and personal history over explicit engagement with social issues.

Employing humble materials with domestic connotations – old carpet, cheap soap, bricks or ash from the hearth – Balka's work forms part of this loosely-drawn tendency. 'Every day I walk in the paths of the past' he has observed, and many of his pieces carry autobiographical significance – for example a 1993 series of approximately two hundred partially-burnt drawings rescued from a fire in his studio. Heat, both a basic, life-sustaining domestic benefit and a destructive, devouring force, is also invoked in many works: his 1993 piece *190 x 60 x 10, 190 x 60 x 10*, two very minimal slabs of terrazzo, steel and felt, contains heating cables that raise its temperature to just above body heat. *Fire Place*, with its shabby upside-down matting, insidiously grotesque concrete shoes and mock-hearth capped by a simultaneously absurd and unsettling human figure, represents the more explicitly figurative side of Balka's work, but conveys a clear sense of the simple means and emotional ambiguity of his practice as a whole.

Fire Place 1986, wood, plaster, bricks and newspaper 110 x 230 x 205 cm

MATTHEW BARNEY (b.USA 1967) The worlds of art, sport and biology are fused in Barney's films and installations. The development of form is addressed in both biology and art, and Barney is exhilarated by the potential of the system we call nature. His dynamic performances on film, and objects made from organic substances, suggest themselves as the external equivalents of vital processes that take place within the body. Barney creates an exact aesthetic logic to make works of peculiar elegance.

OTTOshaft, made in 1992, is named after Jim Otto, an American footballer who continued to play despite having two prosthetic knees. The installation's components are also used as props in the three videos included. The Scottish bagpipes, with their protruding tubes and sac, recur throughout the work, as does the OO based on the logo of Otto's shirt, for Barney a symbol for an orifice. One video is set in a basement car park with elevator shafts leading upwards, an architectural embodiment of the bagpipes, and Otto, played by the artist, shins up and blocks each shaft with substances. In another, the football becomes a pill which Otto and his coach try to pass through stages representing metabolic conversion, from glucose to tapioca, meringue and finally pound cake. For Barney, the cake represents hubris or the ambition to go beyond the limits of nature, and Otto's ordeals test the limits and form of the body. However throughout the installation Barney suggests the pill never reaches pound cake, just as the pipes never play.

In 1994, Barney began his series of five *Cremaster* films, named after the muscle which regulates temperature in the testicles, drawing them in when cold or sexually aroused. The anatomical title suggests the action takes place not only in the world but also in the body. Each has a different setting: a large troupe dancing on a football field, a journey across a glacier, a stylised motorcycle race, a voyage through a bathhouse, an escapade in a skyscraper. All elide the difference between male and female. Often the characters' genitalia are masked, alluding to early foetal development before the organs rise in the female and drop in the male. For Barney, gender is readable only through the desire it attracts and he has created an epic of sexual ambiguity.

OTTOshaft 1992, video and mixed media

GEORG BASELITZ (b.Germany 1938) 'I'm brutal, naive and Gothic', Baselitz has asserted: qualities which find equally uncompromising expression in his splintery, lacerated, anatomically lopsided, and (despite its grand scale) affectingly vulnerable figure, *Untitled*. Made by axing and chainsawing into a single limewood trunk – techniques intended to suppress craft skill or elegant effects, and to emphasise the artist's creative actions – this is one of an early series of wood figures by Baselitz. (His first carving was executed in 1979–80.) Roughly applied blue and black markings loosely identify the figure as female. However, like a number of Baselitz sculptures, its body shape renders its sex strangely ambiguous.

Baselitz grew up in East Germany. Expelled from art school for 'socio-political immaturity', he emigrated to West Berlin in 1957. His reputation rests primarily on his figurative paintings which, like such sculptures as *Untitled*, feature a vigorous, even violent, gestural technique. Famously, Baselitz paints his subjects upside-down in order to prevent his imagery being read as straightforwardly narrative or illusionistic. With A.R. Penck and Anselm Kiefer (see p.186), he is a leader of the German Neo-Expressionist movement that gained prominence, and provoked heated debate, over its perceivedly 'retrograde' tendencies, during the 1970s.

Baselitz's avowed aim is to disregard all artistic precedents, creating work as if from scratch. Nevertheless, *Untitled* arguably refers back to several artistic sources: early twentieth-century work in wood by Picasso and the German Expressionist Kirchner; Gothic sculpture (specifically, the standing figures on cathedral door-jambs); Michelangelo's *Slaves*; and African carving (Baselitz collects African cultural artefacts). Like *Untitled*, these works typically hint at the shape of the block from which they were carved. Indeed, *Untitled* emphasises this by preserving at the work's base a largely unaltered cross-section of the tree-trunk from which it was created.

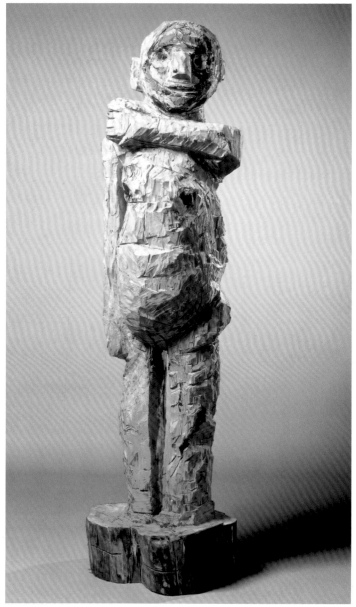

Untitled 1982–3, painted wood 250 x 73 x 59 cm

LOTHAR BAUMGARTEN (b.Germany 1944) Baumgarten challenges the continuing Western tendency to treat other lands and their inhabitants as exotic and exploitable. His work takes many forms, predominantly installations, but also books, photographs and films. Common to all his activities is an interest in the names given to things. He contrasts, for example, an indigenous population's name for their land with the European equivalent, in cases where naming was a prelude to Europeans taking possession of that land.

In the late 1960s Baumgarten studied under Joseph Beuys (see p.126) at the Dusseldorf Academy. He has had a persistent concern with South America and its people. His early works on this subject were based on second-hand contact through printed material. But between 1978 and 1980 he lived in Venezuela, sharing the life and customs of the Yanomami Indians.

El Dorado – Gran Sabana includes panoramic landscape photographs taken during his travels. Settlers saw the land as a prospect for future development and El Dorado was the name they gave to the fabled country where adventurers hoped to discover endless wealth. For the Indians, this grand savannah is a sacred area and the cradle of the region's geological bounty. Baumgarten addresses the transformation of the landscape into a prospect, and the viewer into a prospector, through words stencilled onto the wall which separate the photographs. The names of the minerals extracted by miners lie beneath inverted local names for animals endangered by this activity. The work links landscape representation in art, and the commercial use of an environment deemed more worthy of exploitation than preservation.

El Dorado – Gran Sabana 1977–85, photographs and paint 195.5 x 1989 cm

MAX BECKMANN (b.Germany 1884–1950) In 1915 Beckmann, previously hailed as the 'German Delacroix', was discharged from the German army field medical corps in Flanders after suffering a nervous breakdown. Settling in Frankfurt-am-Main, he turned his back on his pre-war work, and inspired by the Grünewald Isenheim Altarpiece, and paintings by Bruegel and van Gogh, as well as mysticism, he sought to 'grasp the unutterable things of this world'. *Carnival* is Beckmann's masterpiece from this period, painted five years before he found public recognition in the Mannheim *Neue Sachlichkeit* (New Objectivity) exhibition.

The painting depicts three figures – two men and one woman – dressed in costumes from the Commedia dell'Arte as Columbine, Harlequin and the Clown (a self-portrait). The carnival of the painting's title is *Fastnacht*, a wild fancy dress celebration prior to the Lenten period of fasting. Although the three figures are portrayed in an oppressively small interior, without a single focal point, they have the stiffness of puppets isolated from each other. The

madness of the post-war world – its political and social upheaval – is represented by the clown's state of unreason, and it is this self-identification that provides a key to Beckmann's search for an expression of social rebirth in the face of a world turned upside-down. In the later 1920s Beckmann exchanged the Commedia dell'Arte for circus imagery and acrobats. Classified as a 'degenerate artist' by the Nazis in 1937, Beckmann left Germany that year for Amsterdam and was never to return. In 1943 he again depicted *Carnival* and himself as Harlequin against the background of the Second World War and the Nazi occupation of Holland where he was living in precarious exile. The mood of his paintings from this period became increasingly darker, a shift that is well characterised by *Prunier*. This painting, referred to as 'Gobblers' in his diary, is a savage image of gluttony in a Parisian black-market restaurant painted during a period of great hardship for Beckmann when the Dutch were suffering food shortages and starvation following the allied invasion of France.

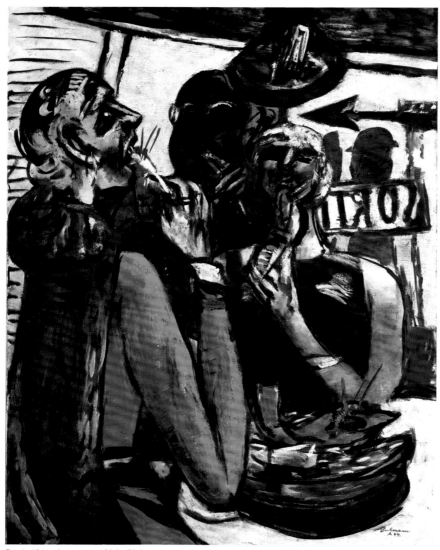

Prunier 1944, oil on canvas 100.3 x 76.8 cm

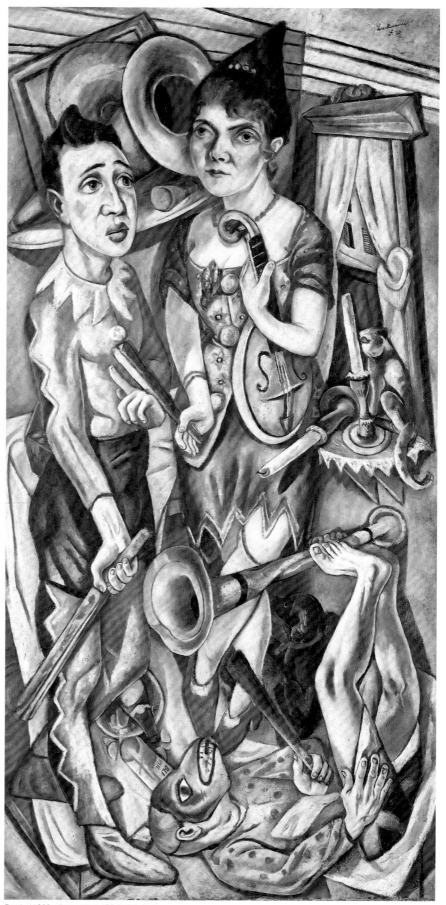

Carnival 1920, oil on canvas 186.4 x 91. 8 cm

JOSEPH BEUYS (b.Germany 1921–1986) Beuys passionately held that society itself should be transformed into a 'total work of art', and that art-making was an intrinsically revolutionary activity in which everybody could potentially participate. The objects in his vitrines are conspicuously simple and 'artless': either readymades, or items formed with a minimum of conventional craft skill, including a pickling jar, a hammer, a felt-wrapped blade and blocks of a wax-and-fat mixture. In principle they could have been assembled by anyone; in fact each item forms a component of the artist's idiosyncratic and distinctive symbolic system. Resembling archaeological displays, the vitrines could be said to invest their contents with an aura of antiquity, or even the magic or mythic significance of relics. The vitrines also recall first-aid boxes or pharmaceutical cabinets. Beuys understood his chosen materials (fat, iron, copper, stone, felt and so on) to be variously capable of generating, storing, or transmitting universal energy, and proposed that such materials, deployed in the ritual of art-making, had the power to assuage social ills. He maintained that his awareness of these healing principles arose from a traumatic personal experience: in 1944, whilst in the Luftwaffe, his plane crashed in the Crimea, and he afterwards claimed that Tartars had revived him by incubating his body in a cocoon of felt and fat – favourite Beuys materials.

The concept of stored energy also informs *The End of the Twentieth Century*, an installation composed of up to forty-four basalt columns, each with a kind of 'eye' – a polished cone of stone fixed in place with clay and felt. A romantic reading might link the piece with northern European myths of slumbering, subterranean warriors awaiting some call to arms; the columns have also been likened to the spent fuel rods of a decommissioned nuclear reactor (being basalt, they actually contain traces of radioactive material). The piece looks back to another major Beuys work launched at Kassel's *Documenta* exhibition in 1982: *7,000 Oaks*, an epic 'social sculpture' involving 7,000 basalt columns (minus 'eyes') and 7,000 oak saplings. One column and one oak could be purchased together for $210, including delivery, for planting around the city (though some travelled further – one is growing in downtown Manhattan). Here Beuys (a founder of the German Green party) combined the practical goal of reforestation with the symbolic concept of the artist as shaman: a restorer of balance to world affairs.

By 1983, Beuys had won international fame, great wealth, and a devoted following. Unsurprisingly, given his work's global ambitions, he also came under attack from both traditionalist and progressive critics. The former asserted that Beuys's working methods concealed a basic lack of conventional skill. The latter, maybe more pertinently, found Beuys's practice unacceptably self-aggrandising, and queried the political implications of his 'shamanistic' persona in the context of modern German history. Rather than offering to replace 'evil' father-figures (specifically, Hitler) with 'benign' ones (as in Beuys), they argued, artists should challenge the whole idea of blind faith in charismatic leadership; aesthetics should not be substituted for politics. A moderate defence of Beuys's art might insist that it can be interpreted in many different ways, and that it discovers an unexpected poetry and poignancy in the juxtaposition of simple materials.

Above: *Untitled (Vitrine)* 1983, mixed media 206 x 220 x 50 cm Right: *The End of the Twentieth Century* 1983–5, basalt, clay and felt

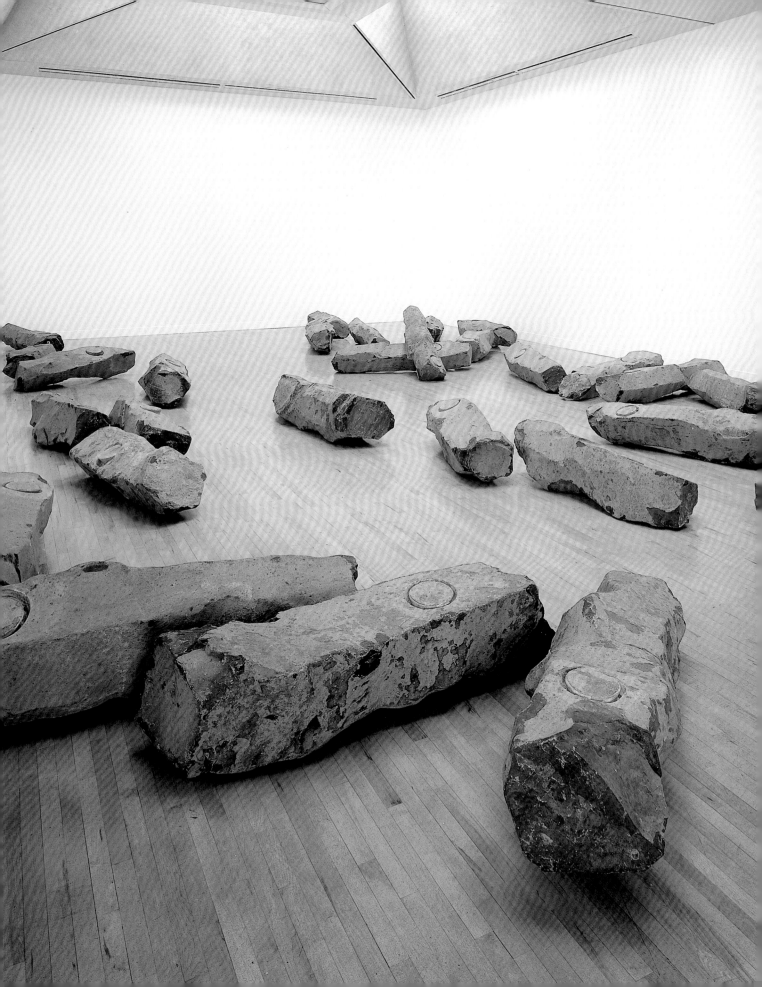

UMBERTO BOCCIONI (b.Italy 1882–1916) Boccioni was a leader of the Italian Futurist group, as a painter, sculptor and theorist. In his brief career before his death in the First World War he produced some of the most striking and ambitious Futurist paintings, a small number of highly innovative sculptures and two manifestos defining a Futurist theory of sculpture, the *Technical Manifesto of Futurist Sculpture* and *The Plastic Foundations of Futurist Sculpture and Painting*, published in 1912 and 1913 respectively.

Founded by the Italian poet Filippo Tommaso Marinetti (1876–1944), and Italian based, Futurism had international ambitions and impact. It was formally launched on Saturday 20 February 1909 with the *Manifesto of Futurism* published on the front page of the Paris daily newspaper *Le Figaro*. Influenced by the German philosopher Nietzsche's concept of a modern superman creating his own system of values, and by the French philosopher Bergson's idea of time as a flux, Futurism proclaimed a technological future and sought to destroy the past. The motor car was the prime Futurist symbol of modernity, energy, speed and dynamism, and in the *Manifesto* Marinetti famously declared 'the world's splendour has been enriched by a new beauty, the beauty of speed. A racing motor car … is more beautiful than the *Victory of Samothrace*' (the celebrated ancient Greek sculpture in the Louvre).

Boccioni's *Unique Forms of Continuity in Space* can be seen as a Nietzschian superman dynamically striding through time and space. Its forms, while recognisably echoing those of the *Victory of Samothrace*, also seem successfully to answer Bergson's call for an art in which we 'will see the material world melt back into a single flux, a continuity of flowing, a becoming'.

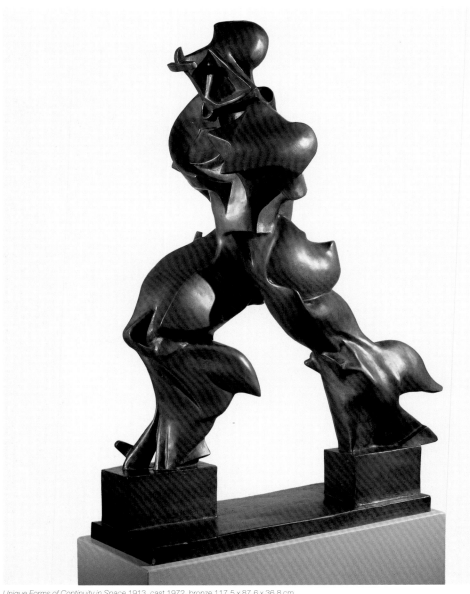

Unique Forms of Continuity in Space 1913, cast 1972, bronze 117.5 x 87.6 x 36.8 cm

PIERRE BONNARD (b.France 1867–1947) Bonnard began his career in 1888 as a founder member of the group of young artists called the Nabis (Hebrew for prophets). Stylistically influenced by the decorative character of Japanese art, the Nabis also wanted art to be a functional part of life. They produced murals, screens, book illustrations, and in Bonnard's case an outstanding contribution to the poster boom of that time. From the late 1890s Bonnard became more purely a painter, emerging as one of the great artistic figures of the first half of the twentieth century.

In his mature work Bonnard challenged the Impressionists, his aim he once said, 'to outshine them in their naturalistic impressions of colour'. He rejected their doctrine of painting direct from nature or the model, preferring to work alone and from memory using slight pencil notations made from life. He developed a highly imaginative, almost visionary use of colour and light, creating landscapes, interiors and domestic scenes, and a long series of nudes based on his wife Marthe, of great visual intensity and often strangeness of atmosphere.

The Bath is one of the several hundred images of Marthe that Bonnard made, but is one of the extraordinary group of four canvases showing her lying full length in the bath. Painted in 1925 in the South of France it shows Bonnard exploiting the reflection of Mediterranean light off the white interior of the bathroom to create effects of shimmering pearlescent colour. In it Marthe still appears as the young woman Bonnard met in 1893, and the bath has reminded many viewers of a sarcophagus or tomb; Bonnard's paintings of this kind are not only celebrations of the sensuous, but a meditation on the passage of time and the ephemerality of pleasure.

The Bath 1925, oil on canvas 86 x 120. 6 cm

LOUISE BOURGEOIS (b.France 1911) Bourgeois's art is hard to categorise. After training at the School of Fine Arts in Paris, she moved to the USA in 1938, becoming an American citizen in 1951. She began her career as a painter but switched to sculpture after her first solo exhibition in 1945. She was linked to Surrealism, but has never followed any particular style or movement, or belonged to a group or school. Her drawings, paintings, sculptures and prints are almost obsessively autobiographical, full of memories of her own childhood and persistently depicting her concern with human isolation and with issues of gender. She has frequently stated that her personal style has evolved from her emotions and experience rather than from a specific artistic-intellectual environment. Discussing her need to express herself as a 'discharge', she has claimed: 'My subject is the rawness of the emotions and the devastating effect of the emotions you go through'. The very personal nature of her approach possibly accounts for the fact that she was not recognised as a major sculptor until the 1970s when her gender-political themes led to her being taken up by feminists.

Cell (Eyes and Mirrors) belongs to a large series of room-like works begun in the 1980s in which found doors and windowpanes are reassembled to form small circular cells. These enclose various arrangements of furniture and sometimes include earlier marble or wood sculptures depicting body parts and/or geometric objects. Besides referring to the most basic human component of the human organism, these cells have also been described as explorations of the 'psychosexual drama of the house' – the house being Bourgeois's childhood family home at Choisy-le-Roi in which her father ran a tapestry restoration business and kept the children's governess, Sadie, as mistress alongside his wife. The artist's intention in making this series was to represent different types of pain, and the complex role of memory is played out by the use of symbols.

In this case, the cell is dominated by a large marble element representing a pair of eyes, recalling a theme that Bourgeois had already explored in a number of earlier works. Here, the surrounding wire mesh and mirrors provide an additional psychological charge, revealing how the work is concerned with ideas of observation and vision; inclusion and exclusion; vulnerability and protection; imprisonment and isolation. With its closed, cage-like exterior preventing access, the cell also implicates the viewer as voyeur, as Peeping Tom, and opens up a further element of psychological fear.

Autobiographical Series is a group of fourteen drypoint engravings made a little later than *Cell*. Embracing a quieter, more reflective mood, they engage with the artist's memories of her life as a young woman and mother. They depict various domestic activities ranging from the personal (washing her long hair in a basin or placing a sculpture) to the familial (intimate images of children and fatherhood). In fact, Bourgeois has made prints since the 1930s and the personal, autobiographical nature of her drypoints, as well as the directness of their technique, is similar to the drawings which she has made throughout her career, not so much as a preparation for working in three dimensions but as a complement to it.

Sculptress 1994, drypoint on paper 33.2 x 20.7 cm *Woman with Suitcase* 1994, drypoint and aquatint on paper 18.3 x 29 cm

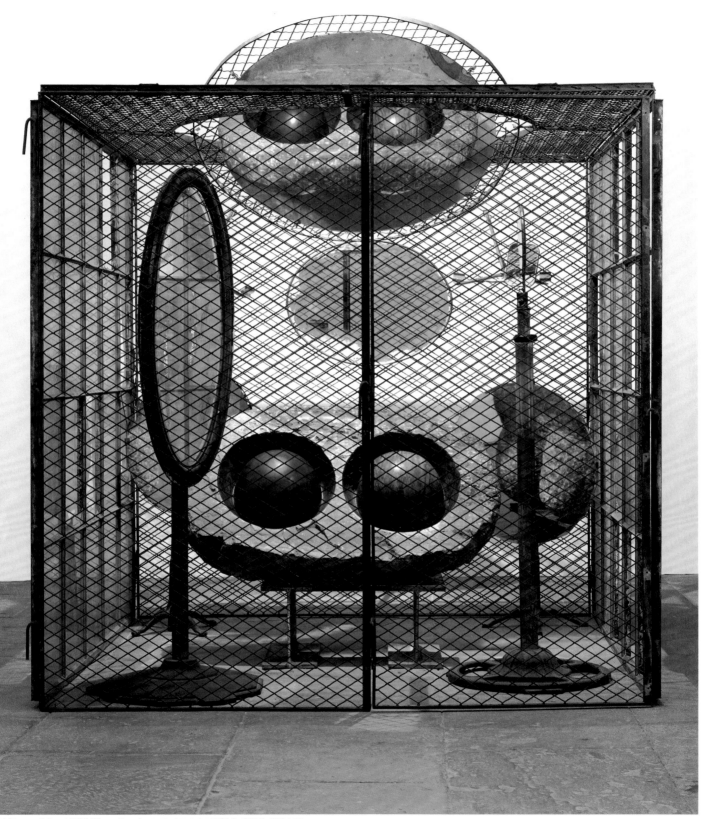

Cell (Eyes and Mirrors) 1989–93, marble, mirrors, steel, and glass 236.2 x 210.8 x 218.4 cm

CONSTANTIN BRANCUSI (b.Romania 1876–1957) Working after 1904 chiefly in France, Brancusi is one of the most respected and influential sculptors of the twentieth century. Although friendly with Modigliani, Matisse, Léger, Picasso, Lipchitz and Duchamp, he was never a member of any artistic group and his greatest fame came after the Second World War when he was in fact working very little.

Desiring to capture the essence of things, Brancusi quickly left behind the naturalistic tradition of Rodin (see p.97) and aimed for a more abstracted approach in his bronzes and carvings. His main ideals were simplicity and truth to the essential nature of his subjects. He worked to remove the distinguishing details of the creatures he chose to sculpt while emphasising their characteristic form. This was an approach also adopted in his portraits. Consequently, he returned to the same subject a number of times, modifying and perfecting the forms, often working them in both direct carving and in polished bronze. The relationship of the form to the base was also highly important and the integration of the two is a significant characteristic of Brancusi's work.

Maiastra is one of five variants of a standing bird which were made between 1910 and 1914 in marble or bronze and which led to a further, more simplified cycle of twenty-two *Birds in Space* over the following seven years. The Tate's bronze *Maiastra* is probably the second version to be made and was originally in the collection of Edward Steichen, where it was perched on

a high column in the owner's garden at Voulangris in France. Steichen returned to America in 1927 and it was probably then that Brancusi provided the low, irregular, rectangular stone base on which the stylised profiles of two further birds have been carved in low relief.

Brancusi's first attempts to make a *Maiastra* – the name of a magic bird in Romanian folk myth – began with the study of real birds. The form then became highly stylised, possessing a small flattened head, open beak, staring eyes and gathered wings which meld into its body. The rounded breast is a protruding oval and so highly polished that the whole form seems luminescent. Brancusi said of the birds that they constituted a 'series of different objects in a central search which remains the same'. Yet despite their commanding presence, the *Maiastras* gave him a lot of trouble and he expressed his dissatisfaction by hoping to make the 'true Maiastra' – a bird which could 'raise its head, without expressing pride, haughtiness or conceit'.

Fish is one of five bronze *Fish* Brancusi made following a marble one of 1922. As with others in this series, the Tate's version is mounted on a shiny, reflective metal disk, reminiscent of a pool of water, on which the fish appears to float. The horizontal movement of the fish across the base, rather than up, as in the *Maiastra*, represents a new form for the artist. Less proud and anthropocentric, it creates a poetic image of fluidity, of floating. In fact, with its sleek, stylised, tapering form, it seems to encapsulate Brancusi's desire not to render a fish itself but 'the flash of its spirit'.

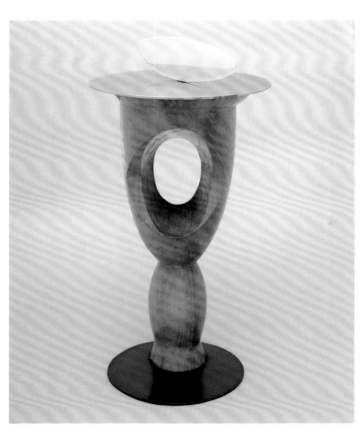

Above: *Fish* 1926, bronze, metal and wood 93.4 x 50.2 x 50.2 cm
Right: *Maiastra* 1911, bronze and stone 90.5 x 17.1 x 17.8 cm

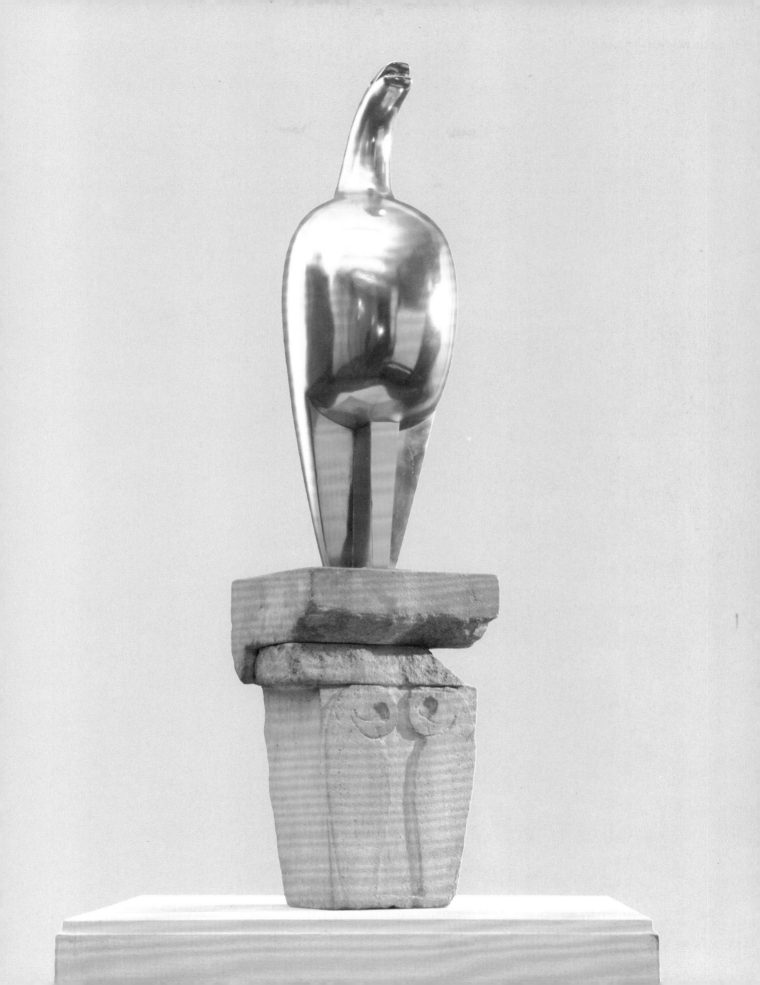

GEORGES BRAQUE (b.France 1882–1963) 'Roped together like two mountaineers' was how Braque famously described the creative partnership with Picasso (see p.212) through which they developed Cubism in 1909–14. The image of mutual reliance in the face of danger is suggestive of their formal inventiveness as well as the incomprehension that greeted the results. There is also a sense of rotating leadership. Braque's investigation in 1907–8 of Cézanne's structural devices in painting – shallow planes, broken brushwork, limited colour – had followed Picasso's exploration of African art. Cubism became a conceptual analysis of visual reality while acknowledging the picture as a representation on a flat surface.

By 1911–12 the collaboration of Braque and Picasso was said to have become so close that even they could not tell their work apart. *Clarinet and Bottle of Rum on a Mantelpiece* was made at this moment. The angled lines control the triangular composition through which the fragmented forms are stacked: the decorative mouldings of the fireplace, the horizontal clarinet (circular bell and cylindrical shaft) and the bottle above. Details such as the bottle's shoulder suggest the transparency of glass. The dappled paint, largely applied in horizontal strokes, gives density to the surrounding space and unites solid and void. The inclusion of the word 'valse' (waltz) – emphasising the flat surface of the painting – shows Braque's interest in popular music and, perhaps, implies a harmony attained from diffuse abstract elements. The First World War, in which Braque was severely wounded, broke the partnership, but all his subsequent work derived from the experience of Cubism, independently modified and personalised.

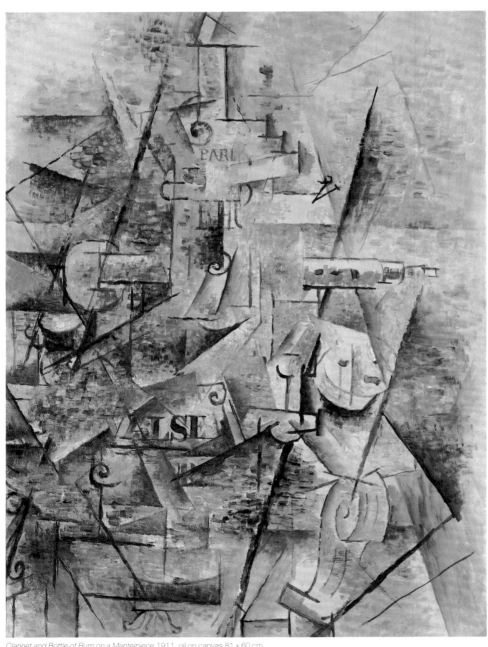

Clarinet and Bottle of Rum on a Mantelpiece 1911, oil on canvas 81 x 60 cm

ANTHONY CARO (b.Great Britain 1924) Caro had worked as Henry Moore's assistant before he visited New York in 1960. There he saw work by contemporary American artists such as David Smith (see p.223) and Kenneth Noland. The effect on Caro's work was immediate: he abandoned the tradition of modelling figures in clay in favour of abstract constructions made in industrial metals, which he often painted in brilliant commercial colours. *Early One Morning* is a large work made of steel and aluminium which has been welded and bolted together. In this work, which is typical of his sculpture from the 1960s, the traditional solid sculptural monolith has given way to a series of flat interlocking planes. It gives the illusion of lightness and suggests a fragile balance between the various component parts.

As the viewer moves around the work, the relationship between the parts is constantly redefined – there is no centre to the work of the sort one would expect from a more conventional figure-based work. The title of the work might refer to a painting by the figurative American artist Edward Hopper. It might also suggest there is an allusion to nature in Caro's use of colour, in spite of the work's industrial materials. The same might be said of *Night Movements*, made some twenty-five years later. A four-part work, it is also made from industrial steel but suggests natural forms. The work's surface is much darker and more organic looking. This is due to the steel having been varnished, waxed and stained rather than painted. The effect is more solid, solemn and slow; something again emphasised by the work's title.

Night Movements 1987–90, steel 276 x 107.7 x 335 cm

Early One Morning 1962, painted steel and aluminium 289.6 x 619.8 x 335.3 cm

PAUL CÉZANNE (b.France 1839–1906) Cézanne began his career as an Impressionist, but quickly became critical of Impressionism for its apparent concern only with the surface of things. Monet, said Cézanne, was 'only an eye', and his famous reported aim was to 'make of Impressionism something solid and lasting like the art of the museums'. Cézanne's achievement was to take the basic Impressionist practice of painting direct from nature and obsessively pursue it to the point where he created a completely new way of representing reality in painting.

Cézanne's late portrait of his gardener Vallier, painted in the year of the artist's death (and probably the last canvas he touched), perfectly illustrates his method at its fullest point of development. The image is built up from discrete brushstrokes each of which represents the colour, or 'tone', that the artist has identified at that point on the model. These brushstrokes overlap

and also appear to be at angles to each other, creating the feeling of solid form. At the same time the overlapping of the brushstrokes, linking every part of the picture together, maintains the unity and harmony of the composition. Without breaking this unity Cézanne adds to his creation of space by painting the gardener's foot in exaggerated perspective, that is, looking larger because it is nearer. Around the right hip there are several repeated outlines. It has been suggested that this kind of effect could be the result of the artist representing slightly differing viewpoints.

Paintings such as this directly influenced Picasso (see p.212) in the creation of Cubism, which in turn opened up new freedoms in the treatment of reality in art as well as the possibility of pure abstraction. For this reason Cézanne has been hailed as the true father of modern art.

The Gardener Vallier c.1906, oil on canvas 65.4 x 54.9 cm

HANNAH COLLINS (b.Great Britain 1956) Collins creates large-scale, monochrome photographs, mounted on cotton. Their cinematic scale is such that they establish an exceptionally direct relationship between the spectator and the image – the viewer can imagine entering them. In the case of *In the Course of Time II* the viewer is invited to walk alongside the photograph, an action analogous to journeying through the landscape depicted. This makes the experience of the work physical and environmental, rather closer to a spectator's experience of sculpture. Collins' visually austere photographs are meditations on history and on actual lived experience. They contrast personal memory with officially recorded events.

In the Course of Time II is from a series of works, collectively titled *The Hunter's Space*, which explore the folkloric imagination of Eastern Europe. The region's folktales, literature and cinema feature a mysterious, lone figure known as the hunter or stalker. Operating on the periphery of society, he acts as a guide through memory and the unconscious. Although Collins' photographs show the territory of the hunter, he never actually appears in the work, indicating that his role is identified with the photographer. Collins took the photographs while travelling in Poland in 1993–4 and although connected, each part of the series can be considered autonomous. They are testaments to identity, to continuity and change, within a Europe theoretically unified by the fall of the Berlin Wall. Leaving her photographs for the most part unpopulated, Collins uses architecture, landscape and space to evoke a human presence. This work shows the Jewish cemetery in Warsaw, immediately bringing to mind the Holocaust. It is a poignant image of absence and loss, reminding us that history is an artificial concept extracted from the experience of individuals.

In the Course of Time II 1994, photograph on paper mounted on muslin 262.4 x 586 cm

TONY CRAGG (b.Great Britain 1949) Since the late 1970s Cragg has been making sculptures from a highly diverse range of materials and found objects – including plastic, glass, wood, bronze, plaster, kevlar, clay, granite and steel. Cragg's work is often made up of fragments, such as shards of broken plastic or wood, which are arranged into a larger form. Later work has sometimes involved more elaborate materials made into increasingly complex interconnected shapes. In *Axehead* sections of timber are laid out on the floor according to height, and together they form the schematic image of an axe. Cragg's work of this time has its opposite in the solid sculptural monolith. *Axehead* is fragmentary, and made of cheap, easily acquired materials. *On the Savannah*, on the other hand is more substantial and cast in bronze, but a memory of the earlier work exists in its three-part structure.

If there is a single recurring image in Cragg's work it is the schematic form of a glass vessel or plastic bottle. This image is often distorted or enlarged, or it begins to mutate or deform. In *On the Savannah*, the bottle motif is enlarged, and stretched to the point of becoming almost unrecognisable. The sculpture appears part totemic, part landscape and part still life. The ubiquitous bottle is given a kind of grandeur; as if the everyday is exalted and dignified, the disposable made permanent. In some works the bottle acquires a humanoid form; in others it appears more like a rolling landscape. It is as if different categories of existence – human being, cultural object, natural form – begin to merge into one another, and thereby to question the validity of our classifications and habits of thought.

On the Savannah 1988, bronze 225 x 400 x 300 cm

Axehead 1982, mixed media 109.2 x 393.1 x 490.2 cm

SALVADOR DALÍ (b.Spain 1904–1989) Dalí is one of the best-known and most influential artists of the twentieth century. His fame is partly attributable to the extraordinary myth he created around himself, and to his famously extravagant and egotistical behaviour, which was apparent even in his youth. He was born in Figueras in Northern Spain. As a young man, he studied at the Royal Academy of San Fernando in Madrid, but he was soon expelled and his real education came from the personal researches and associations he made at this time. He fell in with a rebellious group that included the poet Federico Garcia Lorca and the film-maker Luis Buñuel. With Buñuel, he made the film *Un Chien Andalou* (1929), which won him great notoriety. The same year he had his first solo show of paintings in Paris, with which he was swiftly welcomed into the Surrealist fold. His contact with the Surrealists at this time inspired some of his finest and most memorable paintings, and it also brought him into contact with Gala Eluard, the woman who became his lover, muse, and lifelong companion.

Deeply influenced by Sigmund Freud, the founder of psychoanalysis, Dalí attributed his extraordinary imagery to what he called the 'paranoic-critical method'. He would simulate a state of delirious 'paranoia', in which he could creatively misread the visual world, transforming it to conform to his bizarre obsessions. In *Metamorphosis of Narcissus* Dalí created a powerful double image, inspired by the ancient myth of the beautiful young Narcissus who fell in love with his own reflection and was transformed into the flower of the same name. The painting shows Narcissus kneeling in the pool, in the process of being transformed into a hand holding an egg, from which springs a Narcissus flower.

In addition to writing and painting, Dalí also made a number of three-dimensional works, known as Surrealist Objects, of which *Lobster Telephone* is an outstanding example. These works exploit the psychoanalytic technique of free association to bring together ready-made items in irrational but significant combinations. The lobster and the telephone were a seemingly unlikely conjunction, both with strong sexual connotations for Dalí.

In the 1930s Dalí's relations with the Surrealists deteriorated because of his political ambivalence over the Spanish Civil War. However, he was deeply traumatised by the horrors of the war, as *Autumnal Cannibalism* (see p.47) demonstrates. Dalí said of this picture: 'these Iberian creatures, devouring each other in autumn, symbolise the pathos of civil war seen as a phenomenon of natural history'. The sinister, distorted forms of a man and woman embrace and devour each other at the same time, with the arid Catalan landscape opening out behind them.

Dalí will be remembered by many as an egotistical self-publicist, particularly after he fled to the United States in the 1940s to escape the war in Europe. Here, he became increasingly aware of the rewards of self-promotion and celebrity, and published his autobiography *The Secret Life of Salvador Dalí*. After the war Dalí moved between New York, Paris and Port Lligat in Spain. In his lifetime, two museums were created in his honour; in 1974 he opened the Teatro-Museo Dalí in Figueras and in 1982 the Salvador Dalí Museum in St Petersburg, Florida was established. Gala died that same year. Dalí died in 1989 and was buried in the crypt of the Teatro-Museo.

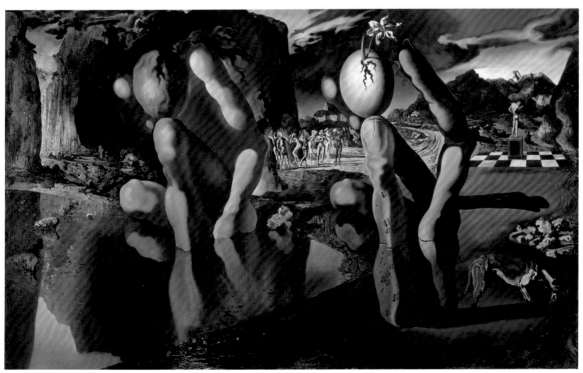

Metamorphosis of Narcissus 1937, oil on canvas 51.1 x 78.1 cm

Lobster Telephone 1936, plastic, painted plaster and mixed media 17.8 x 33 x 17.8 cm

RICHARD DEACON (b.Great Britain 1949) The early 1980s saw the emergence of a new generation of British sculptors who engaged with urban reality, creating an image-based sculpture from ordinary objects or industrial materials. Together with Deacon, these sculptors included Edward Allington, Tony Cragg, Antony Gormley, Anish Kapoor, Julian Opie, Richard Wentworth and Bill Woodrow. Although Deacon's raw materials ranged from home improvement linoleum, wood from the timber yard or corrugated iron found in any hardware store, to industrial welded steel, his work was rooted less in urban narratives than in a more allusive territory that laid claim to a metaphoric and organic iconography. His technique reflects his interest in a virtuoso craftsmanship as well as engineering.

Deacon's breakthrough occurred in 1980 after a year in New York. During that time he had completed a cycle of drawings on the theme of Rainer Maria Rilke's *Sonnets of Orpheus* in which vessel-like spaces register as a mouth, an ear or a musical instrument. The sculptures that Deacon completed in the years immediately following, such as *For Those Who Have Ears #2*, explore the dynamic between mass and volume, surface and edge, and the differing experiences of interior and exterior as much as of container and contained. The placement of Deacon's objects in space acts here as a metaphor for sound. *For Those Who Have Ears #2*, fabricated from laminated wood and adhesive, fills space by providing an open framework for what could be an enlarged fragment of a body. *Struck Dumb*, constructed from welded and bolted steel, is its antithesis: heavy, an exterior shutting off any view of its inside, resolutely squat and forbidding. However, in both cases experience of language and sound have been transformed into ambiguous, yet fabricated, objects.

Struck Dumb 1988, welded steel 158 x 390 x 250 cm

For Those Who Have Ears #2 1983, laminated wood and adhesive 273 x 400 x 110 cm

GIORGIO DE CHIRICO (b.Greece 1888–1978) De Chirico believed we should 'live in the world as if in an immense museum of strangeness', and that is exactly what we find in his paintings. Their atmosphere is one of powerful mystery and enigma: strange empty buildings and squares with long-cast shadows, populated with stark isolated figures, mannequins and odd inexplicable objects. Painted in 1913, soon after De Chirico's arrival in Paris from Italy, *The Uncertainty of the Poet* incorporates some of his best-known motifs: childhood memories of steam trains, classical art and Italian architecture, and particularly the motif of the piazzas, a dominant feature in several of De Chirico's paintings, known collectively as the 'Italian Squares'.

De Chirico maintained that his paintings were revealed to him while in a dream-like trance, and art which captured this hallucinatory reality he called metaphysical painting. His first metaphysical paintings were made in Florence in 1910. When he moved to Paris in 1911 he took them with him. Once exhibited there, they were met with immense curiosity and interest. Nothing like them had been seen before. Later, the Surrealists would herald him as their precursor, and De Chirico's impact on Magritte (see p.192) was so powerful it inspired his whole artistic output.

For a brief while De Chirico formed the *scuolo metafisica,* as other artists became attracted to his ideas. Based in Italy, it was a smallish art movement, having Carlo Carra as its other leading member. However, after the 1920s De Chirico completely repudiated metaphysical painting. Turning instead to academic traditionalism, he developed a fanatical hatred for modern art, even though he was one its most influential progenitors and continued to make copies of his early works.

The Uncertainty of the Poet 1913, oil on canvas 106 x 94 cm

WILLEM DE KOONING (b. The Netherlands 1904–1997) *The Visit* took several months to complete, and changed radically in the process, as photos taken by De Kooning's assistant, John McMahon, reveal. The central figure's arms originally stretched above her head, reaching the canvas's edges. Under her presently rather mask-like face is another set of features – large, made-up eyes and a lipsticked mouth. A second face lurks in the underpainting in the top right-hand corner. This archaeological detail helps explain the title: McMahon thought the two figures resembled a biblical Visitation or Annunciation scene, and De Kooning adopted the notion.

De Kooning emigrated from Rotterdam to the United States aged twenty-four. His first solo show, in 1948, earned him great acclaim from the key critics of American post-war abstraction, and his fame held steady throughout the 1950s. Despite his categorisation as an Abstract Expressionist, De Kooning frequently returned to the painting of recognisable human figures, male and female. His first series of *Women* (1950–5) used a spiky, virtuoso gestural technique to depict brash, almost caricatured females with gnashing teeth, huge breasts and manic, staring eyes. From the first, these works' arguably misogynist overtones provoked controversy, though recent feminist readings have stressed the humour and vigour with which De Kooning invests his gleefully monstrous ladies. *The Visit* belongs to a later series of *Women*, and is in marked contrast. Revelling in a vibrant palette of fleshy pink, orange and red, De Kooning abandons the bristling quality of his earlier work, adopting a looser, more liquid style. Here the splayed figure does not confront, but offers to absorb or engulf the viewer, just as she herself hovers on the brink of dissolving into the medium of the painting.

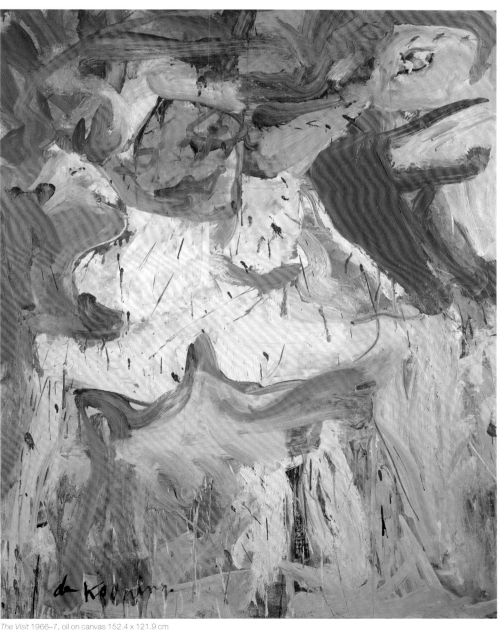

The Visit 1966–7, oil on canvas 152.4 x 121.9 cm

ANDRÉ DERAIN (b.France 1880–1954) Derain was a major figure in Parisian artistic circles. While apparently shifting during the First World War from rebellion to conformity, he was consistent in his belief in the elevation of art above the everyday life that it reflected. With Henri Matisse and Maurice de Vlaminck, Derain became associated with Fauvism – a term derived from the account by a critic of their paintings shown at the Salon d'Automne in 1905, in which the artists were described as 'fauves' (wild beasts). Their exuberant conjunction of pure colours served to heighten luminosity and chromatic intensity following the examples of van Gogh and Seurat. The reciprocal portraits painted by Derain and Matisse at Collioure on the Mediterranean Coast that year typify their approach. Through broken dabs of strong unnatural colour an idea of appearance is nevertheless conveyed which suggests the intensity of light by which form is revealed and obscured.

In the inter-war years Derain turned to traditional subjects and means. This reflected the wider 'return to order' through which established values were renewed as a basis for cultural reconstruction. Replacing luminosity and strong colour with restrained realism, Derain sought permanence in the example of the French seventeenth century. His major group portrait *The Painter and his Family* shows how he reinvented tradition. Complex symbolism infuses the whole and draws attention to the rigorously intellectual and learned realism. The painting aligns the artist's reading wife, his muse-like niece (with the dog) and his sister-in-law as satellites around his art, the mysterious activity enacted between his self-portrait and the hidden canvas. Although admired by colleagues like Balthus, from the late 1940s Derain's approach was increasingly isolated from politically committed realism and expressive abstraction alike.

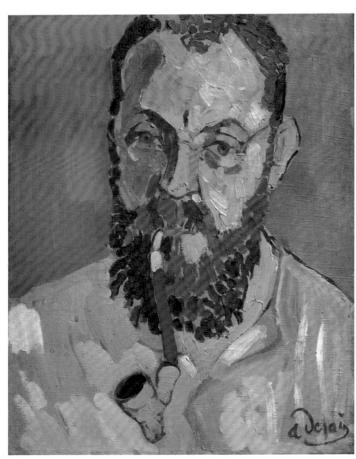

Henri Matisse 1905, oil on canvas 46 x 34.9 cm

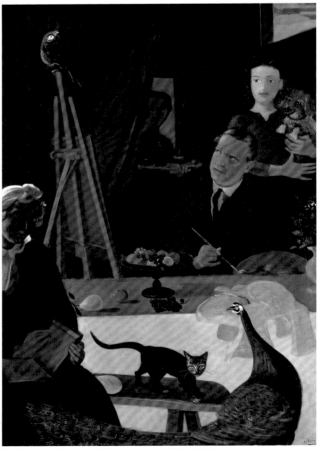

The Painter and his Family c.1939, oil on canvas 176.5 x 123.8 cm

146

JEAN DUBUFFET (b.France 1901–1985) Dubuffet and his associates (including the poet Henri Michaux, the painter Jean Fautrier, and the photographer Brassaï) greatly valued the incised graffiti which appeared on the walls of Paris during the war: crude, enigmatic symbols that represented an underground means of communication and expression in the occupied city. In the later 1940s and 1950s, Dubuffet produced paintings which he labelled 'hautes pâtes' ('raised pastes', mixed from paint, fixative, grit, earth, coal or nameless grime). These offered a surface that could be both painted upon and scratched into. Thus, his portrait of Michaux echoes both the scored technique and the raw imagery of wartime graffiti. More generally, it draws on Dubuffet's passion for Art Brut – 'outsider' art, made by untrained artists, children or the mentally ill. He avidly collected such work, and in 1948, with the leading Surrealist André Breton, and the critic Michel Tapié, formed the

Compagnie de l'Art Brut, an association dedicated to the preservation and promotion of any work that embodied the principles of 'crude' as opposed to 'cultural' (trained or academic) art.

Dubuffet's portrait of Michaux blurs the sitter's identity with that of M. Plume, the absurd, Chaplinesque 'everyman' at the heart of Michaux's novel *The Busy Life*. In a later painting, Dubuffet returns to Michaux's novel for inspiration, depicting its characters tumbling around a detritus-strewn urban landscape, equally hanging on to their respectable hats. In a lecture, Dubuffet said: 'It is distressing to think about those people who are denied beauty because their noses are crooked, or because they are too fat or too old.' Critical of notions of genius, he championed 'outsider' art, and grubby, degraded materials, to encourage a re-evaluation of banality, ugliness, and the overlooked.

Monsieur Plume with Creases in his Trousers (Portrait of Henri Michaux) 1947, oil and grit on canvas 130.2 x 96.5 cm

The Busy Life 1953, oil on canvas 130.2 x 195.6 cm

MARCEL DUCHAMP (b.France 1887–1968) One of the most influential artists of the twentieth century, a precursor of Dada, Surrealism, Conceptual and Op art, Duchamp was notable for questioning the entire rationale of the work of art. With his love of irony, paradox and punning, he challenged traditional aesthetic assumptions, emphasising instead the artistic concept. His best known works, the 'readymades', involved the selection of commonplace objects which he designated as works of art. *Fountain*, described as 'one of his most insidiously subversive artifacts' is a case in point. In 1917, Duchamp selected a urinal from the showroom of the R.L. Mott Iron Works in New York, signed it 'R. Mutt, 1917' and submitted it for inclusion in the biggest art exhibition to have been staged in America. Displayed behind a screen, the work nevertheless became a 'succès de scandale' and was immortalised in a photograph by Alfred Stieglitz before it disappeared, and later in a limited edition of replicas authorised by Duchamp, of which this is one. With its provocative orifices and gently curving shape, the urinal has been read symbolically as female, a ready receptacle for male fluids. However, Duchamp's contemporary defenders called it a 'lovely form' whose 'chaste simplicity' resembled the image of a seated Buddha.

The Tate's *Fresh Widow* is one of an edition made in 1964 at the same time as the replicas of *Fountain* and eleven other objects. It closely resembles the original made in 1920: a miniature french window with panes of shiny black leather, the wooden frame made to Duchamp's specifications by a carpenter, the artist filling in the panes. As with *Fountain*, the piece is also 'signed' and dated: the caption 'FRESH WIDOW COPYRIGHT ROSE SELAVY 1920' runs along the base. The female name marks the first appearance of Duchamp's 'alter ego', chosen, according to the artist, because

'Rose was the corniest name for a girl at that time … And Sélavy was a pun on c'est la vie'. Duchamp's biographer, Calvin Tomkins, suggests that the piece punningly points to other possible characteristics of Duchamp's double: fresh (as in impertinent), French, widowed, closed-up (but easily openable) and with a taste for fun (wearing black leather rather than conventional widow's weeds). Other commentators have connected the work to the Duchampian theme of sexual non-fulfillment in that the blacked-out windows suggest obstruction and frustration. Since the French word for widow, 'veuve', is also the slang term for guillotine, the title may refer to unconscious castration fears.

The sexual innuendo implicit in so much of Duchamp's work was present in the original version of *The Large Glass*, (begun in New York in 1915 but which took many years to 'complete'). This version is a reconstruction, signed by Duchamp, made by the artist Richard Hamilton (see p.166) for the Tate's major Duchamp retrospective in 1966. The highly complex piece was critical for Duchamp and much of his work from 1912-15 was concerned with studies for it. In essence, the free-standing, transparent glass construction contains a complex love-making machine divided into two parts: the upper contains the female section (the Bride's Domain) where the Bride takes the form of a stylised internal combustion engine; in the lower male section, nine 'malic' (male) moulds attached to a chocolate grinder comprise the Bachelor Apparatus. The two sections are destined, frustratingly, never to make contact and they communicate only by means of two circulatory systems. Beyond the obvious sexual implications of the work, interpretations have also focused on alchemical references, Tarot readings, Christian symbolism, Duchamp's interest in perspective and the fourth dimension.

Fresh Widow 1920, replica 1964, mixed media 78.9 x 53.2 x 9.9 cm

Fountain 1917, replica 1964, porcelain 36 x 48 x 61 cm

The Bride Stripped Bare by her Bachelors, Even (The Large Glass) 1915–23, replica 1965–6, oil, lead, dust and varnish on glass 277.5 x 175.9 cm

JACOB EPSTEIN (b.USA 1880–1959) *Rock Drill* is Epstein's major work of the pre First World War period. Originally it stood nearly ten feet tall, a looming robotic figure with powerful arched legs which straddled a vast industrial drill. Epstein had bought the drill during a 'short-lived ardour for machinery' in 1913. It was a considerable departure from his other work at this time and is the only significant example of his affiliation with the English avant-garde movement Vorticism. Influenced by the iconoclastic Italian Futurist movement, Vorticism promoted a new kind of art that would mirror the vitality, energy and aggression of the modern world. Vorticism celebrated the power of machinery and heralded the coming of the First World War as a dynamic force which would cleanse Europe of bourgeois conservatism and complacency.

In 1916 Epstein dismantled *Rock Drill*, already chastened by the tragic realities of the war. He discarded the lower body and cast only the head and torso in bronze. It remains a powerful and frightening image of the mechanisation of the human form. The body is simplified into angular Cubist planes resembling plates of armour, and protectively embedded in the creature's cage-like ribs is a tiny foetus suggesting the force of the procreative drive even in an alien and dehumanised world. The *Rock Drill*'s head is styled like an African tribal mask or the visor of an ancient warrior. Yet despite its attitude of aggression this hybrid also expresses a profound sense of melancholy. Epstein later said of his sculpture: 'Here is the armed, sinister figure of today and tomorrow. No humanity only the terrible Frankenstein's monster we have made ourselves into.'

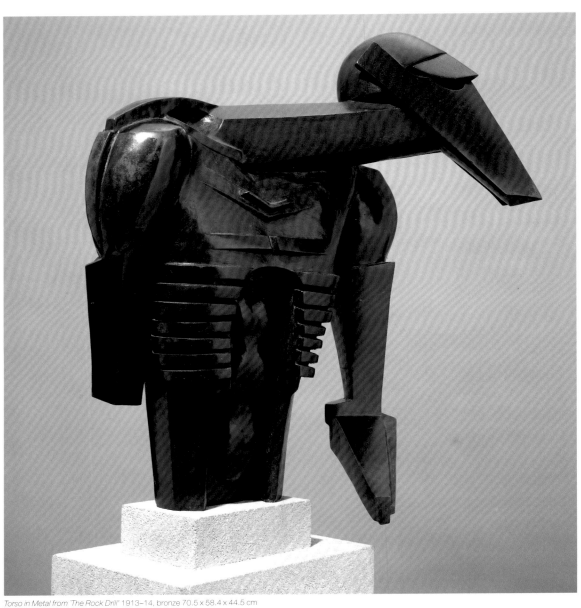

Torso in Metal from 'The Rock Drill' 1913–14, bronze 70.5 x 58.4 x 44.5 cm

MAX ERNST (b. Germany 1891–1976) In 1921 Ernst had his first solo exhibition in Paris. The catalogue introduction, written by André Breton, set the terms for what would form the bedrock of Surrealism: the principle of automatism and the exploration of the unconscious. Automatism was the term applied by the Surrealists to various forms of creativity involving free association and the use of chance. The following year Breton took over control of the Dada journal *Littérature* and inaugurated what became known as the 'period of trances', prior to Breton's founding manifesto of Surrealism in 1924. Ernst's paintings – *Celebes*, painted in Cologne and *Pietà or Revolution by Night*, painted in Paris following his move there in August 1922 – mark the important transition between Dada and Surrealism and are among the most significant visualisations of the automatic state of thinking into which the Surrealist poets fell in pursuit of the unconscious, the marvellous, the dream, madness and hallucinations.

Ernst, who readily attended these hypnotic sleep sessions, was naturally predisposed to Surrealist exploration. By 1921 he identified his work as 'painting beyond painting', the basis of which he found in collage. Although collage had already been exploited by the Cubists, Ernst, in his use of mechanical diagrams and nineteenth-century engravings, set out to make plausible images of impossible situations. For Breton and the other literary Surrealists, Ernst's collaged displacements promised a new form of visual poetry which reflected or corresponded to their writing. The basic form for the elephant-like creature in *Celebes*, for instance, was taken from an illustration of a Sudanese corn bin from an anthropological journal, while the gesticulating headless woman's torso, the teetering forms at the right of the painting, and the landscape of shadows in which Celebes stands, all evoke an atmosphere of disquiet that owes much to the metaphysical paintings of Giorgio De Chirico (see p.144).

Pietà or Revolution by Night stands as the archetypal visual manifesto for the 'period of trances' where imagination was understood by Breton to appear through 'closed eyes'. The title gives a sense of the seriousness of Ernst's purpose, emphasised by the representation of himself, asleep and held in the arms of his father, also with unseeing eyes, as an oedipal pietà. Both Ernst and his father are depicted as petrified beings – Ernst as marble, his father the same colour as the stone walls that surround them – even though they are not solid: where the father's hands grip Ernst they are shown to be not stone but transparent. On the wall behind them is a figure of a man with a bandaged face drawn in outline as if he is both on the wall and at the same time walking up the stairs which seem quite solid. He is another father-figure, the poet-critic Guillaume Apollinaire. With this painting of people in various states of being, Ernst provided a catalogue and manifesto for the new Surrealist art.

Celebes 1921, oil on canvas 125.4 x 107.9 cm

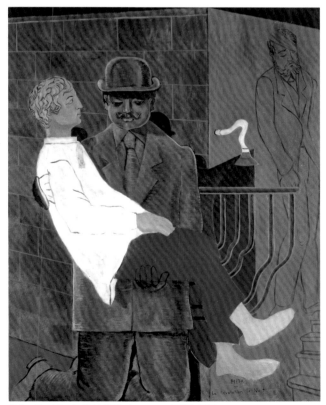

Pietà or Revolution by Night 1923, oil on canvas 116.2 x 88.9 cm

LUCIANO FABRO (b.Italy 1936) Fabro's early work shows his concern with phenomenological theories of the gap between the way we perceive our environment, and its scientific description. His first exhibition in Milan in 1965 brought Fabro into contact with a group of artists including Jannis Kounellis (see p.187) and Michelangelo Pistoletto. Together they showed in the 1967 exhibition *Arte Povera* which launched the important movement of that name. Often unorthodox in form and material, Fabro's Arte Povera work has echoes of the Conceptual art of his contemporaries though it is coloured by the culture of Italy during the Cold War. His *Italia* series, begun in 1968, featured the suspended form of the country and provokes reflections upon the national self-image.

Explorations of myth, philosophy, science and literature have informed Fabro's overarching enquiry into culture. Although avoiding an obvious stylistic unity, he has explored a variety of materials – marble, silk, blown glass – associated with traditional crafts but departing radically from traditional sculptural forms. In *Ovaries* the steel cables snake under their own weight and bind in the apparently fragile marble eggs. Fabro seeks a 'sympathy' in the juxtaposition of such materials, through which each is intensified and gives rise to a third quality. He is reluctant to restrict the potential meanings for *Ovaries*, although he sees the fertilised egg as a unity of female and male; reproduction and birth are immediate associations, extending perhaps to the sensitive issue of birth control in Italy. Nature seems to be mediated through the man-made in a way that reflects Fabro's continual questioning of all intellectual, scientific and cultural activity.

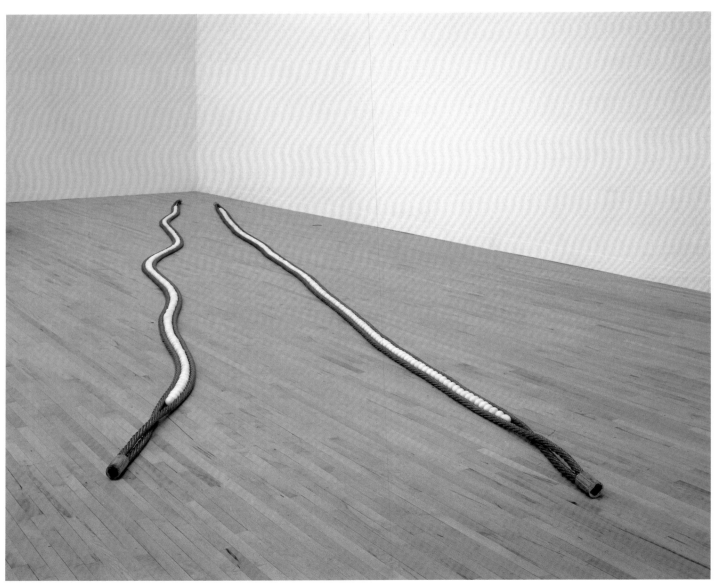

Ovaries 1988, Italian marble and stainless steel 7.5 x 1125 x 150 cm

JEAN FAUTRIER (b.France 1898–1964) In 1943, Fautrier was imprisoned by the SS. He subsequently sought refuge in a sanatorium. There, adopting an outbuilding as a studio, Fautrier worked within earshot of woods where Nazi killings took place by night. The *Hostage* series of paintings and sculptures, produced at this time, is seen by some as Fautrier's most significant work.

First shown in Paris in 1945, *Head of a Hostage* bears witness to the suffering of victims of atrocity, but in an anti-heroic and far from consoling way. Versions of the piece exist in bronze, but this cast is made from lead, carrying with it connotations of weight, toxicity, 'baseness' and mortality. While Fautrier's earlier *Large Tragic Head* (1942) bears recognisable human features (partially scored away by the artist's spatula), the pitted and gouged surface of this later head renders it an inchoate, featureless lump of matter.

Fautrier's *Hostages* have frequently been linked to the writings of Georges Bataille, in particular to his definition of the formless: that which 'has no rights to any sense, and is everywhere crushed underfoot like a spider or a worm'. In rendering its hostage 'formless', Fautrier's work unflinchingly reflects the torturer's dehumanising attitude towards his victim. A key aspect of this work is its refusal to gloss over the obscenity of 'transforming' suffering into a work of art.

Fautrier's reputation has fluctuated, but his work has nevertheless exerted extensive influence. In the 1950s it inspired a younger generation of French artists (dubbed the 'tachistes'). Later shows in Germany also served to bring his work to the attention of the German Neo-Expressionists, including Georg Baselitz (see p.122).

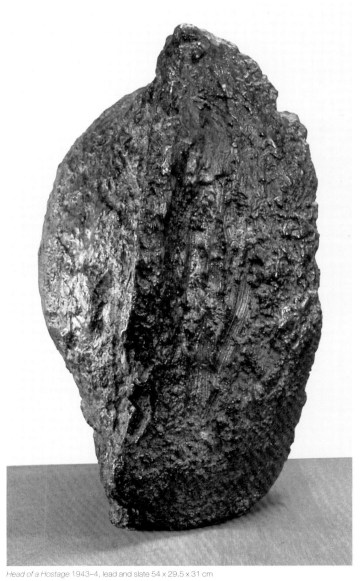

Head of a Hostage 1943–4, lead and slate 54 x 29.5 x 31 cm

IAN HAMILTON FINLAY (b.Bahamas 1925) Finlay was known as a writer of poems, plays and short stories before gaining a reputation as an artist. He briefly attended Glasgow School of Art in the 1940s and based himself in Scotland, founding the Wild Hawthorn Press in Edinburgh in 1961. With this literary background, it is no surprise that a love of language and an intense poetic sensibility underscore his art. Finlay initially worked as a Concrete poet – where words are arranged to form an image appropriate to the subject – and he then had the idea of extending Concrete poetry into three dimensions. He has subsequently developed an art in which ideas and allusions are given physical form in unusual interactions of word, image and physical material.

In Finlay's art, ideas are nurtured over a long period of time. Nature is a major source of inspiration, and his most remarkable achievement is Stonypath, also known as Little Sparta, the landscape garden he has created over many years at his home in Lanarkshire. Historical references feature heavily in much of his work, and there is a political motive behind this. Finlay sees Little Sparta as a republic and evokes the French Revolution as a contemporary metaphor. Similar themes come together in *A Wartime Garden*, where Finlay juxtaposes images of modern warfare with words evoking pastoral themes, and texts by the classical philosopher Plotinus and nineteenth-century writers Hegel, Feuerbach and Novalis. References to different stages of civilisation create a chronological, cultural continuum in the work, but the disparities between text and image give its overall meaning a darker, ironic poignancy.

A Wartime Garden [collaboration with John Andrew] 1989, limestone and painted fibreboard, twenty-four parts 162 x 884 x 886 cm

LUCIO FONTANA (b.Argentina 1899–1968) Viewed in isolation, *Spatial Concept 'Waiting'*, a plain canvas marked by a single near-vertical cut, seems the very embodiment of elegant simplicity. In the context of the prolific practice of Fontana, however, it assumes rather different connotations. Between 1958 and 1967, Fontana produced numerous Tagli ('cut' paintings). Some have several cuts, some have coloured grounds, some employ shaped canvases, some form part of 'spatial environments' displaying series of Tagli together. Fontana's post-war output also included paintings variously adorned with perforations, rhinestones, glitter, gilding, coloured glass and ornamental impasto. He made sculptures from coloured plaster, concrete, neon, ceramic and bronze, and he embarked on design projects for churches and funerary monuments, cinemas and boutiques, experimental TV broadcasts, and even clothes (for example, his 1957 *Spatial Neck-tie*).

Fontana moved from Argentina to Milan aged six, and spent most of his life there, gaining early success as a sculptor of figurative public monuments. In 1946, he and a group of young Argentinian avant-gardists wrote the *White Manifesto*, a document advancing ideas which Fontana later developed into Spatialism, his personal art-making credo. However, as the array of ingredients and activities listed above suggests, Fontana's avant-gardism rejected modernist purity and rationalism, and explored formlessness, disintegration, and the breaking-down of distinctions between 'high' and 'low' cultural forms and materials. The critic Yve-Alain Bois detects 'the quack of bad taste' in Fontana's work, commenting 'he did not deliberately or ironically appropriate kitsch, but worked completely within its thrall'. This is not intended negatively: Fontana's transgressive assault on rationality and taste constitutes a valid artistic exercise. In *Spatial Concept 'Waiting'* the regressive, sadistic slicing gesture could be seen as part of that assault.

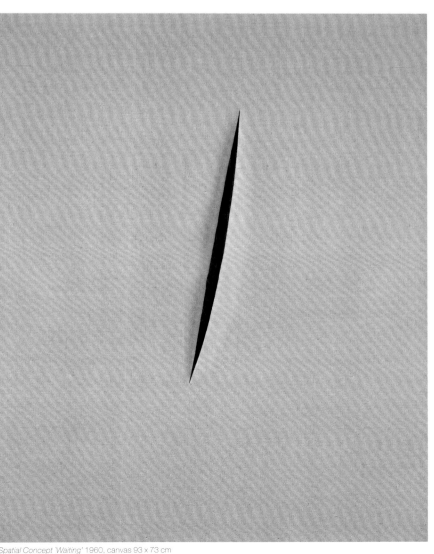

Spatial Concept 'Waiting' 1960, canvas 93 x 73 cm

LUCIAN FREUD (b. Germany 1922) The graphic, linear style of *Girl with a White Dog* is typical of Freud's early work: flat, thinly-applied oils describe the painting's subject in painstaking detail, recalling British and German realism of the 1920s and 1930s – for example, the work of Stanley Spencer or Otto Dix. Later paintings by Freud exploit the textural possibilities of paint to a far greater extent. Aside from its style, however, this work shows Freud's dominant artistic concern: the scrutiny of the live model, nude or clothed, in an explicit studio setting. Its colours are typically muted and inexpressive, and its mood could be characterised as anxious and uncomfortable: the model's exaggerated features carry a look of nervous pleading, whilst her subtly distorted body is compressed into an awkward L-shape on the shallow space of the couch. Freud rhymes the texture of her bathrobe with the dog's bristles. This detail, combined with the robe's plaited belt, subliminally suggests she is being forced to wear some kind of penitential garment. Her bared breast prompts the idea of breastfeeding, but perversely, the creature nestling beside her is a sharp-toothed dog, not a baby.

Freud's work has prompted lively debate amongst critics in recent years. His detractors feel his paintings are marred by a patriarchal, sadistic attitude towards his subjects. His admirers, on the other hand, value his work both for its technical fluency, and its uncompromising, emotional rawness.

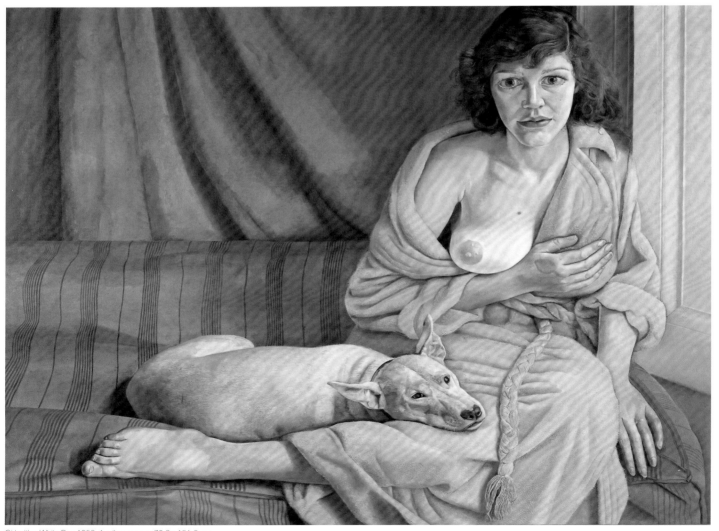

Girl with a White Dog 1950–1, oil on canvas 76.2 x 101.6 cm

NAUM GABO (b. Russia 1890–1977) Gabo was one of the pioneers of constructed sculpture and one of its greatest and most consistent exponents. In the field of purely abstract construction he was outstanding. As a sculptural method, construction added a third way to the ancient techniques of carving wood or stone, and modelling in clay to cast in bronze. It opened up immense new possibilities for art. Construction was invented by Picasso (see p.212) in his Cubist works of 1912–14 but not pursued by him at that time. It was Gabo, and independently his fellow Russian Vladimir Tatlin, who took it up to found a line of abstract sculpture using industrial materials and techniques.

Gabo was born in Russia at Bryansk near Moscow. He was sent to the University of Munich to train as a doctor but switched to science and engineering. He also attended lectures by the celebrated art historian Heinrich Wölfflin and began to develop an interest in art. In 1912 and 1913 he made trips to Paris where he was exposed to avant-garde art including Cubism. At the outbreak of the First World War he moved to Norway and by 1915 was making highly innovatory constructed sculpture there.

The earliest of these had a figurative basis but were already made according to the principle of stereometry that was fundamental to Gabo's later fully abstract work. The essence of stereometric construction is that it enables the artist to define form in terms of space, rather than mass. In his essay *Sculpture: Carving and Construction in Space* published in 1937, Gabo wrote 'Up to now sculptors have preferred the mass and neglected or paid little attention to such an important component of mass as space … we

consider it as an absolute sculptural element … I do not hesitate to affirm that the perception of space is a primary natural sense which belongs to the basic senses of our psychology'.

Gabo's personal theory of abstraction is contained in his *Realistic Manifesto*, published to accompany an exhibition of his work in Moscow in 1920. The title was deceptive, as Gabo later explained: 'We all labelled ourselves constructors – the word realism was used by all of us because we were convinced that what we were doing represented a new reality'. That is, the work has its own reality, is a new creation, not an imitation of some other thing. In the *Realistic Manifesto* Gabo wrote: 'the realisation of our perceptions of the world in forms of space and time is the only aim of our art … We construct our work as the universe constructs its own, as the engineer constructs his bridges … in creating things we take away all that is accidental and local, leaving only the constant rhythm of the forces in them.'

Gabo took an important step in his search for an art of pure space in about 1920 when he adopted the use of transparent plastics and glass. *Construction in Space with Crystalline Centre* and *Red Cavern* are examples of the extraordinarily beautiful works that he made with these materials. Gabo explained that such things are a kind of abstract architecture: 'From the very beginning of the Constructivist Movement it was clear to me that a constructed sculpture, by its very method and technique brings sculpture very near to architecture … My works of this time … are all in the search for an image which would fuse the sculptural element with the architectural element in one unit'.

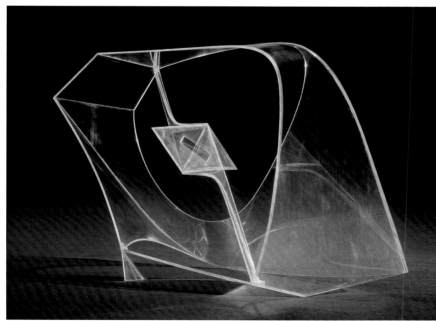

Construction in Space with Crystalline Centre 1938–40, perspex and celluloid 32.4 x 47 x 22 cm

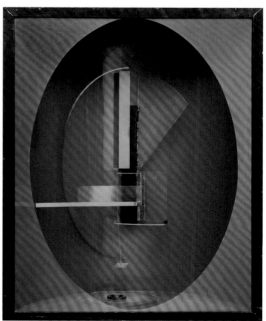

Red Cavern c.1926, plastic, cork, metal and wood 66 x 51.4 x 27.9 cm

ALBERTO GIACOMETTI (b.Switzerland 1901–1966) The son of a painter, Giacometti made art from an early age. After training in Geneva and Italy he moved to Paris in 1922 where he continued his studies. From 1930 to 1935 he participated in the Surrealist movement, making an influential contribution to Surrealist sculpture and object making. *Hour of the Traces* is one of his outstanding Surrealist works. A similar piece, *Suspended Ball* (1930) had been seen by the Surrealist leader André Breton, and by Salvador Dalí (see p.140) when exhibited in Paris in 1930, resulting in an invitation to Giacometti to join the Surrealist group. Dalí subsequently featured a series of Giacometti's sketches for such things in his article 'Surrealist Objects' in the Surrealist house magazine *Le Surréalisme au Service de la Révolution* in December 1931. This article led to object making becoming an important Surrealist activity.

Hour of the Traces represents a stage in Giacometti's lifelong struggle to make sculpture which realised his vision of the human figure. Writing of this time, he said: 'Figures were never for me a compact mass but like a transparent construction. After all sorts of attempts I made cages with an open construction inside.' *Hour of the Traces* hints at a skeletal figure with both male and female attributes. The pendulum-like suspended white form, evoking the mystery of time, may have suggested the title.

In 1935 Giacometti returned to working from the model, causing a rupture with the Surrealists. For the next decade he continued to struggle with his 'vision of reality', spending most of the Second World War in his native Switzerland. By the end of the war he had evolved the new figurative style that he quickly became celebrated for. His skeletal bronzes were seen as encapsulating essential aspects of the intellectual and emotional climate of Europe in the aftermath of the war. He also developed an important practice in painting the figure.

One of the most prominent thinkers of the time was Jean-Paul Sartre, whose Existentialism stressed the isolation of human beings in a godless universe, and the fragility and ephemerality of human existence. To Sartre, Giacometti's sculpture seemed both to express that vision and to be alive in a way that traditional sculpture was not: 'How can you mould a man in stone without petrifying him?' asked Sartre in 'The Search for the Absolute', the essay he wrote for the catalogue of Giacometti's first post-war exhibition in Paris in 1948.

If Giacometti was the great Existentialist artist for Sartre, then Jean Genet, the criminal turned playwright and novelist, was the corresponding writer, becoming the subject of an enormous study by Sartre titled *St Genet*. In 1954 Giacometti was fascinated by the bald skull of a man he saw in a café and invited him to pose. The man was Genet. The result was a pair of painted portraits of which one is in the Tate Collection. A vivid evocation from life of one of the most striking personalities of post-war culture, it also, like Giacometti's sculpture, expresses the artist's particular vision of his fellow man. Genet returned the compliment by writing an essay on Giacometti which Picasso stated to be the best book about an artist he had ever read.

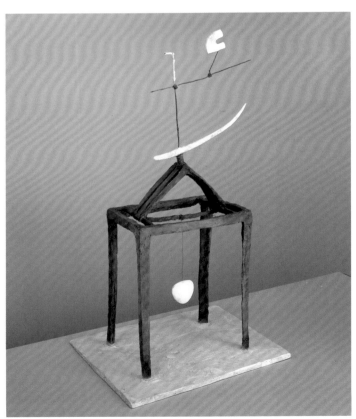

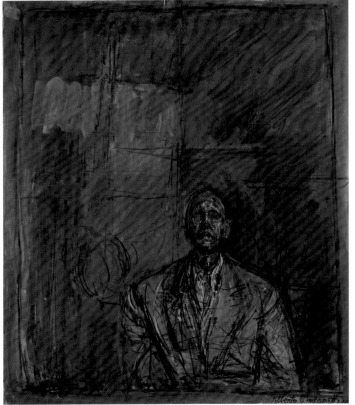

Hour of the Traces 1930, painted plaster, wood and steel 68.6 x 36.2 x 28.6 cm

Above: *Jean Genet* 1954 or 1955, oil on canvas 65.3 x 54.3 cm
Right: *Man Pointing* 1947, bronze 178 x 95 x 52 cm

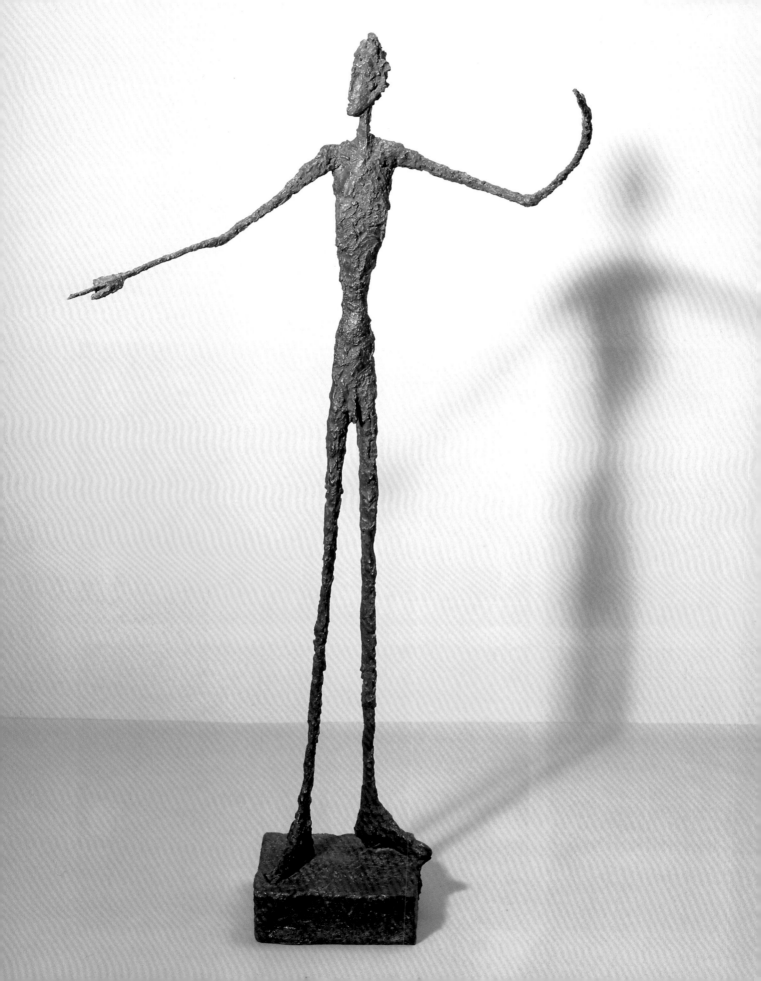

GILBERT AND GEORGE (Gilbert Proesch b.Italy 1943, George Passmore b.Great Britain 1942) Gilbert and George make up one of Britain's most celebrated artistic partnerships. They met at St Martin's School of Art in 1967, and since that time they have lived and worked together as a single entity. As students, they rebelled against the prevailing conventions of abstract British sculpture and sought to broaden and transform accepted practice. Subsequently they began to call everything they did sculpture. Life and art became one, and Gilbert and George became 'living sculptures', creating a series of highly memorable performances throughout the 1970s.

From early on Gilbert and George began to formalise their performance work by means of photography. They developed a complex procedure by which they created large scale often boldly coloured unique photographic pieces, in which the image is constructed from a large number of individual standard sized photographic sheets. In *DEATH HOPE LIFE FEAR* they appear with many of their favourite motifs, including the flower, to represent fecundity, and youths from London's East End, who appear as symbols of ideal manhood. As suggested by the title, the work has four parts, each addressing an individual theme. These works have often been compared to stained-glass windows, and through creating striking, iconic images Gilbert and George seek to convey their ideas forcefully and directly. The subject-matter is always provocative, often addressing taboo issues – sex, homoeroticism, religion, and death – in an explicit and confrontational way.

Gilbert and George continue to be both prolific and notorious, and in some works have now discarded their trademark worsted suits to appear nude. They have also turned their attention to the internal aspects of their bodies, incorporating images of their own faeces and bodily fluids in their work.

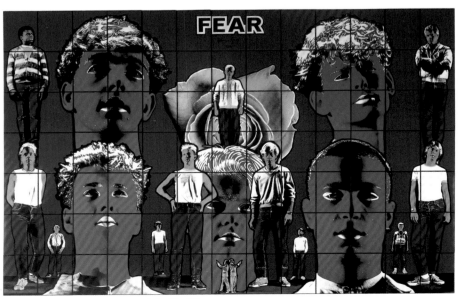

DEATH HOPE LIFE FEAR 1984, hand-coloured photographs, framed 422 x 250 , 422 x 652, 422 x 250, 422 x 652 cm

NAN GOLDIN (b.USA 1953) Jimmy Paulette and Tabboo! have frequently been photographed by Goldin. Here, they are pictured together in an intimate state of semi-undress, shorn of their wigs and evening finery and shown in a vulnerable and affectionate light: Jimmy Paulette standing just outside the bedroom, conscious of the camera and returning the gaze, Tabboo! preoccupied on the floor and sensuously reflected in profile in the full-length mirror, adjacent to his friend.

Since Goldin left Boston as a child runaway in the 1960s, her photography has taken as its main subject the desires, dandyism and eccentricity of a group of people living on the margins of society. Her camera captures a secluded, youthful, nightime world of bedrooms, bathrooms, night clubs, bars, hotel rooms, lofts and parties. Moving among drag queens and cross dressers, many her close friends, Goldin has constantly investigated stereotypical gender distinctions, attempting to redefine them by showing alterna-

tives. If her early images, including her black-and-white photos of the 1970s, may be seen as a celebration of difference, the identities she depicts in her work of the later 1980s and 1990s often seem more unstable. They frequently reflect selves which are threatened or elusive, conscious of their own otherness, and familiar with loss through AIDS. The vivid colouration (a departure from the 'real-life' documentary associations of black and white) often heightens the sense of euphoria and camp in the later club scenes while underlining the poignancy of illness and death in the quieter images.

While Goldin's work has struck a chord with younger photographers seeking to blur the divisions between high art and fashion photography (she has notoriously been dubbed the mother of 'heroin chic'), it also remains a potent and enduring exploration of the variety of the human psyche within portraiture at the end of the millennium.

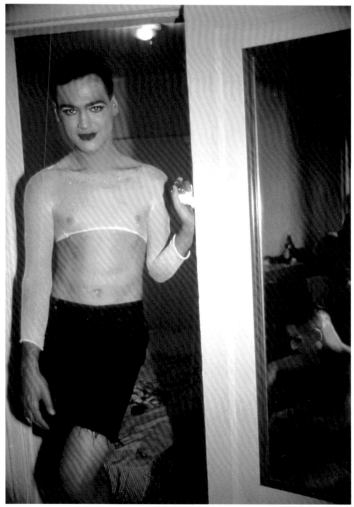

Jimmy Paulette and Tabboo! undressing, NYC 1991, photograph on paper 101.5 x 69.5 cm

ARSHILE GORKY (b.Armenia 1904–1948) Gorky received little formal art training, but – guided by his sophisticated, art-loving mother – spent his childhood immersed in the rich visual culture of his native Armenia. It was a culture under threat: by 1919, Ottoman Turkish persecution had caused the deaths of over a million Armenians, including Gorky's mother, and forced a further million into exile. Gorky fled to America, and his painting is deeply informed by his experience of displacement. He constantly sought, he said, to 'resurrect Armenia with my brush'. *Waterfall* may have been partly inspired by the scenery of Connecticut's Housatonic River, but its vivid colouring might equally be read as an evocation of Armenian landscape, and its use of dark line to bound areas of colour and define form, as a reinstatement of traditional Armenian painting techniques.

Produced during the happiest and most fruitful period of the artist's life, *Waterfall* shows Gorky's technique (developed from 1941 on) of diluting his paints with turpentine to produce watery, flowing veils of colour. Beyond this effect, though, there is no literally identifiable waterfall in the picture. Towards the top of the painting, a heart-shaped scarlet form enfolding a phallic dart delightfully combines Surrealist-influenced sexual symbolism with the image of a radiantly smiling face. In fact, the painting appears to show a couple embracing. Cultural historian Harry Rand has suggested that *Waterfall*, like several of Gorky's major paintings, draws on a photographic source, in this case a stereoscopic souvenir photo of newlyweds embracing in the woods at Niagara Gorge. From this unassuming material, Gorky evolves an allusive, gently voluptuous reverie of happy romance.

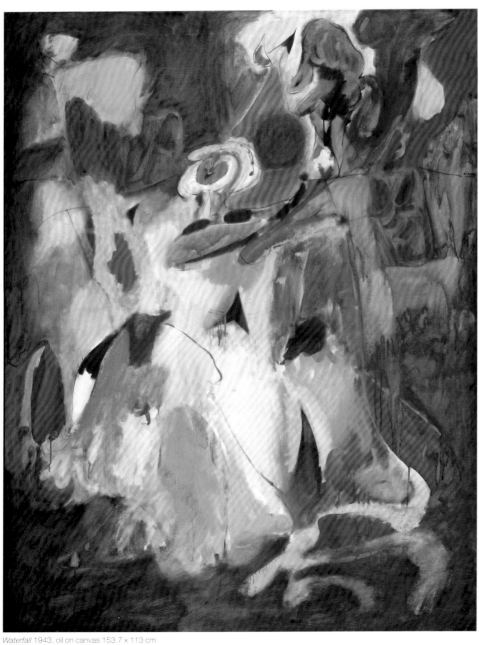

Waterfall 1943, oil on canvas 153.7 x 113 cm

ANTONY GORMLEY (b.Great Britain 1950) At the beginning of the 1980s, Gormley pioneered a then unfashionable return to the body as subject which remains a major theme of his work. He has subsequently made many sculptures which use a cast of his own body in a variety of poses. However, Gormley does not see himself as a figurative artist. Instead he views his sculptures as vehicles for universal themes related to the human condition. Influenced by his Catholic upbringing and a training in Buddhist meditation, Gormley's emphasis on the human form in his work stems from a belief that the body is 'the locus of being', the place where mind and matter meet. Gormley views himself as part of the English mystical tradition which runs through William Blake, Samuel Palmer and Stanley Spencer.

Untitled (for Francis) is the figure of man with his arms outstretched in a striking but ambiguous pose which suggests a simultaneous act of passive submission and active embrace. This is the traditional pose of the Christian saint Francis (to whom the title refers) as he receives the *stigmata*, the wounds of Christ, upon his body. In a re-enactment of Christ's crucifixion this moment unites physical suffering with spiritual renewal and redemption. Accordingly Gormley's figure also bears gaping wounds pierced through his hands, feet and chest. These eye-shaped holes provide channels between the exterior and interior space of the sculpture suggesting the interdependence of body and spirit. The relationship between the viewer and the object is paramount because the sculpture, Gormley proposes, acts 'as a sounding-board for notions of self'.

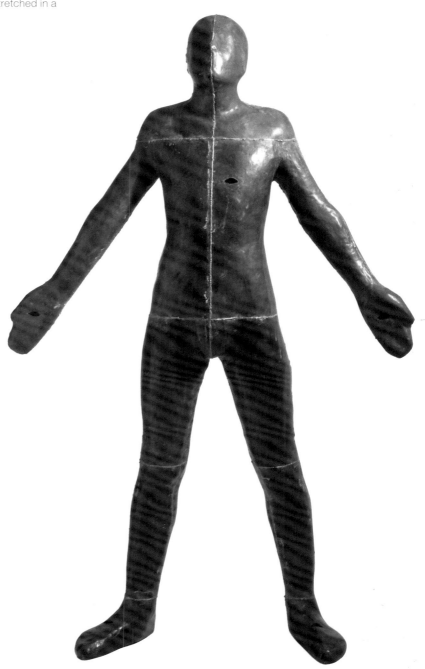

Untitled (for Francis) 1985, lead, plaster, polyester resin and fibreglass 190 x 117 x 29 cm

163

PHILIP GUSTON (b.Canada 1913–1980) The American painter Guston had a career which straddled three major movements of twentieth-century art. He achieved early success with politically-motivated mural commissions in a heroic Socialist Realist style inspired by the Mexican muralists and *quattrocento* Italian masters such as Piero della Francesca. Later in New York he encountered Abstract Expressionism, and against natural inclination, moved to abstraction. His abstract paintings of the 1960s were sometimes described as 'abstract impressionism' for their impressionistic handling of paint and concern with the depiction of light. However by the mid-1960s his work betrayed hints of figuration, and in 1970 Guston abandoned abstraction completely in a radical move which prefigured the return to representation made by a younger generation of artists in the 1970s and 1980s.

Eager to return to the 'world of tangible things', Guston avidly began to draw the everyday objects around him: books, shoes, hands and ashtrays. He developed a satirical cartoon style and found new freedom in the imaginative possibilities suggested by the shapes of these ordinary objects. Combining ironic humour and latent aggression, Guston's late paintings are filled with goggle-eyed self-portraits, hooded Ku Klux Klansmen and the tangled detritus of the modern world. The artist has described his smoking, hooded figures as self-portraits which are intended to undermine the evil normally associated with such images. *Hat*, however, is an unusually calm and simple composition despite Guston's garish trademark pink. Hovering tentatively against a painterly abstract background of pink and black colour planes (perhaps a parodic allusion to the colour field paintings of his friends Rothko and Newman) is a loose, comic-strip depiction of a hat. The painting dramatises the continuous conflict between abstraction and figuration in Guston's art and expresses his belief that 'the visible world is abstract and mysterious enough'.

Hat 1976, oil on canvas 203.2 x 292.1 cm

RENATO GUTTUSO (b.Italy 1912–1987) The flurry of collaged newspaper scraps surrounding the protagonists of this painting by Guttuso indicates that politics form the nub of the discussion. Headlines read 'PROLETARIO' and 'Mosc[ow]'; Cyrillic text also appears. Chain-smoking, nail-biting, and manhandling the furniture, Guttuso's debaters are in full spate. The text fragments, the picture's date, and the composition's dramatic diagonal split, invite the speculation that Stalinism, the Cold War and the international crisis in Communist solidarity could be on the agenda here. However, the similarity of Guttuso's figures, with their short, bristling haircuts, may legitimate a double reading: *The Discussion* might equally show one man wrestling with his political conscience. Either way, the standing figure is clearly a self-portrait: Guttuso, an active Communist Party member from 1940 to 1983, is dealing with issues close to his heart.

Guttuso moved from his native Sicily to Rome in 1937. Between then and 1943 he painted his most famous works: *Execution in the Country* (1938), *Flight from Etna* (1938–9) and *Crucifixion* (1940–1). In 1942, the Vatican condemned *Crucifixion* and threatened those who went to see it with excommunication. *The Discussion* incorporates vaguely Cubist elements (collage, a restricted palette of greys and ochres, passages of fragmented composition), but at heart it retains traditional figurative concerns. Guttuso's work is of art historical interest in that it crystallises some of twentieth-century Social Realist painting's basic problems: looking directly back to mid-nineteenth-century Realism, it attempts to use figurative painting to reflect and illustrate lived political realities, at a time when the 'politics of representation' – the testing-out of the theories and values implicit in art-making itself – had become avant-garde artists' central concern.

The Discussion 1959–60, oil on canvas 220 x 248 cm

RICHARD HAMILTON (b.Great Britain 1922) At the forefront of British Pop art in the 1950s, Hamilton's work has consistently drawn on mass-media imagery and the artefacts of consumer society. For Hamilton, the impact on art of mass culture was not only unavoidable, but something to be celebrated. In 1956, in collaboration with other members of the Independent Group, Hamilton organised the pioneering group show *This is Tomorrow* at the Whitechapel Art Gallery in London. Hamilton contributed his now widely familiar collage of a household interior, *Just what is it that makes today's homes so different, so appealing?* Assembled from magazine adverts for consumer products, cartoon strips, a photo of a health and fitness muscle-man and a soft-porn model, it is a dense, jumbled up parody of domestic bliss and the so-called American Dream.

Since the 1950s, as Hamilton's work progressed, he has kept up with the latest developments in media technology, employing them interdependently with the more traditional processes of painting, collage and lithography. This changing fusion of media is manifest across *The citizen*, *The subject* and *The state,* works produced over a twelve-year period between 1981 and 1993 which relate to the different sides of the sectarian struggle in Northern Ireland.

The first of these pictures, *The citizen,* came about after Hamilton had seen a television documentary about the 'dirty protest' of republican prisoners in the H Blocks. Based on a composite of frames taken from the TV film, the right-hand panel shows a long-haired and long-bearded prisoner in Christ-like pose who, refusing to wear prison clothes, is naked except for his prison blanket. The left-hand panel, consisting of seemingly abstract, brown wavy lines refers to the practice of prisoners smearing their own excrement on their cell walls.

For *The subject,* Hamilton utilised Paintbox, a sophisticated computer programme, in an attempt to replicate electronically the visual feel of its counterpart, *The citizen.* Like *The citizen,* the right-hand panel of *The subject* is a composite image, this time of a parading Orangeman, though in this case a more complex combination of a still from television footage, a black-and-white photo, a colour transparency, as well as a segment of *The citizen* (the cell bars reproduced as a window behind the Orangeman). The left-hand panel is again relatively abstract, and shows the lights and hazy night-time outline of an armoured vehicle in a bomb-damaged street.

The state, the third in the series, is of a British soldier, the party caught in the middle of the conflict, and it is unclear whether the soldier is walking forwards, or backwards in retreat. Here, Hamilton has painted directly onto a colour photograph and has included actual camouflage material.

Though most commonly associated with Pop art, Hamilton has also pursued a lasting relationship with the work of Marcel Duchamp, going so far as to remake in exact detail one of Duchamp's most celebrated works *The Large Glass* (see p.149). Although Hamilton's art has enthusiastically explored the imagery of contemporary culture, his work can still be categorised within the main pictorial genres, such as landscapes, interiors and portraiture, Hamilton himself maintaining he is, to a large extent, a highly traditional artist.

The subject 1988–90, acrylic on canvas 238 x 235 cm

The state 1993, oil, enamel and mixed media on cibachrome on canvas 242 x 235 cm

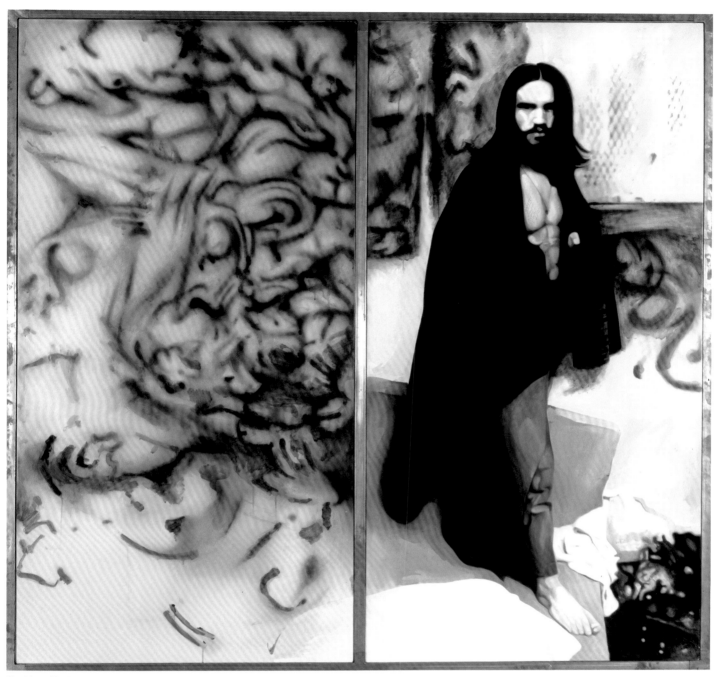

The citizen 1981–3, oil on canvas, two panels 200 x 100.9, 200 x 100 cm

MONA HATOUM (b.Beirut 1952) In 1975 Hatoum was on a visit to Britain when civil war broke out in the Lebanon. Unable to return, she settled in London, where she continues to live and work. Hatoum became known in the early 1980s for a series of remarkable live performance pieces. These were often extremely physically demanding and focused on themes of violence, oppression, voyeurism, and the resilience as well as vulnerability of the human body. From the late 1980s she continued to explore these themes in sculpture, installation and video.

Incommunicado exemplifies a number of central aspects of her work: the transformation of real objects into powerful metaphors; the expression of disturbing subject matter within structures of considerable formal purity; and the presentation of empty spaces which nevertheless imply a human presence, or absence. *Incommunicado* is based on a commercially available child's hospital cot, of a kind commonly supplied to third world countries. The artist removed the base bars and replaced them with tightly strung wires, which are in fact guitar strings. The cot, with its metal construction, barred sides and institutional character was already a forbidding object; the taut wires, suggesting some kind of cutting device, tip it over into something sinister. It should be a place of comfort and healing, yet becomes something quite other. Its bareness and threat tragically evoke an absent occupant.

Incommunicado 1993, metal cot and wire 126.4 x 57.5 x 93.5 cm

BARBARA HEPWORTH (b.Great Britain 1903–1975) 'The sculptor carves because he must' Hepworth stated, expressing the physical need and moral prerogative underlying her work. Form emerged from a reconciliation of the preconceived idea and the experience of cutting the stone or wood. This helps to explain her early departures from naturalism in 1929–32, but also her limited use of pure geometry in the abstract works that precede a return to natural forms.

Hepworth's shift to abstract form in 1935 was long heralded, and paralleled developments by colleagues in Hampstead such as Henry Moore (see p.202) and Ben Nicholson (her future husband). *Three Forms* established a new independence. The positioning of the elements is crucial: the sphere implies mobility away from the larger anchoring forms. Yet they are linked proportionally in size and in the interval between them. The carving demonstrates Hepworth's craft sensibility and her long-term concern with organic form. The white marble embodies the sense of clarity to which Hepworth and her colleagues aspired at the moment when they introduced international 'constructive art' (embracing differing aspects of Constructivism) to Britain in 1935–6. Their harmonious works were proposed as anticipations of social renewal and were based in a utopian view of progress shared with scientists and planners and promoted in the publication *Circle: International Survey of Constructive Art* (1937). Although the Second World War stunted these ambitions, Hepworth remained committed to an art which was both abstract and socially motivated. As the dominant sculptor in St Ives from 1939, she saw its artistic community as a microcosm of culture's role in the world. This ideal of communication was acknowledged in her international reputation and embodied in her *Single Form* (1961–4) made for the United Nations building in New York.

Three Forms 1935, Serravezza marble 20 x 53.3 x 34.3 cm

EVA HESSE (b.Germany 1936–1970) Hesse is associated with the American avant-garde art of the 1960s. Although trained as a painter she is best known for her drawings and three-dimensional work made between 1965 and 1970. She was associated with New York Minimalism, in part because of the use in her work of repetition and unconventional, non-artistic materials. In other respects Hesse's is quite independent of the work being made at the time by her male counterparts. Many of her three-dimensional works are wall-based and carry strong references to the rectangular format of painting. But typically, and literally, these works go beyond painting. Hesse employed a wide variety of everyday materials which were often attached to a flat rectangular surface in such a way that they hung or dangled or fell to the floor. In particular it was in her use of non-rigid, flexible materials – such as rope, rubber tubing or latex – that Hesse moved away from Minimalism. It also led her and other artists towards an art which, while remaining emphatically abstract, made strong references to the human body. *Addendum* is made from painted papier-mâché, wood and rubber tubing. It is characteristic of her work of the period in that a rigid rectangular structure is used to support a number of free-hanging cords which intertwine as they come to rest on the floor. The space between each of the hemispheres is increased by half an inch as it progresses from left to right. For Hesse, *Addendum* contained a dynamic and unstable opposition, a 'contradiction of the rational series of semi-spheres and irrational flow of lines on the floor.' In an interview made after her death, Hesse's contemporary Carl Andre said of her legacy: 'Perhaps I am the bones and the body of sculpture, and perhaps Richard Serra is the muscle, but Eva Hesse is the brain and the nervous system extending far into the future.'

Addendum 1967, painted papier mâché, wood and cord 12.4 x 302.9 x 20.6 cm

SUSAN HILLER (b.USA 1940) Hiller is an American artist who trained as an anthropologist and who has worked in London since 1973. *From the Freud Museum* is the result of an invitation made to her to create a work in Sigmund Freud's last home in Hampstead – a house which contained his own collection of antiquities and which itself has been turned into a museum. In the original installation, Hiller placed a series of objects in open archeological specimen boxes in a vitrine in Freud's old bedroom. Her starting point was 'artless, worthless artefacts and materials … fragments, trivia and reproductions – which seemed to carry an aura of memory', and which triggered off something or which followed through a set of associations for the artist. Each individual box presents the viewer 'with a word (each is titled), a thing or object and an image or text or chart, a representation'. Believing that 'any conscious figuration of objects tells a story', and that each of the boxes made and positioned in the vitrine is part of a process which is 'very dream-like', Hiller, in a typical manner, invites viewers to spend time with the work and make their own connections between each box and the rest of the display. Important questions which arise concern the museum's function as repository, issues of forgetting and remembering, and how the act of collecting itself is connected with ideas of mortality and death. As with other works by Hiller, the project also deals with the dangers of classification (how meaning is never actually fixed but always changes), and reveals her interest in the discarded or ephemeral object and in the Freudian notion of the manifest and hidden content within dreams. The recurrent desire in her work has been to unlock the lost or invisible world of subjective experience.

From the Freud Museum 1991–6, mixed media

DAMIEN HIRST (b.Great Britain 1965) Hirst's art takes on the big themes, such as life, death, love, truth and art itself. Most famously he has displayed, in tanks of formaldehyde, dead animals, both whole and in parts, presenting them as blunt *memento mori*. Other work has used live tropical butterflies, displays of sinister looking surgical instruments, gruesome photos from forensic pathology books, and hordes of flies meeting their death at the bars of electric fly killers.

Modern medicine has also been a recurrent theme, with Hirst seeing it as closely related to art; the great healer, a replacement for God, mind alterer, potential placebo and generally hopeful panacea. *Pharmacy,* with its clean and cool floor-to-ceiling drug cabinet walls, hovers close to a realistic imitation of a chemist's dispensary. At the same time the industrial graphics of the drug packaging, the vitrine presentation, its geometric formalism, suggest a complex, subtle artwork, deliberately evoking the machine aesthetic of Minimalism while remaining conceptually enigmatic. The other components of *Pharmacy* contribute a deliberate theatricality. Some, like the apothecary bottles, are consistent with the subject of the installation, while the fly killer is a recycled quotation from Hirst's other work – a stark reminder of the death we hope to postpone by taking pills.

Maverick entrepreneur, artstar, and celebrity, Hirst is the dominant figure of a generation of British artists emanating originally from Goldsmiths college in London. Hirst has said all his work is collage, and certainly his earliest work owes a close debt to Kurt Schwitters. Francis Bacon, Donald Judd, Bruce Nauman and Jeff Koons would also feature among his precursors, as would Andy Warhol for his production line methods.

Pharmacy 1992, mixed media

Forms Without Life 1991, MDF cabinet, melamine, wood, steel, glass and sea shells 183 x 274.6 x 30.7 cm

DAVID HOCKNEY (b.Great Britain 1937) From his early 1960s college days in London to the present, Hockney's art has proved to be enduringly popular. Though his work does incorporate abstract gestures, as well as illusionistic devices, cut-out imagery, typography and the appearance of different styles of painting on a single canvas, Hockney has always favoured figurative description over pure abstraction. It is this continuation of the figurative tradition, along with his wonderful draughtsmanship, and an avowed intention to make an accessible, pleasurable kind of art, which has ensured his widespread success.

In 1964, in search of a different, lighter, more open vista, Hockney arrived in Los Angeles. It was a fruitful move, producing some of his most memorable paintings. The bright fresco colours, the pink-walled houses and palm-festooned gardens, the private blue-lagoons of swimming pools, and a ready supply of young male models, provided exactly the kind of visual material Hockney was looking for. Nowhere is this world better idealised than in *A Bigger Splash*. Large-scaled, dream-like, soaked in glorious sunshine acrylics, the illusionistic white splashes and spurts of water combine together to evoke a picture-perfect paradise.

Hockney's curiosity and experimentation have kept him on a unending trail of artistic discovery, making it difficult to place him in any single art movement. Though painting and drawing remain his most recognisable media, alongside his innovative photo-collages, he has also created stage designs, worked with fax and photocopying machines, and wide-ranging printing techniques. Often linked to early British Pop art, Hockney has perhaps more in common with American figurative painters like Edward Hopper, Alex Katz and Eric Fischl.

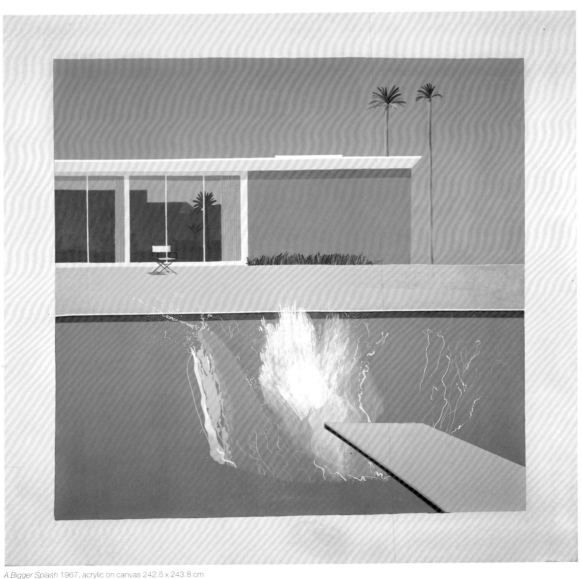

A Bigger Splash 1967, acrylic on canvas 242.6 x 243.8 cm

JENNY HOLZER (b.USA 1950) *Truisms* (1977–9) was Holzer's first series of public text works. With it she intended to 'make big issues in culture intelligible as public art'. Initially produced as a series of wall posters pasted anonymously around New York, *Truisms* consists of a collection of one sentence clichés commenting on life or the manner in which it could or should be led. Phrases such as 'FREEDOM IS A LUXURY NOT A NECESSITY' or 'GIVING FREE REIN TO YOUR EMOTIONS IS AN HONEST WAY TO LIVE' have a neutral tone without any identifying authorial characteristics; it is as if they have always existed.

Since *Truisms* she has made about ten groups of work each addressing aspects of sex, war and death. Holzer here adopts Conceptual art's substitution of the object by text, but also uses language in her work to question the possession and deployment of language in society. Holzer's anonymous and frequently contradictory voice throws the onus of responsibility for its reading onto the viewer as a way of provoking public discussion. Her work is also concerned with distribution and naturally inhabits the landscape of urban signage. In 1982 she first used the spectacolour billboard in New York's Times Square to broadcast her *Truisms,* and has subsequently used electronic signs for gallery work (such as the Tate's 1984 example of *Truisms*) as well as for public work. *Truisms* has also been realised in the form of signs on taxis, inscriptions on granite benches, television and radio broadcasts, patches on baseball caps, T-shirts, cash register receipts, a dance work and a website (http://adaweb.com/cgi-bin/jfsjr/truism).

Truisms 1984, metal, plastic and electronic components 16.9 x 153.9 x 16.2 cm

REBECCA HORN (b.Germany 1944) Gallery visitors unaware of the workings of Horn's *Concert For Anarchy* are guaranteed a great surprise when they first witness the piece in action. An ornate concert-grand piano hanging inverted from steel cables, *Concert for Anarchy* periodically performs an explosive high-wire act: the lid crashes open, and the separate keys shoot forth, protruding from the body of the instrument at crazy angles. Gradually, the piano reassembles itself, its keys withdraw, and it once again hangs silent, in wait for the unwary.

Horn's gleeful misuse of a grand piano might possibly be read as a subversive gesture toward the German high Romantic tradition and the grandiose myths often attached to artists such as Beethoven or Brahms. However, the word 'anarchy' in the title is arguably more a 'style statement' than a declaration of hard-nosed political intent. Horn's approach to art-making is highly subjective, and her pieces revel in elegant effects and a flamboyant, often decadent, theatricality. They display a well-defined personal repertoire of devices and approaches: most notably, a nostalgic fascination with obsolescence. Horn frequently uses electrical mechanisms to bring to erratic, quirky life such things as antique typewriters, battered suitcases, opera glasses, or ostrich-feather fans. She also borrows 'antique' imagery from the Surrealists and their associates, drawing on Duchamp (see p.148) and Picabia's eroticised machine diagrams of the 1910s and 1920s, and the sado-masochistic corsets and bizarre arterial apparatuses painted by Frida Kahlo. Many of Horn's pieces echo Surrealism's association of eroticism with pain or danger, or have a quasi-fetishistic character, but unlike the Surrealists, she does not claim a Freudian basis for her practice. *Concert for Anarchy* could also be understood as a quotation – this time, from her compatriot Joseph Beuys (see p.126), whose 1985 installation *Plight* featured a grand piano confined within a womb-like, felt-insulated chamber. While *Plight* was heavily freighted with references to Beuys's idiosyncratic socio-political world-views, Horn's piano seems a thrilling *jeu d'esprit*.

If there is a disturbing dimension to *Concert for Anarchy*, it maybe lies in the piece's predictability rather than its 'anarchy'. Lurching through its incurable cycle of collapse and reassembly, the piece recalls a recurrent symptom or compulsively repeated action. As a young woman, Horn was hospitalised for many months due to lung poisoning, a fact that has often been cited to explain her use of medical equipment such as hospital beds, or disabled people's tools, such as wheelchairs and white canes. Works made during and after her period of convalescence in the 1970s often featured prosthetic devices that both extended and restricted the wearer's body. She subsequently produced a feature-length film (*Buster's Bedroom*, 1990) set in a sanatorium, and in 1986 constructed the piece *Ballet of the Woodpeckers* for a hall within a psychiatric institution in Vienna. It provided a setting where, for the first time in the institution's history, patients and visitors could mingle together. The piece's mirrors generate vistas stretching to infinity, and tiny silver hammers tap against their surfaces, like birds cautiously exploring their reflections – maybe a metaphor for the tentative, precarious interactions with the outside world Horn envisaged taking place in the installation's original site.

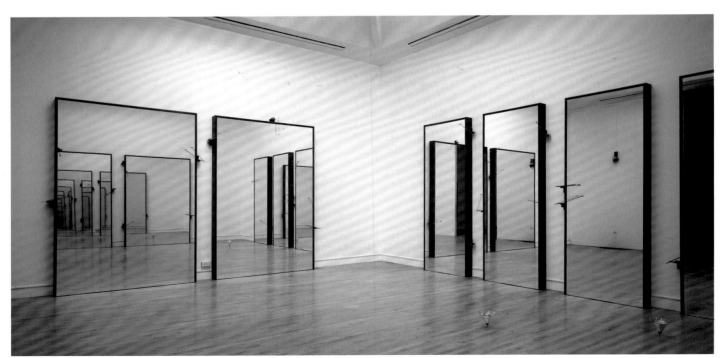

Above: *Ballet of the Woodpeckers* 1986, mixed media Right: *Concert for Anarchy* 1990, painted wood, metal and electronic components 150 x 106 x 155.5 cm

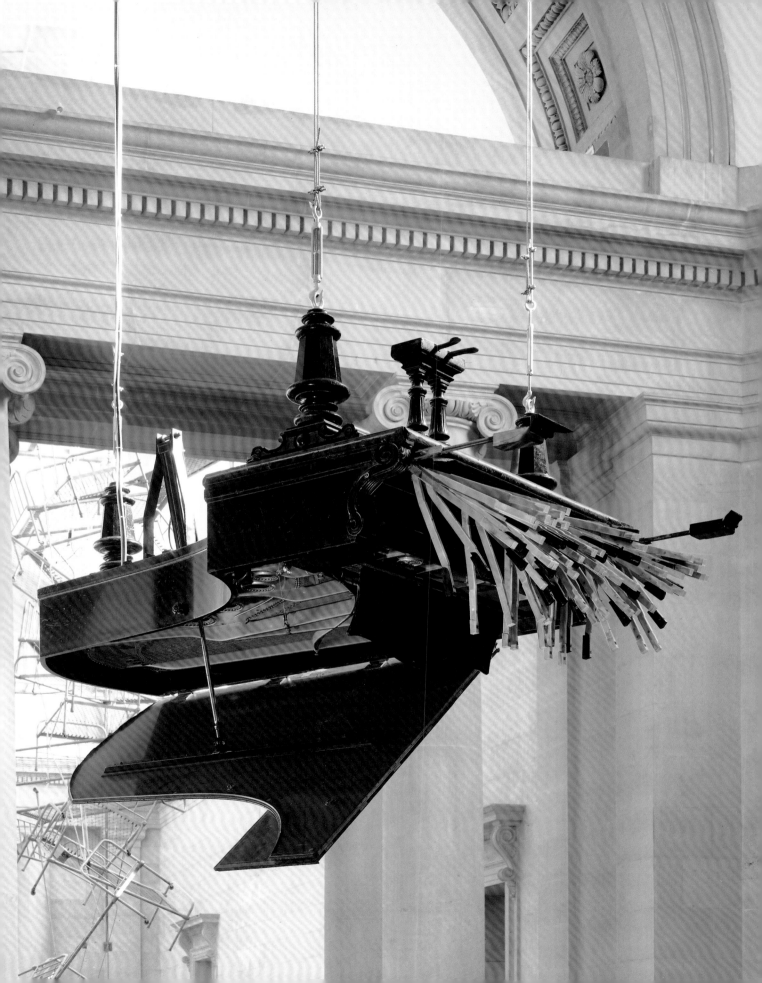

GWEN JOHN (b.Great Britain 1876–1939) John spent her formative years travelling between London and France. Towards the end of the nineteenth century, she studied at the Slade School of Art in London where she learnt a sober, tempered kind of Impressionism based on solid drawing technique; later she studied under Whistler in Paris.

In 1907 she settled down to relative isolation in a Paris suburb, preferring the company of nuns at the local convent to the cafés and night-time haunts normally frequented by artists. Appropriate then that John's subject matter is almost exclusively restricted to portraits of solitary women, who most often appear in an interior. Perhaps seated with hands clasped, or standing by a window gazing out, they express quiet reticence and a sense of withdrawal from the world. *Nude Girl*, a three-quarter length portrait of a female acquaintance, is one of the artist's more sombre paintings. Built up of small,

controlled brushstrokes, it is as restrained in mood as the typically repressed, muted colours of John's palette. Her other favoured subjects were cats, orphan children and nuns, often repeating one subject with the minutest of variation.

The fact that John reluctantly showed or sold her paintings, and rarely signed or dated them, ensured that the present recognition for her work did not happen in her lifetime. For a brief while she maintained links to the New English Art Club in London (an alternative to the conservative Royal Academy) which was made up of former Slade students, including her more famous, flamboyant brother, Augustus John. But otherwise Gwen John remained aloof from any art movement or group, and followed her own path with single-minded purpose.

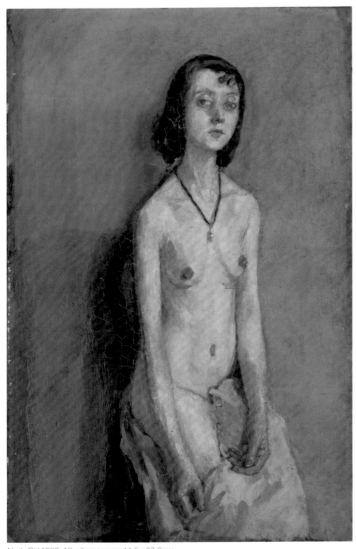

Nude Girl 1909–10, oil on canvas 44.5 x 27.9 cm

JASPER JOHNS (b.USA 1930) Johns began to exhibit in New York in the mid-1950s. Together with Robert Rauschenberg, his work was credited with showing a way beyond the abstraction and expressionism of an earlier generation of New York painters. In introducing everyday imagery and objects, Johns' early work has often been seen as an ironic, if respectful, commentary on the more spontaneous, lyrical improvisations of his predecessors.

Dancers on a Plane appears to continue this process. The canvas surface is covered with a pattern of regular hatchings in oil and acrylic paint. It is divided vertically by a half-visible line, and stencilled lettering runs across the lower edge of the work. The entire canvas is set in a painted bronze frame, the two vertical sides of which are lined with knives, forks and spoons. The painting appears dense and cryptic like a puzzle containing a series of clues or false trails. Painted forms, language, and objects are unified pictorially, but their meaning remains unclear. Each of the elements forms part of a vocabulary of motifs that Johns has employed in his works over a number of years, some of which refer to language and abstract symbols, and some of which have a more direct connection with the body. This knowledge fuels the expectation that there might be some private code at work. But at the same time, works such as this might remind us that any work of art can only ever contain fragments of information, and that this information will always remain ambiguous and uncertain. *Dancers on a Plane* suggests, perhaps, that these ambiguities and uncertainties, rather than their resolution, are the subject of Johns' art.

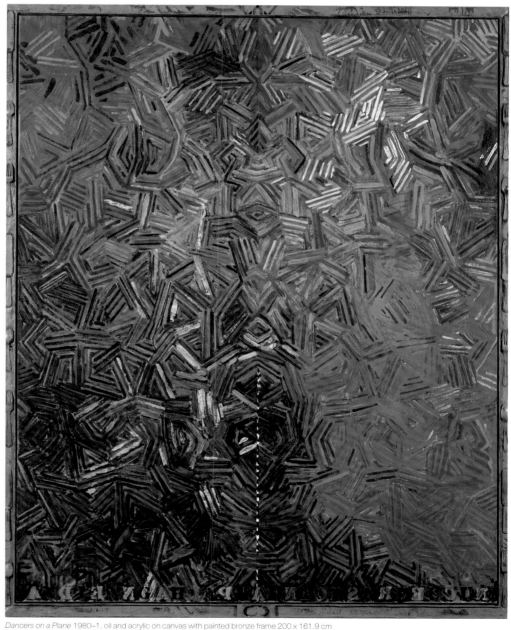

Dancers on a Plane 1980–1, oil and acrylic on canvas with painted bronze frame 200 x 161.9 cm

DONALD JUDD (b.USA 1928–1994) Judd was trained as a painter, but in the early 1960s began to exhibit reliefs and freestanding works assembled from commercially available timber, metals and plastics. By 1965 all his work was made in factories from instructions and diagrams he had supplied. Judd is credited with being a leading figure in New York Minimalism – a term to which he objected strongly. Nevertheless, 'Specific Objects', an essay he wrote in 1965, was seen by many as a manifesto for just such a new movement. It began with the now famous remark: 'Half or more of the best new work in the last few years has been neither painting nor sculpture.' Preferring the term 'three-dimensional work' or just 'objects', Judd listed some forty artists whose work was increasingly defined by literalness in its use of materials and space, and a resistance to any illusion or representation.

Judd's own work remained loyal to these principles throughout his long and productive career. Always 'Untitled' and always abstract, the work can none the less be seen as having as its subject the materials, surfaces and colours of everyday urban and industrial life. *Untitled* (1972) is made in copper, enamel and aluminium. It combines reflective materials and applied colour in direct, simple forms. The open box format is one of the most consistent hallmarks of Judd's work. It enabled the artist to experiment with a wide variety of rigid industrial materials, often in unexpected combinations. At the same time it allowed him to explore planes and spaces and to avoid the heavy monolithic masses of traditional sculpture. Thus, although often made

in substantial sections of steel or copper, the work characteristically appears quite light. Any bulky materials are further qualified by their often shiny, bright or painted surfaces.

Untitled (1980) combines ten identical galvanised steel, aluminium and coloured acrylic units into a single vertical 'stack'. The parts are separated by spaces the same size as the sections themselves, and this again emphasises the lightness of the work. The work is an 'object' in so far as its materials and fittings are never disguised or made to represent something they are not; the work is 'specific' in that it is a combination of one particular metal with one particular coloured plastic. Other 'stacks' made by Judd have exactly the same dimensions but vary in their materials and construction, and thus each different object has a different specific quality.

Untitled (DJ 85-51) is one of a large series of painted aluminium constructions made by Judd in the 1980s. The wall-mounted work is again based on the open box format. In this case each unit is visibly bolted together into a regular, horizontal configuration. The colours are chosen from the industrial colour chart and are spray-painted onto each section before assembly. Judd was keenly interested in colour and its effects throughout his career – a consequence, perhaps, of his training as a painter. He maintained that after Abstract Expressionism, 'colour, to continue, had to occur in space'. That is, he believed that colour, like everything else in art, had to be dealt with as a literal property of objects, not as a means of making an optical illusion or representation.

Untitled 1972, copper, enamel and aluminium 916 x 155.5 x 178.2 cm

Untitled (DJ 85-51) 1985, painted aluminium 30 x 300 x 30 cm

Untitled 1980, steel, aluminium and perspex 22.9 x 101.6 x 78.7 cm

WASSILY KANDINSKY (b.Russia 1866–1944) Kandinsky was one of the first artists to paint an effectively abstract painting. He had a deep, religious-like faith in the power of art, believing it should come from an inner primal force or psychic impulse that he called 'The Principle of Inner Necessity'. For this new, quite mystical way of making art, a very different kind of visual language was needed – non-objective art. There could be no figurative description, or in fact any direct reference to the material world, only improvised abstract shapes and forms, and a free vibrant use of colour.

Partially retaining some representational imagery, *Cossacks* was produced a year before Kandinsky's complete transition to abstract painting. One can loosely make out mounted cossacks in the top left of the picture, a castle, a rainbow and a flock of birds. Otherwise it has the same exuberant use of colour, improvised free forms and dynamic composition of his purely abstract work.

Kandinsky, a relative late-comer to art, was thirty when he left Moscow in 1896 and moved to Munich to become an artist. A cosmopolitan with an international perspective, Kandinsky became involved with numerous avant-garde art groups. In 1913 he formed the Munich based Der Blaue Reiter with Franz Marc, aimed at promoting his brand of art and that of like-minded artists. And in 1922 he travelled to Weimar to join the Bauhaus, the revolutionary art school founded by Walter Gropius. He was also a voluminous writer, publishing art theory books, manifestos, lectures, poems and stage plays, and for several generations of artists his book *On the Spiritual in Art* was essential reading.

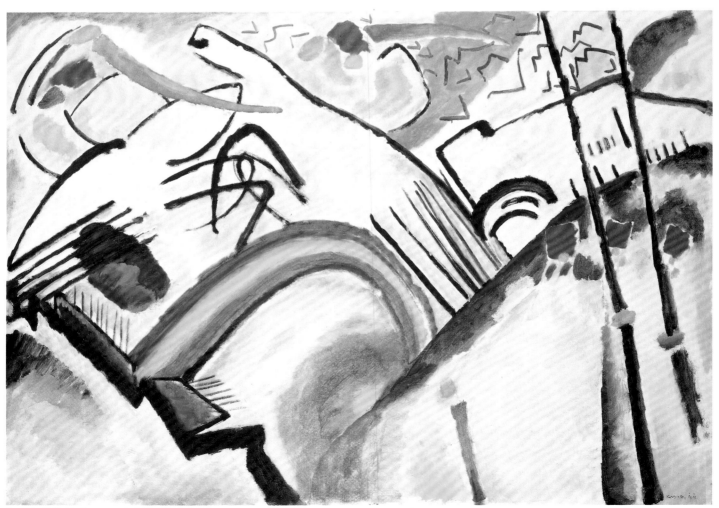

Cossacks 1910–11, oil on canvas 94.6 x 130.2 cm

ANISH KAPOOR (b.India 1954) Associated with a new wave of British sculpture of the 1980s, Kapoor's work crosses the boundaries between objects and paintings. Many of the objects he makes question their own physicality, suggesting a sense of weightlessness which seems to rob the work of its material substance.

Adam is typical of Kapoor's work of the late 1980s in its relation to human scale and to the anthropomorphic connotations of the vertical form. Unlike his earlier, brightly pigmented work, this is one of a series of large, roughly hewn blocks concerned with deep, inner spaces. The viewer peers and is drawn into a voided rectangle which is hollowed out at head height within the solid sandstone. Despite obvious concerns with mass, weight and volume, the void inside the stone renders it weightless, volumeless and ephemeral. While the title refers to the original Judaeo-Christian man, the interior space also opens up readings of tomb or womb, of the black darkness of night, or even of the sky itself.

In *A Wing at the Heart of Things* the opposite occurs metaphorically: earth is contained within and sky without. The blue-painted slate slabs resemble fallen pieces of sky, their very flatness rendering them apparently weightless. The shape of the stones suggests the extensive sweep of an angel's wings – a spiritual association deepened by the allusive deep blue pigment. Yet Kapoor also deploys the non-specific religious symbolism of Mark Rothko (see p.218), Barnett Newman (see p.206) and Yves Klein. In his case, the use of dense pigmentation dematerialises the sculptural forms so that presence and absence are simultaneously suggested. Such a union of opposites exemplifies the sense of 'wholeness' which Kapoor seems to invoke throughout his work.

Adam 1988–9, sandstone and pigment 239 x 120.5 x 104 cm *A Wing at the Heart of Things* 1990, slate and pigment, two parts 28 x 353 x 270, 25 x 295 x 320 cm

MARY KELLY (b.USA 1941) Kelly is a major figure of the Conceptual and feminist art movements. She trained as an artist in London in the late 1960s during the birth of the European women's movement. Initially Kelly made no distinction between art-making and political action: her earliest works were collaborative projects designed to raise awareness about the social, legal and political position of women. She has consistently avoided traditionally 'patriarchal' art, such as painting or sculpture, and has worked instead on sequential projects and series which emphasise process more than product (or art object). Later, influenced by feminist writers such as Juliet Mitchell and Laura Mulvey, Kelly made a significant turn towards psychoanalysis in her work. Her introduction of issues concerning subjectivity and gender difference was a key development within feminist art practice and Conceptual art. Kelly returned to live in America in the mid-1980s.

Post-Partum Document re-addresses a key theme in art history: the maternity. It is a six part work in which Kelly explores her relationship with her son over a period of six years. She describes the work as 'an interplay of voices – the mother's experience, feminist analysis, academic discussion, political debate.' Kelly deliberately creates a sense of distance from the powerfully emotional experience of motherhood by using pseudo-scientific and characteristically masculine strategies such as diagrams, recordings and Latin names.

Experimentum Mentis III: Weaning from the Dyad, the third part of the series, documents the child's first experience of going to a nursery. It consists of thirteen framed panels, three of which are diagrams and ten are typed texts recording conversations between Kelly and her son, overlaid with childish scribbling. Alongside the texts are Kelly's hand-written reflections and reactions which parody the stereotype of the female confessional diary. In this phase of the project Kelly explores a key moment in psychoanalytic theory when the child first breaks away from the 'dyad' or mother-and-child unit.

Post-Partum Document. Analysed Markings And Diary Perspective Schema (Experimentum Mentis III: Weaning from the Dyad) 1975, collage, pencil, crayon, chalk and printed diagrams on paper 28.5 x 36 cm

WILLIAM KENTRIDGE (b.South Africa 1955) Kentridge's films are created from his progressively altered, erased, and re-drawn charcoal drawings. The drawings are filmed using stop-frame animation, and sequenced to produce loosely narrative plots in which dream-like passages are juxtaposed with grim documentary realism. The films relate to the last thirty troubled years of South African history, and Kentridge's attempt to come to terms with his memories of the brutal apartheid era.

The seven film series *Drawings for Projection*, made between 1989 and 1998, follows the intertwined lives of two white South Africans: Soho Eckstein, a typical, pin-stripe suited industrialist, and Felix Teitlebaum, who is more of an isolated, passive observer of events. Partly autobiographical, Soho and Felix are two sides of the same character; they experience the world through almost the same eyes, yet act, think and feel in very different ways to each other. Kentridge allows for abilities in their view-points, and suggests that each is similarly culpable for the horrors of their shared world.

In *History of the Main Complaint*, (from the *Drawings for Projection* series), we see Soho lying in hospital. He is in bed and in a coma, but still wearing his business suit. He seems as if he is perhaps at the end, about to expire. Images of his internal organs are shown on a bedside monitor, interrupted with flashes of Soho's recollections of seeing atrocities being carried out. Yet when Soho awakes at the end of the film, he seems unaffected by all this trauma, and it's back to business as usual.

Kentridge's social critique has much in common with the work of Goya and Hogarth, as well as the vicious satires of Georg Grosz and the caustic realism of Leon Golub. One of the lessons of his work is that although art may not have the power directly to change things, it can still creating lasting images of things we might otherwise prefer to forget.

History of the Main Complaint 1996, animation film

ANSELM KIEFER (b.Germany 1945) Kiefer was one of the few artists of the immediate post-war generation to address recent German history in the context of Germany's rich religious, historical and mythological past. As a result of this, Kiefer's works often refer to sensitive subject matter; an early series of photographs featured himself making the Nazi salute next to famous European monuments. His juxtapositions of past and present suggest extraordinary and complex meditations upon German history.

Parsifal I, II and III are three of four paintings which Kiefer made in 1973 based on the legend of Parsifal (or Perceval), inspired by Wagner's famous last opera of this title. They depict the woodgrained studio at Kiefer's home in the Oden forest. Like an empty stage-set, the attic room acts as a metaphor for the artist's imagination, a *tabula rasa* onto which Kiefer plays out his psychological dramas. The Parsifal legend tells of the pursuit of self-knowl-

edge over earthly temptation. Parsifal is a young and foolish knight (Fal Parsi – 'foolish innocent'), whose destiny is to bring peace to the kingdom of the Grail. To do this he must pass through a series of trials to gain the sacred spear which can heal the mortal wound of Amfortas, the Grail's guardian. These paintings can be seen as representing three stages in Parsifal's life; his birth in *Parsifal I*; his defeat of the wicked knight Ither in *Parsifal II* (see p.85); and his recovery of the sacred spear in *Parsifal III*. The names of the main protagonists are inscribed around the three canvases along with the names, in *Parsifal III*, of the members of the Baader-Meinhof group, a notorious terrorist gang active in 1970s Germany. Kiefer creates a dramatic contrast between the historical and mythological references in the work and the radical politics of a left-wing youth movement.

Parsifal III 1973, oil and blood on paper on canvas 300.7 x 434.5 cm

JANNIS KOUNELLIS (b.Greece 1936) Kounellis has lived in Rome since 1956 where he became associated with the Italian Arte Povera movement. Inspired by political events, his work draws on history with a specific sensitivity and he has developed a personal artistic language to reflect this. As with other Arte Povera artists, his interests also lie in the use of simple, 'impoverished' materials, and in exploring the relations between nature and culture, art and society.

Untitled was originally installed in Rome as the third part of an interconnecting three-room installation. The work extends over two walls and includes a line drawing of an industrial landscape, complete with smoking chimney, a group of charcoal-inscribed drawings on paper, and two stuffed black birds (a jackdaw and a hooded crow) impaled by arrows upon the wall. As is customary for him, Kounellis has reworked earlier images to make this piece. Although the industrial imagery relates to an imaginary nineteenth-

century townscape, it was also used in a 1976 installation in the form of a real brick chimney with smoke smuts on the ceiling. He commented then that 'Smoke creates ghosts and the chimney looks like a castle'. Charcoal, like smoke, is a trace of something that cannot come back into being: a metaphor for passing time and history. Burnt products (such as carbon and charcoal) are common at this point of Kounellis's career, much in the way that live fire featured in his work of the late 1960s and early 1970s. Birds also recur in other works.

The meaning of Kounellis's imagery is seldom clear-cut, but commenting upon his intentions in 1982, the artist suggested: 'I search among fragments (emotional and formal) for the scatterings of history. I search dramatically for unity, although it is unattainable, although it is Utopian, although it is impossible, and for all these reasons, dramatic.'

Untitled 1979, charcoal, paper, arrows and stuffed birds 360 x 500 cm

FERNAND LÉGER (b.France 1881–1955) In 1913, reeling from the impact of Futurist rhetoric about the energy and dynamism of modern life, Fernand Léger wrote: 'Present-day life, more fragmented and faster moving than life in previous eras, has to accept as its means of expression an art of dynamic divisionism.' Léger was already established as one of the Cubist painters but he felt Cubism had become complacent. He wanted an art which was bold, fragmented and jarring – an art in which both form and content reflected the dissonance of the industrial age. This was reflected in his dramatic contrasts of forms and colours which remained a key principle in his work throughout his lifetime.

After the First World War Léger renounced abstraction and turned to realistic subject matter once again: the city, machines, figures and everyday objects. His experience as a soldier in the trenches encouraged him to paint subjects that would be accessible to ordinary people. This interest continued late into his career, and in the 1940s and 1950s he painted a series of pictures depicting the leisure pursuits of the working population, including cycling, picnics and in particular, circuses.

In *The Acrobat and his Partner*, Léger sets up a dramatic interplay between the hard-edged vertical elements, like the ladder, chair and crane, and the rounded, modelled forms of the giant acrobat. For Léger the acrobat was a symbol of the heroism and dynamism of life. He is depicted at the centre of a spiralling vortex, his body curled into a graceful pose expressive of continual motion.

The Acrobat and his Partner 1948, oil on canvas 130.2 x 162.6 cm

SOL LEWITT (b.USA 1928) LeWitt is a New York-based artist whose work is associated with the emergence, in the mid-1960s, of Minimal and Conceptual art. Since that time his work has taken two main forms: three-dimensional 'structures', and site specific 'wall drawings'. Both types of work are usually planned in advance by LeWitt and then executed according to a precise set of instructions by one or more assistants. The work is conceptual in the sense that the artist's concept or idea precedes and is independent of the execution of the work. It is minimal in the sense that it is regular, three-dimensional, and made from light industrial materials by skilled technicians.

Five Open Geometric Structures is typical of the artist's three-dimensional work. Nearly all such work, from 1965 to the present date, has what LeWitt referred to as a 'hard industrial' look; it has no expressive features, a non-crafted appearance, and a flat white painted surface. It is thus a significant departure from the idea of art as something necessarily both autographic and improvised. Nevertheless, the forms are often open rather than closed, and the appearance is of something transparent and clear.

LeWitt's work often explores the relationship between idea and realisation, conception and perception. He has stated that he often won't know what the finished work will look like from his initial description or drawing. A very simple idea may produce extraordinarily complicated results; or a complicated idea may result in something with great visual clarity. The work may thus be seen, in part, as a reflection on the question of authorship, and on the value of ideas and manual skills in art.

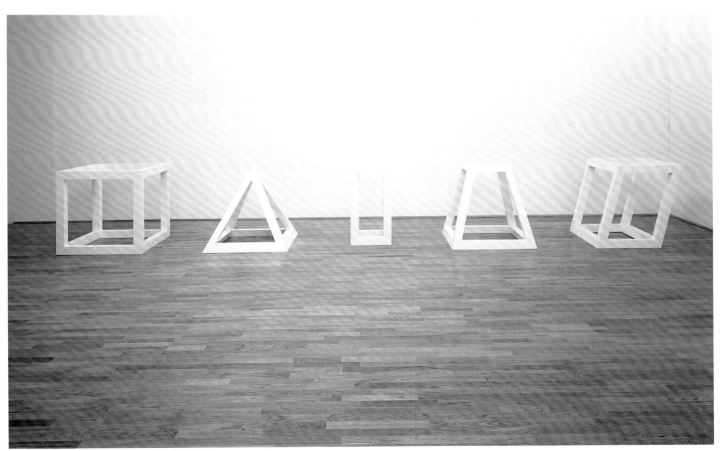

Five Open Geometric Structures 1979, painted wood, five parts 92 x 672 x 91.4 cm

ROY LICHTENSTEIN (b.USA 1923–1997) Lichtenstein became notorious in the early 1960s for a series of paintings based on images taken from comic books. At exactly the same moment a number of other American artists, most notably Andy Warhol and Claes Oldenburg (see pp.229,207), also began to make art that took its sources from popular culture, the urban environment, and the world of the mass media and advertising. There were parallel developments in Britain and Europe and the term Pop art quickly came into use to describe this phenomenon.

In America, Pop can be seen as a reaction to the introspection of Abstract Expressionism which dominated art in the 1950s. Lichtenstein himself commented: 'art has become … unrealistic … it has less and less to do with the world … signs and comic strips are interesting as subject matter. There are certain things that are usable, forceful and vital about commercial art'. Lichtenstein deployed remarkable powers as a draughtsman to redraw and recompose his sources so that they became complex and striking formal structures while fully retaining the essential qualities of the origonal. So much so indeed that Lichtenstein was often accused of simply mechanically copying them.

Lichtenstein's comic paintings consist almost exclusively of images from war comics and love comics, and in spite of his studiedly detached attitude to his subject matter and the apparent lack of comment in the works themselves, these paintings constitute a fascinating, thought provoking and often witty commentary on these areas of perennial human interest. At the same time in other works he explored art itself as a subject, again often with some wit. In a series of paintings and prints he poked fun at the previous generation, the Abstract Expressionists, recreating their lush, highly personal brushstrokes in his detached, flat, graphic style. This work was of course also topical: the particular context of the comic paintings was the new sexual freedom being explored by the teenagers of the wartime baby boom and their concomitant dating rituals, and the mythologising of the Second World War and the Korean War by Hollywood and in novels and comics. *Whaam!* casts a gently ironic look at the simplified heroics of war mythology and it is possibly not a coincidence that it was painted just as another American war, in Vietnam, was breaking out.

Whaam! 1963, acrylic and oil on canvas 172.7 x 406.4 cm

RICHARD LONG (b.Great Britain 1945) Long's artistic practice is based around walking; his sculptures, photographs and text works all relate to this daily universal activity. He sees walking as a process in its own right which emphasises the human relationship to the land. Like the American Land artists, Long wanted to expand the boundaries of art and escape the commercialism of the gallery system by making impermanent works in often remote or inaccessible places. His introduction of the real time and real space of a physical walk into the art work was a radical re-interpretation of the British landscape tradition.

A Line Made by Walking (see p.51) documents Long's first art work based on a walk. Like many of his early walks this took place in his local environment around South-West England. Long repeatedly crossed a field along the same line, slowly treading a visible path into the ground. Since then his walks have developed into epic journeys across deserts, forests and mountain ranges around the world. He often picks up stones, twigs or other natural materials found during his walks, sometimes creating an impromptu sculpture which he documents with photographs, or else brings back to the gallery. *Slate Circle* is made from off-cuts of slate from a quarry that Long passed in mid-Wales in 1977. He often revisits sites of previous walks and this link between a walk and a later sculpture is characteristic of Long's fascination with circularity and the cycles in nature. He says that his work is a 'balance between the patterns of nature and the formalism of human, abstract ideas like lines and circles. It is where my human characteristics meet the natural forces and patterns of the world'.

Slate Circle 1979, slate, diameter 660 cm

RENE MAGRITTE (b.Belgium 1898–1967) Magritte aimed to make the real, everyday world appear unreal or mysterious. He hoped to expose the illogical relationship between what we perceive as being real and the conventions of realism in painting. Often in Magritte's work, the image's lack of obvious rationale is made all the more disturbing by the meticulous manner in which it is painted.

At the beginning of his career Magritte belonged to a group of avant-garde artists and writers in Brussels, and in 1925 he became aware of Surrealism in Paris. In 1927 he moved there, returning to Brussels in 1930, where he lived in a suburban house with his wife for most of the rest of his life.

The Reckless Sleeper is one of a group of paintings executed in Paris with motifs of molten lead and wood planking with a conspicuous grain. Magritte provides a stark image of a sleeping figure with a motley collection of objects sunk into a grey tablet below. The objects are all recurrent images in Magritte's work and here they evoke the Surrealists' fascination with sleep and the activity of the mind when released from conscious control. The slab suggests the outline of a man's head and the embedded objects may be thoughts. The candle and the bowler hat are typical Freudian sexual symbols for male and female, but the meaning of other 'thought images' is more

elusive. Intriguingly, the sleeper is in a coffin-like box and the slab is also reminiscent of a tombstone.

Man with a Newspaper was also made during Magritte's time in Paris. The image is based on an illustration for an ideal stove featured in a popular early twentieth-century health guide. Magritte followed the main lines of the composition but eliminated a number of details and simplified the forms throughout. A sense of mystery is partly created by the lack of detail in the interior and partly by the continuing absence of the man, after the first frame. The repetition of the same image in four compartments, almost identical except for the initial presence of the figure, is suggestive of a film strip. The format also entices us to 'spot the difference' and there is one subtle change which adds to the sense of the inexplicable: the viewpoint in the lower panels is slightly, but distinctly, higher than in the upper two.

Magritte has said that this work, 'like my other paintings, is concerned with the description of a thought which is inspired or poetic as it both resembles forms in the visual world and is able to evoke mystery. The image of a thought does not correspond to philosophy. What I paint contains no idea. I paint something to be seen: "an image in itself" which is the image of a thought "in itself". This thought (like all mystery) defies interpretation.'

The Reckless Sleeper 1928, oil on canvas 115.6 x 81.3 cm

Man with a Newspaper 1928, oil on canvas 115.6 x 81.3 cm

KASIMIR MALEVICH (b.Ukraine 1878–1935) This work was painted by the leading Russian pioneer of abstract art at the time of the famous Petrograd exhibition, *0.10* in 1915–16. It is a superb example of the style named by the artist as Dynamic Suprematism. In the painting, a series of small, variously coloured geometrical elements are positioned in differing relationships both to each other and to a large grey triangle which lies beneath them, asymmetrically placed upon a white ground. With the flatness of the forms and the tilted appearance of some of the surrounding shapes, the individual elements within the painting evoke a floating sensation: some appear to push forwards while others slip back. Informed by a wide array of esoteric thought (including the notion of new consciousness as the fourth dimension), Malevich aimed to express these interests in painting. Believing that our own space is too circumscribed by the 'ring of the horizon' which 'confines the artist and the forms of nature', he sought to achieve a form of cosmic integration by using a language of completely non-objective form and by developing novel spatial relationships which might lead the viewer to a new perception of space. While he considered that a white background was more appropriate than blue for giving 'a true impression of the infinite', the small elements can perhaps be read as myriad satellites leading the voyager to a realm beyond. Malevich was highly influential for a large number of Russian artists in the years surrounding the Russian Revolution, even though his Suprematist style was opposed by the more utilitarian approach of Rodchenko, Tatlin and their followers.

Dynamic Suprematism 1915 or 1916, oil on canvas 80.3 x 80 cm

HENRI MATISSE (b.France 1869–1954) In 1908 Matisse wrote: 'I have colours, a canvas, and I must express myself with purity, even though I do it in the briefest manner by putting down, for instance, four or five spots of colour, or by drawing four or five lines which have plastic expression.' Colour was the prime focus of Matisse's art – decorative in conception and emotionally expressive – his aim being to produce 'an art of balance, of purity and serenity'. Prior to 1908 his style shifted from a structural and formal solidity that owes much to Cézanne, to a Neo-Impressionism in which disembodied colour was the primary expressive medium, and then to paintings where strong undiluted colour was applied in an expressive manner – his so-called Fauve works. Throughout his career Matisse swung between flat colour and schematic, often arabesque drawing, and modelled form. Yet his terms of reference remained constant: the strength of his emotional impulse as an artist and his singleminded use of colour and line.

Standing Nude dates from his period of unrestrained Fauvist experimentation. Fauvism was a term coined by critics to describe the style in which Matisse, André Derain, Henri Manguin and Maurice Vlaminck painted. Colour, predominantly bright reds and greens, was used for its own effect and not in a descriptive way. However, where the paint handling of Standing Nude is distinctly Fauvist in its freedom, the work's colour is not. This monumental figure refers instead to the example of Michelangelo and Cézanne, as well as to Matisse's own investigations of structured form through sculpture, for example in the series of four sculptures of a woman's back that occupied him between 1908 and 1931 (see p.101). Larger than life size, these reliefs show the back of a woman as if drawn out of a slab of metal. The 'Backs' become successively simplified – the last version, of 1931, shows the back split by the positive form of hair running down the spine, against the negative space between the figure's legs.

If Matisse's painting is understood as a dialogue between colour and the structuring possibilities of line, his final series of works, the 'gouaches découpées' or cut gouaches, stand as a fitting summation of his artistic intentions. The Snail, one of the last and greatest of these works, consists of coarsely cut rectangles of coloured paper arranged roughly in the spiral shape of a snail's shell, and relies for its formal rhythm solely on the interaction of colour that expands the representation of a modest snail's shell to monumental scale. Matisse wrote that 'cutting into living colour reminds me of the sculptor's direct carving' and the cut gouaches embodied for him the final expressive possibilities of pure colour and line.

Standing Nude 1907, oil on canvas 92.1 x 64.8 cm

The Snail 1953, gouache on paper, cut and pasted on paper mounted on canvas 286.4 x 287 cm

STEVE MCQUEEN (b.Great Britain 1969) Unlike the work of his contemporaries who use film and video – Sam Taylor-Wood or Gillian Wearing (see p.230) for instance – the filmwork of McQueen is austere. His films are usually silent and black and white (although he has recently used colour and ambient sound). They do not describe a clear narrative or conventional plot, and are allusive rather than strident in tone and subject matter. *Bear*, McQueen's first installation film, was also the first of a loose trilogy of films which all portray relationships: in *Bear* between two naked black men (one of whom is the artist); in *Five Easy Pieces* (1995) between a woman tightrope walker and a group of men hula-hooping beneath her; and in *Stage* (1996) between a black man and a white woman. Although often interpreted in terms of race and gender politics, their subject fundamentally springs from the medium of film itself – McQueen draws heavily on the language of commercial cinema, experimental film and the work of conceptual artists who have used film, such as Bruce Nauman (see p.205). *Bear* utilises a catalogue of low camera angles and close-ups to convey the movement of the two actors' bodies through space. Their movement is ambiguous, as confrontation changes to embrace, a dance changes into a fight and back again, laughter is replaced by tension. It is a film caught in the middle of a narrative, there being no origin or resolution to the confrontation. McQueen has said about his work that 'cinema is a narrative form and by putting the camera at a different angle – on the ceiling or under a glass table – we are questioning that narrative as well as the way we are looking at things.'

Bear 1993, video

MARIO MERZ (b.Italy 1925) Merz made his earliest drawings and paintings in Italy in the immediate post-war period, following a period of imprisonment for holding anti-fascist views. By the mid-1960s Merz had moved away from painting to explore process and Conceptual art, and was one of the artists who became part of the Arte Povera movement. The anti-elitist sentiment of this group, and their sense of social responsibility led them to explore materials previously thought unsuitable for art as a protest against Western industrialisation and consumer culture. *Cone* (c.1967), fabricated according to the ancient craft of basket weaving, is representative of this use of apparently humble materials and techniques to disrupt the status of art as a commodity. In reply to the student and worker demonstrations in France and Italy in 1968, Merz made the first of his igloos, which carried slogans linking them directly with the utopian ideals of the protestors. By 1970, Merz had become fascinated with the Fibonacci formula, a numerical sequence of progression in which each number is the sum of the two preceding ones (1, 1, 2, 3, 5, 8, 13, etc). The sequence is infinite, and it describes the growth pattern of certain organic structures, such as leaves, which Merz has featured in his work. It can also be applied to architecture. Thus Merz has said that 'The igloo is the ideal organic form.' The igloo is also equated in Merz's philosophy with ancient nomadic cultures that utilise basic structures like tents, sheds and huts. *Do We Turn Round inside Houses, or Is It Houses which Turn around Us?* addresses the theme of shelter and the relation of humans to their environment.

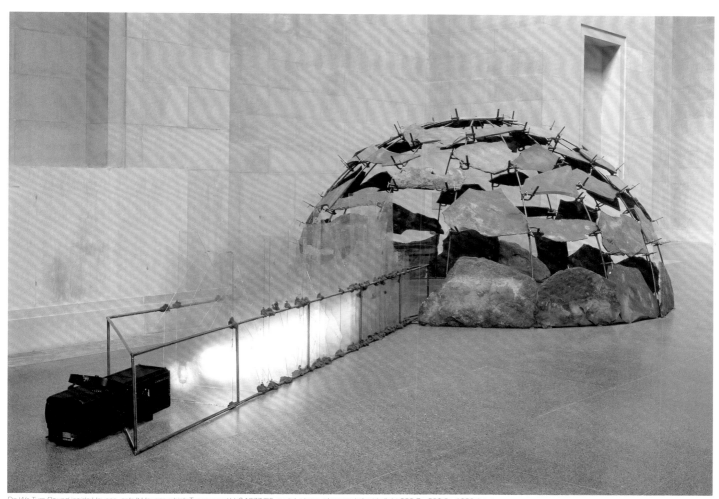

Do We Turn Round inside Houses, or Is It Houses which Turn around Us? 1977/85, metal, stone, glass and electric light 266.7 x 500.3 x 1026.1 cm

JOAN MIRÓ (b.Spain 1893–1983) *Head of a Catalan Peasant* was painted in Paris at a time when Miró was absorbed by Surrealist ideas such as automatic drawing and the use of chance and dream imagery. Consistent with this, he described his practice of staring at the studio wall until he detected a pattern in the uneven and stained surface: 'in 1925, I was drawing almost entirely from hallucinations … I would sit for long periods looking at the bare walls of my studio trying to capture these shapes on paper.' Miró's series of four Catalan peasant heads, all dating from the years 1924–25, while reflecting his preoccupations and practice of the time, can be considered an expression of nationalist sentiment related to the suppression of Catalan identity – specifically the language – that was then taking place. The paintings may also be displaced self-portraits, embodying Miró's desire to be seen as an 'international Catalan'.

A system of signs is used to define the peasant's head; these include the red Catalan *barratina* or cap, the schematically rendered beard, and the eyes from which lines of vision emanate. A grid maps out the face, connecting the features and defining the surface of the canvas. The blue ground oscillates between the appearance of abstract flatness, and of an infinite expanse. The emblematic face floats in the emptied-out void of the sky, with only the clouds in the top right corner otherwise occupying the space. The left eye is rendered slightly smaller than the right, an ironic use of a painterly device suggesting distance which adds to this fluctuation between flatness and depth. Above all, this effect is achieved through the application of paint onto an absorbent white surface, so that the colour appears dry and chalky, like a fresco.

Head of a Catalan Peasant 1925, oil on canvas 92.4 x 73 cm

AMEDEO MODIGLIANI (b.Italy 1884–1920) Modigliani arrived in Paris in 1906, then the indisputable centre of modern art and a veritable laboratory of artistic experimentation. He found himself at the heart of the international avant-garde and a member of the Societé des Independents. Caught up in a search for an artistic style of his own, his early paintings show the obvious influence of other artists, ranging from Cézanne, to Seurat and Toulouse-Lautrec.

The decisive turning point came in 1909, when Modigliani decided to take up sculpture, and went to work under Romanian émigré Constantin Brancusi (see p.132). During that time he developed his now highly recognisable style of portraying the human body, especially the female face. He concentrated mainly on sculpting heads, finding inspiration in the tribal masks of Africa and Oceania, and in the classical purity of Greek and Roman statues. The linear simplicity and interlocking, elliptical planes of *Head*, and its irresistible mixture of sacredness and sensuality, make it a perfectly resolved example of Modigliani's work from this sculptural period.

Ill health and lack of money forced Modigliani to give up sculpture after only three years. On returning to painting he took with him the discoveries he had made in sculpture, translating them directly into his painted portraits and nude figures.

Already painting intensely by the age of fifteen, Modigliani had a passion for art and life, and later alcohol and drugs. He lived a high octane bohemian lifestyle, and his models were often his lovers and artist friends. Sadly, whatever sense of tranquillity and repose we find in his art was never matched in his personal life, and he died from what was described as tubercular meningitis aged only thirty-six.

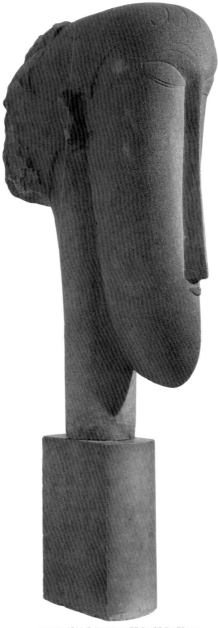

Head c.1911-2, limestone 63.5 x 12.5 x 35 cm

PIET MONDRIAN (b.The Netherlands 1872–1944) Mondrian was a major originator of abstract art and a founding member of the Dutch De Stijl movement which espoused the principles of geometric abstraction in art and design. Having studied at the Rijksakademie in Rotterdam, he spent much of his career working abroad, including Paris, London and New York. He became best known for his uncompromisingly flat, geometric paintings which, with their bold black lines and use of primary colours, reflect his search for a universal order, purity and beauty behind the changing world of appearances. Mondrian was fascinated by the relationship between verticals and horizontals found in the landscape: between the uprights of trees and buildings and the perpendicular axis of the earth and sea.

These three paintings reveal important and gradual stages in Mondrian's development. *Sun, Church in Zeeland* comes from the period 1908–11 when he was working on a number of Dutch motifs – dune landscapes of the North Sea coast, trees and towers. Whereas Mondrian normally painted in series at this point, this is one of only two paintings he made of this particular church. The bright, unmixed colours and the bold and expressive handling recall the work of van Gogh, the Divisionists and the Fauves. Yet the strong vertical and central thrust of the church (which is shown cut off at the top of the painting before the roof begins) already reveals Mondrian's interest in axiality, echoed in the horizontal and vertical dabs of paint which unify the structure of the church facade and knit together the surface of the painting. The sheer intensity of the contrasting colours suggests the spiritual, other-

worldly quality which Mondrian was already striving for at this time.

In *Tree* (which comes from a series of individual studies stretching over a period of time) the brilliant Fauvist hues of some of his earlier compositions are exchanged for a more linear approach. By now, Mondrian was living in Paris, and was acquainted with Picasso's work at first hand. In common with the Cubists, he subdued his colour range and focused on structure. However, the remarkable flatness of his style and the originality of his approach was already suggesting a different form of Cubism. In this painting, a series of mostly vertical black lines play a major role in defining the motif, while the horizontals are mainly constituted by individual strokes of paint.

In *Composition with Grey, Red, Yellow and Blue* Mondrian's interest in colour and line are brought together. Any representational reference has disappeared as he strives to express relationships, rather than objects, in the work. The painting is structured through the use of verticals and horizontals in grid-like formation, and colour is reduced to the three primaries plus two non-colours, black and grey. Believing by now that 'a balanced relation can exist with discords', he achieves here a dynamic set of relationships through an asymmetrical arrangement. By extending squares into rectangles and varying their dimensions across the picture plane, a fluctuating tension is created. In this way, *Composition* points to the more open, white expanses and black lattices of Mondrian's paintings of the later 1920s and 1930s, and marks his transition from abstracting from nature to taking inspiration from the rationalising grids of the modern city.

Sun, Church in Zeeland 1910, oil on canvas 88.9 x 61 cm

Tree c.1913, oil on canvas 100.3 x 67.3 cm

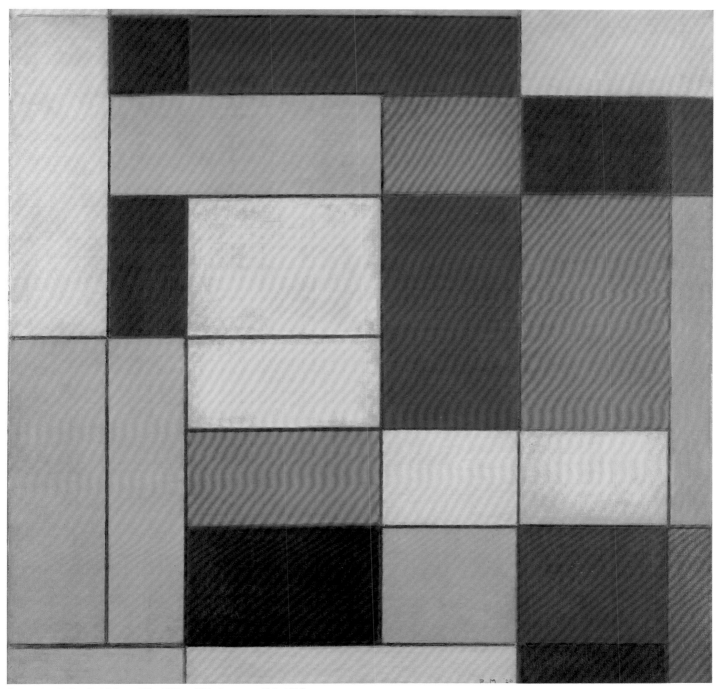

Composition with Grey, Red, Yellow and Blue 1920 – c.1926, oil on canvas 99.7 x 100.3 cm

HENRY MOORE (b. Great Britain 1898–1986) Moore was the dominant British sculptor of the mid-twentieth century. His early reputation rested on the perceived purity of carving (in contrast to modelling, with its potential revisions), and his modification of realism by means of reference to cultures outside the European mainstream. Moore studied and taught at the Royal College of Art in London in the 1920s, and was associated with most inter-war artistic developments from Constructive art to Surrealism. Even abstracted works, such as *Composition* (1932) in African wonderstone (Tate Collection), reflected his favoured concern with the female form. This tendency is epitomised by *Recumbent Figure*, commissioned by the modernist architect Serge Chermayeff. The work was sited outdoors so that an equation between the female body and the land was emphasised. The slightly rough surface of the Hornton stone is retained, while the form is subjected to Moore's characteristic erosion and reconfiguration.

During the Second World War his officially commissioned drawings of the London air-raid shelters made Moore a household name. The grandeur invested in the individual figures expressed a sense of resilience in the national consciousness. His *Madonna and Child* (1943) for St Matthew's church, Northampton, reflected this reassurance, but a glimpse of the anxieties of the post-war period is suggested by the skeletal *Reclining Figure* (see p.103) in burnished plaster. Nevertheless, Moore found himself in inter-national demand for monuments to reconstruction, as his recumbent figures were understood as suitably humanist. His public projects maintained a sense of progressive formal experimentation and implicitly championed the individualism of western democracy. Moore's enormous productivity in stone and bronze was facilitated by teams of assistants at his studios in rural Hertfordshire.

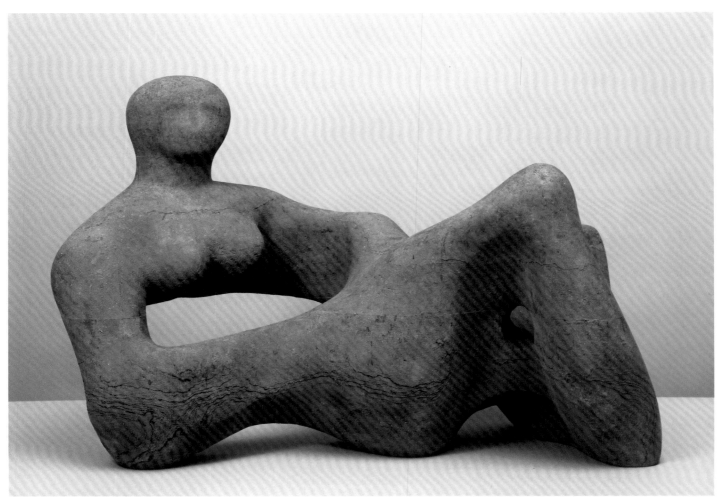

Recumbent Figure 1938, green Hornton stone 88.9 × 132.7 × 73.7 cm

ROBERT MORRIS (b.USA 1931) This four-part, floor-based work was first made by the American artist Morris in 1965. Morris had made simple, geometric, three-dimensional objects as props for a series of dance performances in the late 1950s. His use of commercial materials (in this case mirrored glass), regular geometric forms and industrial fabrication techniques, links his work with the Minimal art that was then emerging in New York. In one of a number of highly influential essays written by the artist between 1965 and 1969, and collectively titled *Notes on Sculpture*, Morris stated that work such as his 'takes relationships out of the work and makes them a function of space, light, and the viewer's field of vision'. That is to say, for Morris the conditions under which the work is viewed are a part of the work; the work does not have an existence separate from these contingencies. Around this time, the use of reflective surfaces became fairly widespread in the work of artists who were keen both to exploit newer commercial and industrial materials, and to get away from the more traditional finishes associated with fine art. For Morris, however, the use of mirrored glass meant that the pure geometric form was constantly interrupted by the reflections of its gallery setting, the viewers, and the other reflective cubes. In this it is literally impossible to see the work independently of the space, light, and the viewers' field of vision.

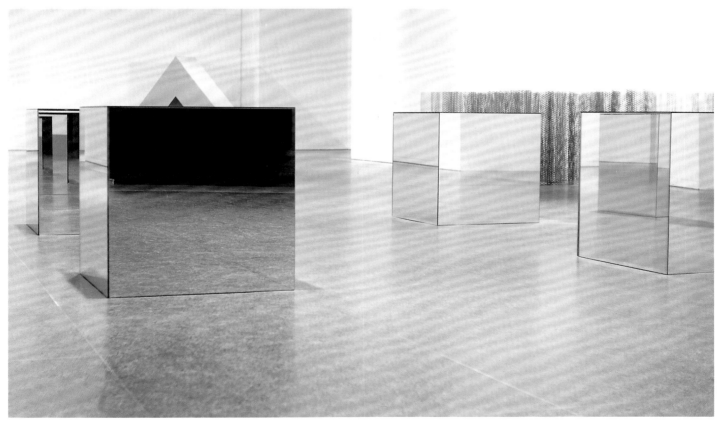

Untitled 1965/71, mirror plate glass and wood 91.4 x 91.4 x 91.4 cm

EDVARD MUNCH (b.Norway 1863–1944) 'No longer should you paint interiors with men reading and women sitting. There must be living beings who breathe and feel and love and suffer'. With these words Munch in 1889 defined the difference between the art he proposed and that of the Impressionists. Not only was Munch's subject matter to be radically different from the reassuring world of the Impressionists; his use of colour was artificial, emotional and expressive, rather than simply a response to nature. In *The Sick Child* the theme is expressed through the predominant, literally sickly green, set off by touches of hot red. The child's face burns from within with the feverish pallor of the tuberculosis victim. The grief of the woman at the bedside is conveyed by her overall silhouette and the deep blue-black of her clothes and hair.

The origins of the picture lie in the death of Munch's sister in 1877 from that then common and deadly disease. Its immediate trigger however came in 1885 when Munch accompanied his father, who was a doctor, on a visit to a boy who had broken his leg. The artist was struck by the boy's anguished sister sitting in the room, and asked her to pose for the child in the painting.

Munch painted six versions of *The Sick Child* and it marks one of the starting points of that major current in modern art known as Expressionism, in which form and colour are stylised or distorted for emotional effect.

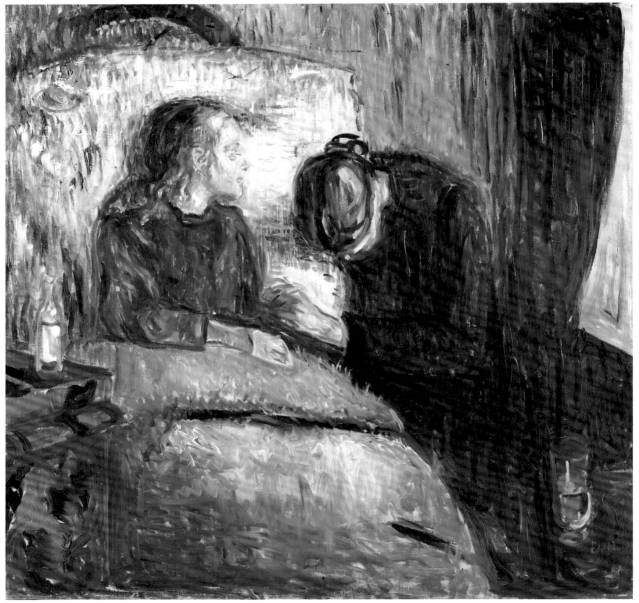

The Sick Child 1907, oil on canvas 118.7 x 121 cm

BRUCE NAUMAN (b.USA 1941) Nauman, a highly influential independent artist, has worked in an extraordinary array of media over the last thirty-five years, refusing to be pigeon-holed by media or style of practice. Trained as a painter in California in the mid-1960s, he turned to sculpture, performance, film, dance and video works, frequently investigating language games and perceptual and psychological awareness.

Violent Incident explores the escalation of violence from aggressive words to violent actions through a practical joke gone badly wrong. A pleasant candlelit dinner deteriorates into a threatening physical struggle as a man pulls the chair out from under his companion, toppling her. The two abuse each other and fight with a knife. Yet simple readings of gender conflict are upturned as the eighteen-second action, which is screened laterally across four video monitors, is repeated on a lower stack where the couple go through exactly the same actions but the roles are swapped. In fact, the installation seems to uphold Nauman's remark that his work comes out of 'being frustrated with the human condition', with people's refusal to understand each other and their capacity for cruelty.

While the high vantage point of the camera suggests contemporary concerns with surveillance, the use of repetition, the staggered pacing, the choreographed actions, the acoustic reverberations of particular phrases and the serial movement across the monitors also reveal Nauman's ongoing interest in the experimental music and dance scene he was involved in during the 1960s. Nevertheless, *Violent Incident* is one of the first of his works to use video after a gap of thirteen years, to employ actors and to be made in colour.

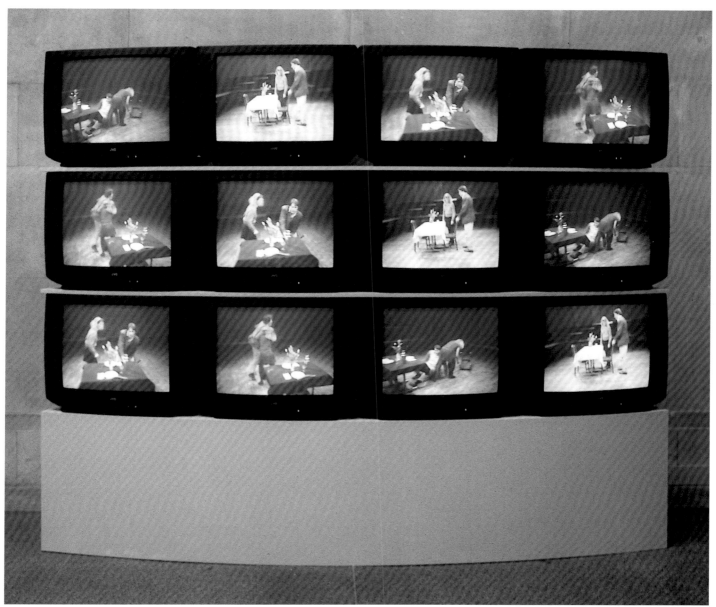

Violent Incident 1986, video 200 x 250 x 90 cm

BARNETT NEWMAN (b.USA 1905–1970) Newman is one of the principal artists to be associated with the movement that came to be known as Abstract Expressionism. Based in New York his work came to prominence during the late 1940s and 1950s. Newman's painting is typically made on a large scale; it is emphatically abstract, and deceptively simple. The majority of these works contain one or more vertical or near vertical lines inscribed within a broad, flatly painted field of saturated oil or acrylic colour. The linear elements, or 'zips', are often made by masking off areas of the canvas with tape, which is then removed at some point during the painting process. Thus the zips can appear either to rest on the surface of the colour plane or lie somewhere behind it.

The work has been interpreted in a variety of ways. For some commentators Newman's is a self-referential abstract practice, in which the lines and planes are seen principally to emphasise the shape and structure of the rectangular canvas. However, Newman himself aimed to make work in the tradition of a 'tragic' or 'sublime' art. The work would have the ambition of the epic schemes of, say, Michelangelo, but would be made in entirely modern, that is to say, abstract terms. The title often provides a clue to Newman's thinking. *Adam* is clearly not meant as a likeness in a conventional sense. The work is perhaps more concerned with abstract concepts such as beginnings, origins and Creation – other works of the time have titles such as *One* and *In The Beginning*. For Newman the artist could not adequately illustrate such fundamental ideas through conventional imagery. Rather his aim was to produce an abstract equivalent for the experience of oneness or beginning.

Adam 1951–2, oil on canvas 242.9 x 202.9 cm

CLAES OLDENBURG (b.Sweden 1929) Oldenburg first came to wide attention as one of the leading figures of American Pop art in the early 1960s. Whereas fellow artists such as Andy Warhol and Roy Lichtenstein (p.229,190) presented their source material in apparently unmediated ways, Oldenburg subjected his to often bizarre metamorphoses, and his work in particular brings into focus Pop art's debt to Surrealism. Oldenburg also exemplifies the life affirming, life embracing aspect of Pop and its ambition to bring art sharply into contact with reality – specifically the burgeoning urban consumerist culture of the post-war world. In art his aim seems to have been to transform a specific object into one which evoked or referred to as wide a range of other things as possible, which became an expression of life itself. In 1961 Oldenburg published an extraordinary manifesto, a series of aphoristic statements all beginning with the same phrase and which concluded: 'I am for an art that takes its forms from the lines of life itself, that twists and extends and accumulates … and is sweet and stupid as life itself.'

Oldenburg achieved his aims notably by making his sculpture soft, so that it could take on differing forms. *Soft Drainpipe – Blue (Cool) Version* unusually has a mechanical means of adjustment. Depending on the position, this work, based on a section of guttering and a downpipe, can suggest things ranging from a letter T, to an elephant's trunk, to male genitals, to a crucifixion. Oldenburg was a very early pioneer of environment or installation art when from December 1961 to January 1962 he opened his studio in New York as *The Store*, selling sculptural recreations of a wide range of goods.

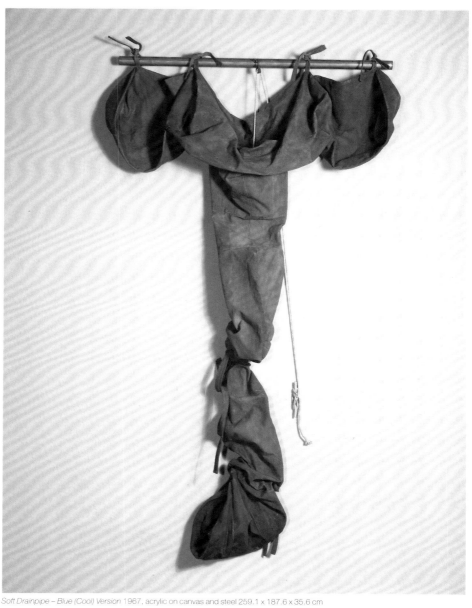

Soft Drainpipe – Blue (Cool) Version 1967, acrylic on canvas and steel 259.1 x 187.6 x 35.6 cm

JULIAN OPIE (b.Great Britain 1958) Opie first came to prominence following *The Sculpture Show* at the Hayward Gallery in London in 1983 which defined a new approach to sculpture. A student of the increasingly influential art school Goldsmiths College, Opie's early work drew on popular culture and the everyday for its subject matter, and its objectified and figurative nature. His hand-painted and obviously handmade sculptures of domestic objects brought together the sculpturally antithetical strategies of picturing and fabricating in works that looked like comic book images of reality. These works were followed in 1986 by folded and painted steel structures that were less specific in subject, less handmade and lacked a pictured figuration. Then in 1987 he began to make life size structures that emulated office furniture, bringing together minimalist abstraction, the tradi-

tion of the Duchampian readymade (see p.148) and a fascination with product design. In the 1990s Opie's work turned to the city. *It Is Believed That Some Dinosaurs Could Run Faster Than a Cheetah*, is ostensibly a group of vertical oblong boxes arranged to form a partly open cube. The outside faces of the cube are painted white, but the faces of the individual oblong boxes, inside the cube, have been coloured. The grid patterning and the colour-coding of the channels inside the cube resemble the imposed geometry of modern city planning. The reference to distance and speed in the title has been taken up by Opie more recently in work that engages with the experience of travelling by car. Opie's work has consistently swung between representations of domesticity and corporate life, of history and modernity.

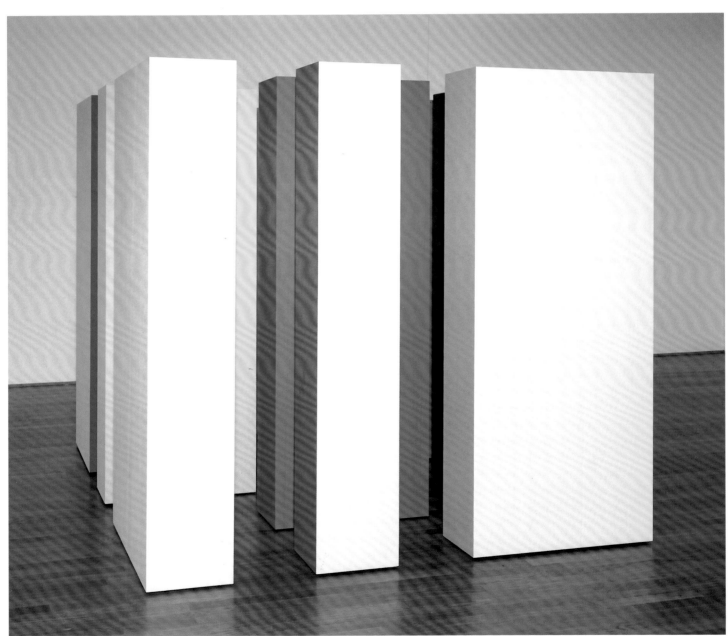

It Is Believed That Some Dinosaurs Could Run Faster Than a Cheetah 1991, painted wood 200 x 200 x 280 cm

EDUARDO PAOLOZZI (b.Great Britain 1924) The impression of objects, both literally and metaphorically, is a key aspect of the work of Paolozzi. Many of his sculptures use cast objects or machine parts, while his collages bring unrelated elements together into a new whole. Paolozzi spent the late 1940s in London and Paris. His early work echoes the existential anxieties expressed by such artists as Giacometti and Bacon (see p.158,118), as well as by the sculptors with whom he showed at the 1952 Venice Biennale and for whom Herbert Read coined the term 'the geometry of fear'. An antidote to this foreboding was to be found in the optimism of popular culture, especially advertisements from affluent America, and Paolozzi used such magazine images in a series of collages called *Bunk* which evoked a new technological world of convenience and consumerism.

These interests were shared with Richard Hamilton (see p.166) and the Independent Group associated with the Institute of Contemporary Arts, and were reflected in the environment conceived for the 1956 exhibition *This is Tomorrow* at the Whitechapel Art Gallery in London. *Cyclops* shows Paolozzi's sculptural equivalent to collage as it retains the impressions of disparate objects in wax sheets from which the sculpture was assembled before being cast in bronze. In the 1960s he took this further in adopting a more mechanistic aesthetic and precision, using industrial materials alongside found elements. Paolozzi has made notable public works which include the mosaics for Tottenham Court Road Underground station and *Newton* for the British Library, one of the largest examples of his method of cutting and reassembling his figurative sculptures to slightly dislocated effect.

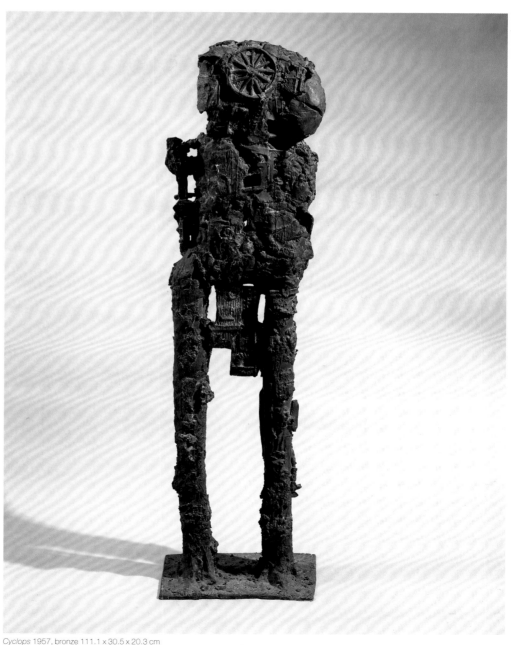

Cyclops 1957, bronze 111.1 x 30.5 x 20.3 cm

CORNELIA PARKER (b.Great Britain 1956) In 1988 Parker laid out a large number of domestic silver objects in the path of a steam roller; these flattened objects were then suspended by transparent wires in the Hayward Gallery, London. In 1991 a garden shed, assembled in the Chisenhale Gallery, London, and filled with objects bought from local car boot sales, was taken away and blown up by the British School of Ammunition. The fragments of the shed and its contents were then brought back to the gallery and suspended from the ceiling by wires and illuminated by an ordinary household light bulb. The character of these two works – *Thirty Pieces of Silver* (1988) and *Cold Dark Matter: An Exploded View* – point to features that have remained constant for Parker. Their flattening or being blown up does not mark an end, but is actually the beginning of their transformation in which meaning is found in their subsequent suspended state. The garden shed can be identified as a place of refuge whose symbolic resonance is enhanced by having been destroyed. Parker's formal arrangement of the shed's fragments, along with the remains of the things that she had filled it with, provides a freeze-frame of a violent explosion which emphasises the object's complete transformation. Parker's process is akin to that of an alchemist – turning base metal into gold. The work's title refers both to astronomy and physics and more recently Parker has made work with meteorites and has planned for work to be transported into space.

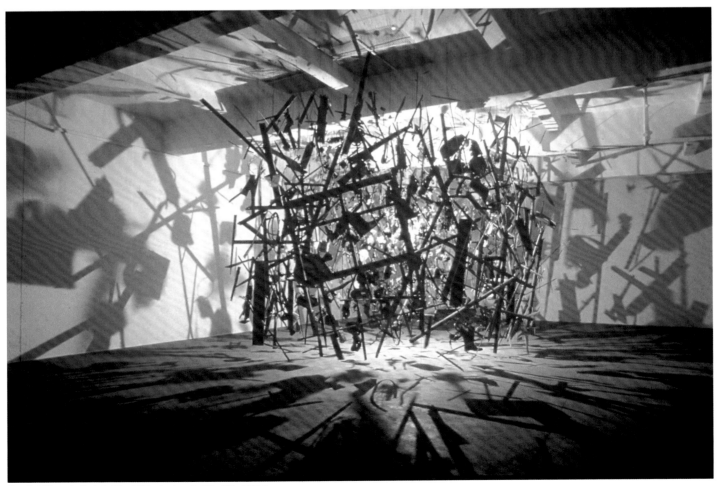

Cold Dark Matter: An Exploded View 1991, mixed media 400 x 500 x 500 cm

GIUSEPPE PENONE (b.Italy 1947) Penone's sculpture takes its inspiration from the landscape and forests of his childhood home in the Italian Alps. His earliest sculptures, from 1968, took the form of subtle changes made to the growth of trees, such as restricting the growth of a tree by a cast of his hand grasping the trunk. Penone was one of the few Arte Povera artists who actually worked in the landscape. These artists – like Mario Merz, Jannis Kounellis and Luciano Fabro (see p.197,187 and 152) – emerged at the same time as Minimal and Conceptual artists in the 1960s and were marked by the 'poor' materials they used in their assault on the elevated histories of Italian art since the Renaissance.

Tree of 12 Metres is from a series of works that Penone has been making since 1969 when he made *His being in the twenty-second year of his life at a fantastic hour*, in which he stripped away the layers from a baulk of wood until the remaining number of tree rings matched his age. In doing so he proposed an absolute relationship between 'the breath of the tree and my breath', while also returning the manufactured material to its original form. These works are sometimes arranged singly, or as groups or 'forests' of trees. With both elements of *Tree of 12 Metres*, the form of the tree has been completely excavated from the baulk, leaving a small part as plinth. Penone's aim with these sculptural events – also realised in his terracotta *Breath* sculptures which adopt the shape of his breath and show indentations of his body, or in sculptures that address the action of water on stone – is the charting of a temporal fluidity and growth in even the hardest of materials.

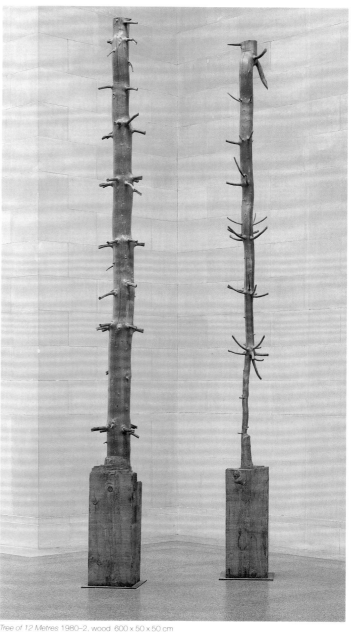

Tree of 12 Metres 1980–2, wood 600 x 50 x 50 cm

PABLO PICASSO (b.Spain 1881–1973) From 1907 Picasso, together with Georges Braque (see p.134), developed the new form of painting which became known as Cubism. Picasso's *Seated Nude* is from the first mature phase of Cubism, sometimes referred to as analytic. This term reflects the fragmentation of the subject into a multitude of planes and facets that occurred in early Cubism and which constituted a radical departure from the existing conventions by which reality was represented in painting. Thus the figure and the space around it are rendered on equal terms in *Seated Nude*. The coherence of the painting is due to Picasso's skilful use of chiaroscuro, ensuring that while unified with the surrounding space the figure remains clearly distinguishable from it. The painting exhibits a powerful, almost mechanical monumentality.

Picasso's *The Three Dancers* marks one of the turning points in his art. It coincided with the appearance of Surrealism in Paris, and Picasso was hailed as a master by the Surrealists although he held aloof from the group. It also marks a resurgence of Picasso's interest in African art that had first appeared in about 1906–7. The figures relate to fetish sculptures, while Picasso uses the dance as a way of addressing taboos through evoking shamanistic ritual. There are in fact four rather than three figures, which appear to represent people who had a deeply personal significance for the artist. The black profile on the right represents Ramon Pichot, an old friend of Picasso who died during the painting of this work. On the left, the most brutally rendered dancer may be Pichot's wife Germaine, cast as a *femme fatale*. The central figure, seemingly crucified between them, can perhaps be identified as the ghostly figure of Carlos Casegemas, a young painter and close friend of Picasso who committed suicide many years previously following rejection by Germaine. Pichot's death seems to have awakened the painful memory of this event, resulting in a work which the critic Ronald Alley considered marked by 'emotional violence and expressionist distortion'.

The rhythmic, curvilinear forms of *Nude Woman in a Red Armchair* create an intimate portrait of Picasso's young mistress Marie-Thérèse Walter. The luxuriant, thickly applied colour, the arabesques of the chair and the sensual tone of the work can be considered evidence of Picasso's rivalry with Matisse. Marie-Thérèse is given an ample, round face, painted white, intersected by a profile in blue. The profile can also be read as a second figure leaning over to embrace the nude, making the work a rendition of the kiss, a universal theme.

Picasso's *Weeping Woman* is one of the last of a series of works that mark his obsession with this subject during 1937. The motif of a woman in tears, sometimes clutching a dead child, was derived from Picasso's mural *Guernica*, one of his most politically engaged works and a response to the devastating attack on the Basque town of Guernica during the Spanish Civil War. French newspapers carried photographs of the victims of the bombing, including women and children. Picasso's images of weeping women are responses to these news reports; they can be considered as a symbol for the suffering of Spain and also identified with the Spanish religious cult of the Mater Dolorosa, Our Lady of Sorrows. The imagery of tears is employed here by Picasso to express the plight of his country. That the features of the woman portrayed are those of Picasso's then mistress Dora Maar shows that there was a more personal dimension, as ever, to Picasso's work.

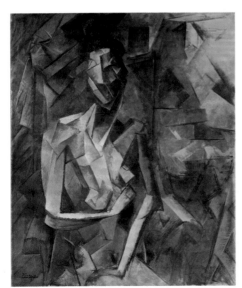

Seated Nude 1909–10, oil on canvas 92.1 x 73 cm

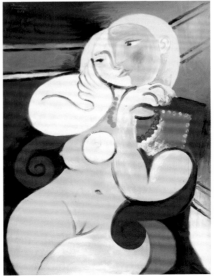

Nude Woman in a Red Armchair 1932
oil on canvas 129.9 x 97.2 cm

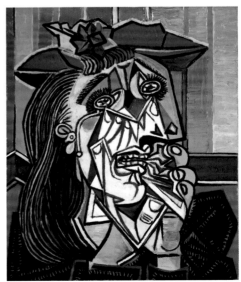

Weeping Woman 1937, oil on canvas 60.8 x 50 cm

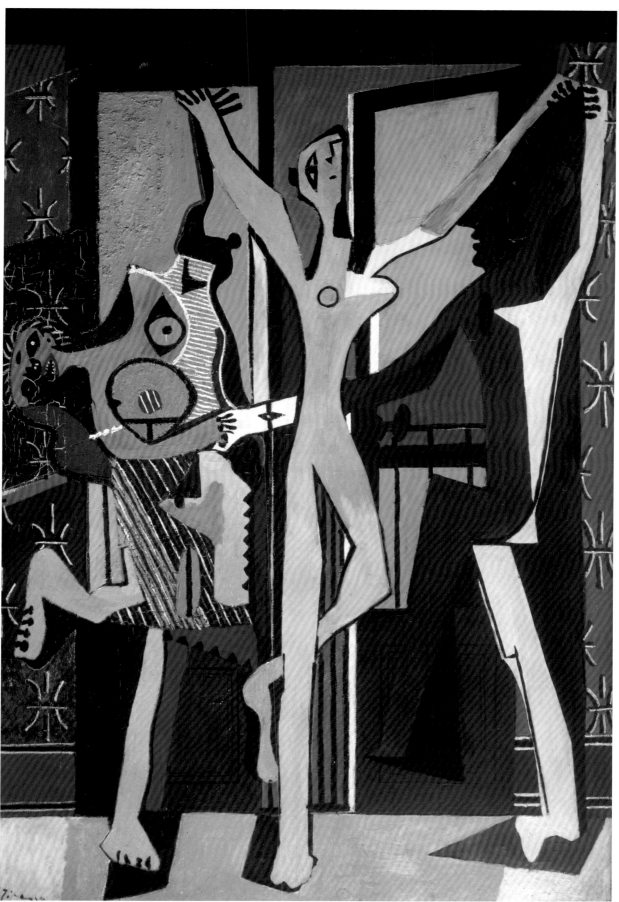

The Three Dancers 1925, oil on canvas 215.3 x 142.2 cm

JACKSON POLLOCK (b.USA 1912–1956) Jackson Pollock is widely seen as the key figure in western art in the mid-twentieth century, exercising an influence on the second half of the century comparable to that of Picasso on the first half. By the end of the 1930s, to Pollock and a generation of talented American artists, it seemed that the great Europeans had about wrapped up art: Picasso and the Surrealists had done everything it was possible to do with the figure, while Kandinsky, Malevich and Mondrian had exhausted abstraction. 'Painting is finished; we should give it up' wrote Barnett Newman, another of the leading figures in what became known as Abstract Expressionism. It was Pollock who, as even his great rival Willem de Kooning acknowledged, 'broke the ice' and reinvented painting, evolving a new technique and synthesising abstraction and figuration into something dramatically new.

Jackson Pollock was born the youngest of five brothers, in the town of Cody, Wyoming, and grew up in Arizona and California. His father was an unsuccessful farmer. Cody was named after Buffalo Bill Cody, and this early background gave rise to the myth of Pollock as the all-American cowboy artist – a myth which Pollock encouraged. In 1930 Pollock moved to New York to continue an art training begun in Los Angeles. By the end of the 1930s he was working in a manner that combined the influence of Picasso's figure painting of that time with Surrealism. Pollock was particularly interested in the Surrealist idea of making art from the unconscious mind. In pursuit of this he adopted increasingly free and improvisatory ways of painting so that

the content of the work was as much embodied in its forms as in its readable subject. In *Naked Man with Knife*, the figures are fragmented and incorporated into an overall rhythmic and expressive structure. This process took a leap forward in *Birth*, in which a bent leg can just be discerned at the lower left, a gesturing hand at the right, and above, contorted mask-like faces.

In the late summer of 1947 Pollock made a crucial change to his way of painting when he began to work the canvas on the ground, trailing and dripping the paint onto it. By the following year he was working on a large scale, moving around the canvas like a dancer, in an almost trance-like state, establishing a direct connection between his inner world and the painting. His major early drip painting *Summertime* is purely abstract yet intensely evocative, the trailed black forms suggestive of a procession of dancers performing some ritual in a setting of the open prairie of Pollock's native West. From 1948 to the end of 1950 Pollock produced a succession of such works, until a return of his chronic alcoholism brought a hiatus and then a change of direction. When he resumed painting in the summer of 1951 he embarked on the so-called black paintings, of which *Number 14* (p.49) is an outstanding example. Sinister figures seem to lurk in the painting, reflecting perhaps his renewed personal stress. This was the last consistent group of major works he made, although the celebrated *Blue Poles* of 1952 was a final heroic manifestation of the Pollock of the high point of 1948–50. After that he painted little until his death at the wheel of his car on 11 August 1956.

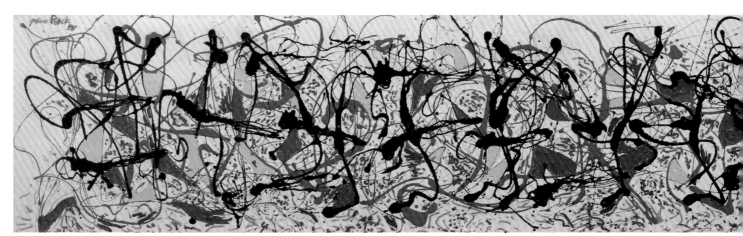

Summertime: Number 9A 1948, oil, enamel and house paint on canvas 84.8 x 555 cm

Naked Man with Knife c.1938-40, oil on canvas 127 x 91.4 cm

Birth c.1941, oil on canvas 116.4 x 55.1 cm

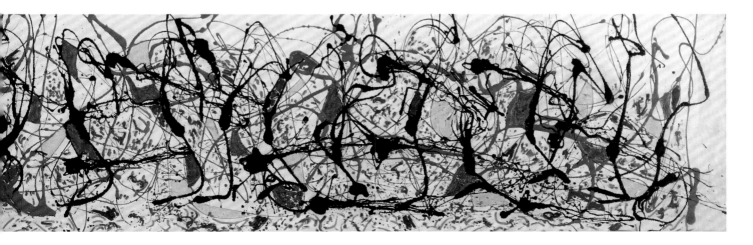

GERMAINE RICHIER (b.France 1904–1959) Richier trained at the School of Fine Arts in Montpelier, then moved to Paris where she established her own studio in 1933. She became a modestly successful sculptor of fastidiously observed and crafted portraits and nudes. Richier spent the Second World War in Zurich, and from 1942 her work began to change as she infused her human figures with animal and plant imagery, creating disturbingly distorted and metamorphic creatures. She also gave them increasingly freely worked and emphatic surface textures. The results contained a unique blend of observation and imagination, and were widely seen as expressive of the themes of anxiety, suffering, death and isolation

that were prominent in European art in the immediate aftermath of the war. Richier's figures were 'Kafkaesque images of tortured, atom-bombed, pitiful men' according to the art historian Margit Rowell. Two of her best known sculptures, *Storm Man* and *Hurricane Woman* (1948-9), perfectly fit this description. The theme of death is particularly explicit in *The Shepherd of the Landes* (1951), where the skull-like head was cast from a lump of brick and cement, hollowed and carved by the sea, that Richier found on a beach.

Richier's sculpture has affinities with that of Giacometti (see p.158) as well as parallels with that of the post-war British sculptors whose work was dubbed 'the geometry of fear' by the critic Herbert Read in 1952.

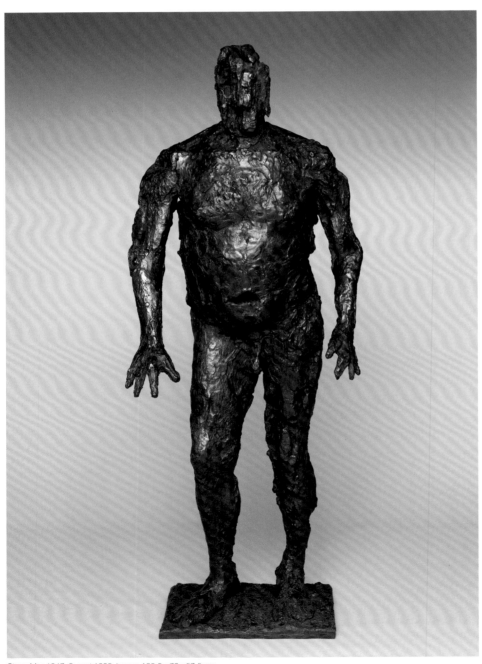

Storm Man 1947–8, cast 1995, bronze 190.5 x 72 x 57.5 cm

BRIDGET RILEY (b.Great Britain 1931) Riley shot to international prominence in 1965 when her work was included in *The Responsive Eye* exhibition at the Museum of Modern Art in New York. Her black-and-white paintings of the preceding five years use repeated forms and lines to produce illusions which draw the viewer's attention to the mechanisms of perception. In *Hesitate*, the illusion of a deep fold is irresistible, even as it is evidently created by the diminution of circles into ovals and by the subtle shifts in tone. The painting belongs to a series (all with mysteriously emotive titles) in which Riley used different grades of grey to change 'tempo'. She described how she pitched 'this type of grey movement against the structure of the formal movement' of the ovals.

Immediately regarded as part of the international Op art trend (together with Victor Vasarely), Riley had a successful European touring exhibition in 1970–1. It marked a change in her work with the introduction of colour. The potentially vast complexity of juxtaposed hues was controlled by formal simplicity, usually reliant upon stripes with relieving and enlivening interstices of white. Serpentine lines introduced illusions of waves. In the 1980s, working in France as well as London, Riley restructured this formal vocabulary by cutting the dominant verticals with diagonals. The resulting rhomboids and lozenges of intense colour overlap the vertical divides to introduce suggestions of space. In these dense fields of colour Riley's long standing concern with the conjunction of visual and emotional energies remains paramount.

Hesitate 1964, oil on canvas 106.7 x 112.4 cm

MARK ROTHKO (b.Russia 1903–1970) *Untitled* is an early example of Rothko's mature work. The surrealistic landscapes and biomorphic shapes of his mid-1940s paintings have given way to a static, abstract composition, built up with broadly brushed veils of paint. Rectangular 'colourfields' appear to float over, or lie behind, one another (yellow over white, greyish-white over red, and so on) so that no single element dominates. If the central, white-under-yellow strip of *Untitled* carries a residual sense of being a horizon line, this is undercut by its failure to extend to the limits of the canvas: a unified strip around the painting's edge binds the work together, rendering it more a window than a landscape. The metaphor of a window is maybe even more appropriate to *Black on Maroon*, a painting from Rothko's Seagram Murals series. Here, a nebulous, hovering rectangular 'opening' seems to give onto either infinity, or nothingness. Rothko sometimes described his paintings as 'facades', also as 'dramas', ambiguous words, which leave open to question exactly what the works might reveal or conceal.

Rothko's family emigrated from Russia to the United States when he was ten. From 1925, Rothko lived in New York, where with Jackson Pollock, Barnett Newman and Willem de Kooning he achieved pre-eminence as a leading Abstract Expressionist. Clement Greenberg, one of the movement's most influential champions, considered works such as Rothko's to be of vital importance because they exemplified painting in its essential state, stripped of representational content. However, Rothko himself consistently understood his abstract forms to be charged with symbolic meaning. It has been shown that the compositions of the more fragmented abstract works of the late 1940s which preceded *Untitled* are based on Renaissance religious paintings, and Rothko never abandoned a complex sense of his paintings as anthropomorphic, describing them as 'organisms', and associating their formal properties with human presence. Psychoanalytic interpretations have proposed that works such as the Seagram paintings are unconsciously 'maternal' in character: enveloping the viewer in a both comforting and overwhelming manner, they replay the tensions inherent in a tiny infant's experience of its mother's body. If this reading is valid, then the sombre colours used by Rothko to relive that experience are deeply evocative of sadness and loss.

The Seagram works originate in a 1958 commission offered to Rothko by the architect Philip Johnson to make a series of works for a restaurant in Mies van der Rohe's Seagram Building on New York's Park Avenue. Rothko completed three separate series of 'sketches' and 'murals', actually, large-scale stretched canvases, not works directly painted onto the building's walls. At the end of the process, however, the artist refused to deliver the work to its commissioners. The restaurant, it is suggested, fell too far short of an ideal setting imagined by Rothko whilst at work. It is also clear that Rothko, an anti-Stalinist, but with communist and anarchist sympathies, felt highly ambivalent about displaying his work in so exclusive a venue. In the mid-1960s, the Tate Gallery began negotiations with Rothko over a possible donation of work, and in 1970, just months after the artist's suicide, the Tate's display of Seagram paintings, arranged according to a plan approved by Rothko, went on public view in London.

Black on Maroon 1959, oil on canvas 266.7 x 457.2 cm

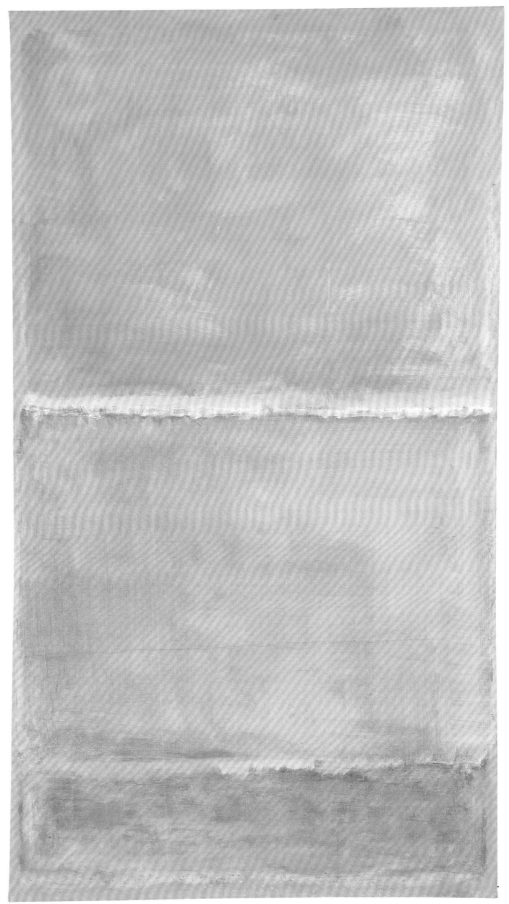

Untitled c.1951-2, oil on canvas 189 x 100.8 cm

KARL SCHMIDT-ROTTLUFF (b.Germany 1884–1976) Schmidt-Rottluff was a founder member of Brücke (Bridge), the German Expressionist group established in Dresden in 1905. Like other movements of the early Modernist era, Brücke wanted to strip away the 'civilising' conventions of bourgeois life, and aspired to restore primordial harmony between man and nature. Inspired by Frederick Nietzsche's concept of the Will to Power, these artists aimed for direct self-expression uninhibited by the constraints of modern urban life. Each year between 1907 and 1911, members of the Brücke group visited the nearby lakes of Moritzburg, where they experimented with a 'primitive' lifestyle: living in the open air, going nude and playing games with bows and arrows.

Two Women is one of several images of bathers or female nudes in landscape which Schmidt-Rottluff painted in response to his visits to Moritzburg and the North Sea coast. These paintings drew inspiration from Paul Gauguin's images of Polynesian women which also present an idealised fantasy of primitive life. The two women are painted in simplified blocks of colour. Their angular forms and sharp features are made to rhyme with the rocky landscape around them. Schmidt-Rottluff's distinctive angular style developed from his extensive work with woodcuts. Unlike his other paintings, here the colours are muted and naturalistic, and despite some tonal modelling on the women's arms and back, there is a characteristic impression of flatness. The women's faces look blank, stylised into expressionless tribal masks. The original owner of this painting, art historian and critic Rosa Schapire, a lifelong friend and patron of Schmidt-Rottluff and Brücke detected a sense of melancholy and loneliness in the scene.

Two Women 1912, oil on canvas 76.5 x 84.5 cm

RICHARD SERRA (b.USA 1939) In 1967 and 1968 Serra compiled a list of verbs and nouns describing his sculptural concerns at that point as an investigation of process. These words – 'to roll, to crease, to fold … to simplify … to suspend … of tension, of gravity … to continue' – stand as a definition not only of his own work but also of that of many other process or anti-form artists who were his contemporaries: Robert Smithson, Robert Morris, Eva Hesse and Bruce Nauman (see p.203, 170 and 205). These artists made work that was devoid of symbolism and referred to nothing other than itself, so as to become a part of the real experience of the viewer located in the space in which the aesthetic encounter took place. Although such ideas were to spawn a tradition of sculpture that was site-specific and concerned with installation, of greater significance is the attack mounted on illusion by this preoccupation with a sculpture's physical reality.

Serra's preferred material at the time of finishing his list was lead. Its physical state could be manipulated with ease and in 1968 and 1969 his lead was rolled, torn, melted and cast. His use of industrial materials also forms a link with the minimalism of Carl Andre and Donald Judd, (see p.114,180). Serra also embarked on a series of 'prop' works, mostly constructed from lead, including *2–2–1: To Dickie and Tina* and *Shovel Plate Prop* (1969). The component parts of these works were propped up and held by each other in a state that Serra described as 'suspended animation' and 'arrested motion', that creates 'a sense of presence, an isolated time'. *Shovel Plate Prop* consists of a sheet that is propped in a vertical position away from a wall by a rolled lead tube that leans from the top edge of the sheet to the wall. *2–2–1: To Dickie and Tina* consists of two pairs of lead sheets and one single sheet that stay upright only by the force and weight of another rolled lead tube that lies touching one corner of each sheet. The meaning of these sculptures is determined by the truth of their individual structure in which a precarious stability is maintained simply by means of gravity.

Since 1970 Serra has increasingly moved away from the art gallery and made site-specific work on an increasingly large scale in more public spaces – a positioning that has also come to form a greater part of his works' meaning: 'How a work alters a given site is the issue', he has said.

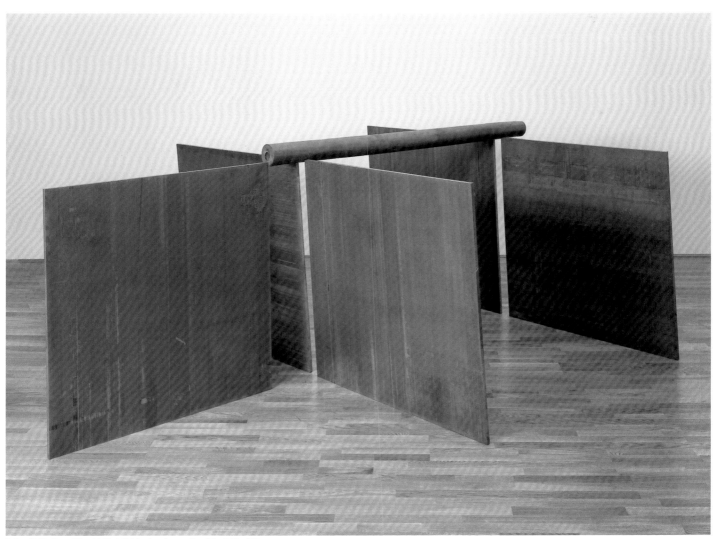

2-2-1: To Dickie and Tina 1969, 1994, lead antimony alloy 132 x 349 x 132 cm

CINDY SHERMAN (b.USA 1954) Sherman, one of the most popular and well-known contemporary artists, first attracted attention with her famous series of *Untitled Film Stills*. Alongside artists such as Barbara Kruger, Sherman has made works that explore female roles in society and challenge the clichéd representation of women projected by the mass media, Hollywood or the fashion industry. Employing an array of elaborate props and costumes, Sherman photographed herself posing as a variety of female stereotypes including sex kitten, glamour queen, fragile victim, bored housewife and naive schoolgirl. With the precision of an actor, she researches and builds up a character creating evocative vignettes which resemble stills from European cinema or Hollywood B-movies. Since the mid-1980s Sherman's work has increasingly veered towards the surreal and grotesque, experimenting with a range of prosthetics, mannequins and masks.

Untitled Film Still #17 is one of several images in the *Film Stills* series which depicts a lone woman in the city. Young and housewifely, this woman wears a polka-dotted head scarf and white blouse. A typical New York apartment block appears to tower above her, emphasised by the low camera angle. She seems out of her element, perhaps a country woman visiting the city, and yet she stares accusingly at the camera. This is one of the rare *Film Stills* where the protagonist directly confronts the viewer, thereby implicating the viewer in the imagined drama and making them a co-conspirator in the artificial construction of the image.

Untitled Film Still #17 1978, reprinted 1998, photograph on paper 74.5 x 95 cm

DAVID SMITH (b.USA 1906–1965) Industry, craft and art came together in the adoption of iron and steel for sculpture. Far from the traditions of modelling or carving, the methods of the welder introduced strength with delicacy, form without mass. Smith worked with metal from the 1930s stimulated by the example of González and Picasso. With the American entry into the Second World War, he served as a welder at the American Locomotive Factory in Schenectady. On his release he made *Home of the Welder*, a quasi-autobiographical sculpture in which the millstone of that job is prominent, while other elements – women and children – suggest a confessional aspect.

The soft cutting into steel gave way in Smith's post-war work to assemblages of found industrial and agricultural implements, united by their common material and treatment. Although urban in feeling, Smith's works from 1940 onwards were made at Bolton Landing in upstate New York. The delicate linear constructions retain anthropomorphic associations but also bear comparison to the work of contemporary painters such as Jackson Pollock (see p.214). Following widespread acclaim in the 1950s, Smith entered a period of diversity exemplified by *Wagon II* and *Cubi XIX*, both made in 1964. The massive structure of the former, with wheels and a vertical 'driver', recalls miniature Etruscan sculptures of charioteers. For the *Cubi* series, Smith used a quite different material: brushed stainless steel. The geometrical volumes here are constructed rather than described through line, but the composition remains light because of the surface treatment, which Smith compared to making 'square clouds'. A fatal car crash in 1965 cut short this fertile productivity.

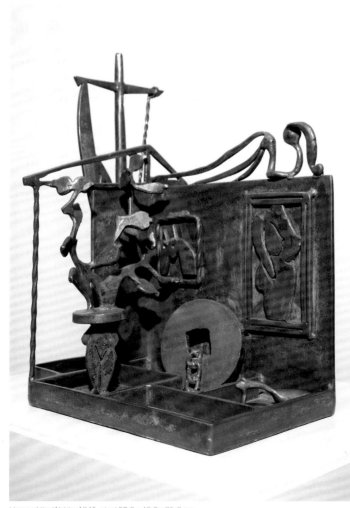

Home of the Welder 1945, steel 53.3 x 43.8 x 35.6 cm

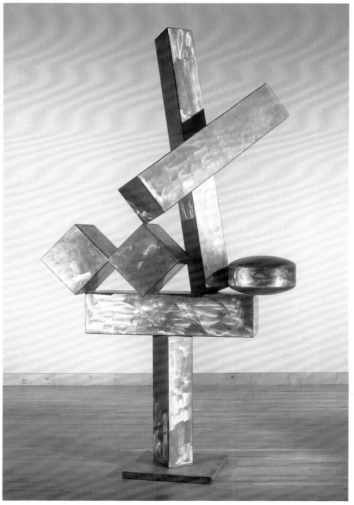

Cubi XIX 1964, stainless steel 286.4 x 148 x 101.6 cm

THOMAS STRUTH (b.Germany 1954) Struth established his reputation in the early 1980s with photographs of austere black and white cityscapes. Whether places or people, Struth presents his subjects with deliberate impartiality, minimising psychological or narrative content and thereby limiting the viewer's ability to read the image. Struth follows in a tradition that emphasises photographic objectivity, drawing on precedents such as August Sander's documentary social portraits in the 1930s and more recently Bernd and Hiller Becher's photographic survey of industrial architecture begun in the late 1950s. As a student under Bernd Becher at the Düsseldorf Academy, Struth developed his resistance to authorial intervention and began to employ his distinctly classical style of composition.

In the mid-1980s Struth began to work on a colour series, *Museum Pictures*, which meditates upon the process of looking. Relaxing his previous compositional restraints, Struth captured unstaged, spontaneous photographs of visitors in famous art galleries. In *National Gallery I* a group of people cluster around three Venetian paintings. Dominating the centre is Cima's *The Incredulity of Saint Thomas*, a Renaissance painting depicting the story of 'doubting Thomas', the disciple who lacked faith in the resurrected Christ until he had placed his fingers inside Christ's wound. The story questions the truth of visual information, drawing attention to the ambiguities at play within Struth's photograph. The colours and postures of the figures in Cima's painting are mirrored by the gallery visitors and by extending the perspectival recession of the painting, Struth creates continuity between the fictitious audience within the painting, the gallery visitors and we, the viewer. This achieves a striking sense of equality between viewer and viewed, subject and object.

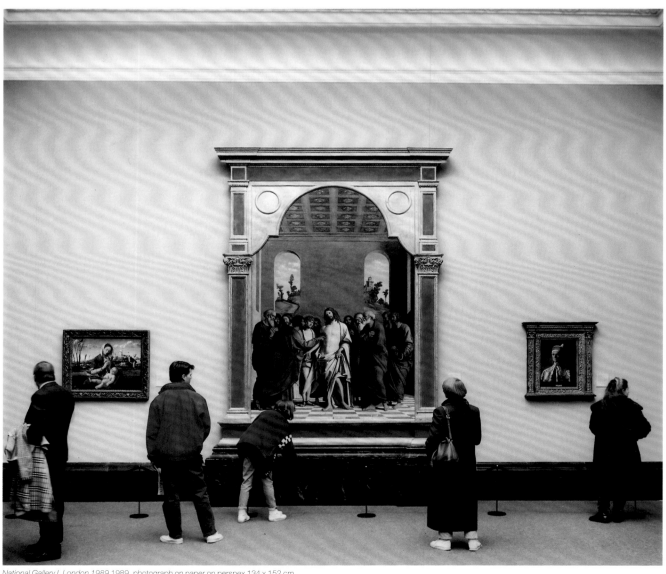

National Gallery I, London 1989 1989, photograph on paper on perspex 134 x 152 cm

YVES TANGUY (b.France 1900–1955) Tanguy joined the French merchant marine in 1918 and then did military service from 1920–22. After discharge he had a variety of jobs in Paris until in 1923 he saw two paintings in a gallery window that inspired him to become a painter. They were by Giorgio De Chirico (see p.144), and one of them belonged to André Breton who the following year was to launch Surrealism. De Chirico was to prove a key inspiration for Surrealist painting. Tanguy eventually met Breton in 1925; they became firm friends and Tanguy remained a core member of the Surrealist group in Paris until his departure to America in 1939. There he remained, achieving considerable recognition and becoming an American citizen in 1948.

Self-taught, by 1927 Tanguy developed his characteristic manner in which mysterious creatures, abstract yet strangely alive, disport themselves in empty landscapes, suggesting beaches and seascapes with no horizon. In later works such as *The Transparent Ones* some of the forms have taken on a mechanical character and all appear to be floating free in a misty space. Breton's admiration for Tanguy stemmed partly from his recognition that Tanguy combined two aspects of Surrealist painting – the dreamlike illusionism stemming from De Chirico and exemplified by Dalí (whose early work reveals the strong influence of Tanguy) and the 'automatic', in which improvisatory methods ensured a direct flow of material from the subconscious and where the results tended necessarily to be abstract. The American critic James Thrall Soby has suggested that the origins of Tanguy's art lie in the experience of childhood summers spent at Locronan in Brittany: 'The fields near Locronan are peopled with menhirs and dolmens from prehistoric times and these, subjectively transformed, are frequent properties in the dream world Tanguy celebrated as an adult painter.'

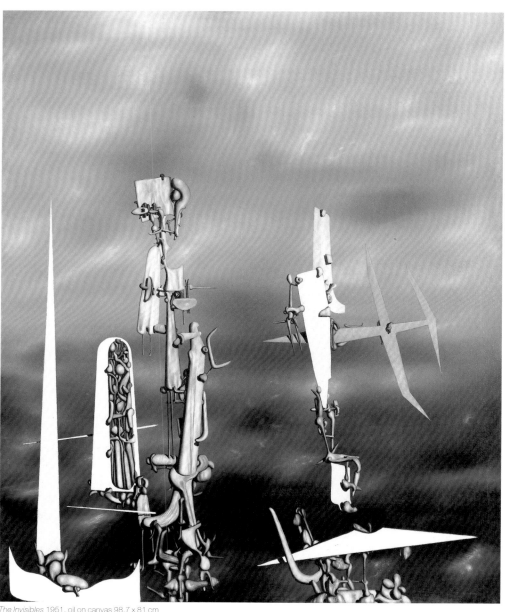

The Invisibles 1951, oil on canvas 98.7 x 81 cm

DOROTHEA TANNING (b.USA 1910) The Surrealist artist Tanning was born in Galesburg, Illinois, a place where, she later said, 'nothing happens but the wallpaper'. She developed a rich fantasy life, influenced by her reading of Gothic and Romantic literature which, she said, 'forever corrupted' her. She studied art in Chicago, then moved to New York. In 1936 she discovered Surrealism at the major exhibition *Fantastic Art, Dada and Surrealism* at the Museum of Modern Art and by 1941 was exhibiting at the Julien Levy Gallery, a centre for Surrealist art. In 1943 she was included in a group show of women artists there which included Surrealists such as Léonor Fini and Meret Oppenheim. Before the show Levy asked Max Ernst (see p.151), one of the founders of Surrealist art, who was now in New York, to visit Tanning and report on her latest work. They quickly became lovers and married in 1946. In her art however, Tanning maintained an entirely independent and distinctive path, exemplified by *Eine Kleine Nachtmusik*, one of her best known works. It depicts a young girl confronting a giant sunflower and another girl, in fact a doll, according to the artist, propped in an attitude of exhaustion. The demeanour and tattered clothing of both figures suggests a recent encounter with powerful, perhaps erotic forces; the hair of the living girl still streams upwards as if in the slipstream of a fierce wind. Tanning became fascinated by sunflowers when she grew them at the Arizona home she shared with Ernst. The one here she described as 'a symbol of all the things youth has to face'. The title is that of the well known light-hearted piece of music by Mozart, and sets up an ironic counterpoint to the sense of lurking menace of the painting.

Eine Kleine Nachtmusik 1943, oil on canvas 40.7 x 61 cm

BILL VIOLA (b.USA 1951) At Syracuse University, New York, in the 1970s Viola worked with video and assisted on installations by Nam June Paik, Peter Campus and other artists experimenting with new media at the local Everson Museum. He was involved with experimental music and travelled widely recording traditional dance, the legacy of which is apparent in the attention to sound and the overall structures of his video pieces. He studied Zen Buddhism in Japan and became interested in spiritual concerns shared between East and West. Some of these interests are reflected in the combination of mortality and spirituality in the *Nantes Triptych*. While echoing the tripartite form of Christian altarpieces (it was originally made for the Chapelle de l'Oratoire in Nantes) it draws together on a monumental scale the fundamental experiences of life. Images of a young woman giving birth and an old woman dying, flank that of a man plunging into water. The suspended state of this central figure is enhanced by projecting onto scrim so that the light around him forms a luminous cloud. These themes were anticipated in earlier works. Diving was a sign of emerging individuality in *The Reflecting Pool* (1977–9) while the related *Silent Life* (1979) traced the awakening character in the faces of new-born babies. Viola's installation *Science of the Heart* (1983) set above a bed the image and sound of a beating heart accelerating and decelerating to ominous silence until resuming the cycle. The gasp for air of the immersed figure in *The Messenger* (1996), made for Durham Cathedral, captures the affirmative in these psychologically charged and universal themes, reinventing the spiritual ambitions of past art for contemporary technology.

Nantes Triptych 1992, video and mixed media

JEFF WALL (b.Canada 1946) Wall makes photographs which combine the latest digital technology with the large scale and complex composition of history painting. Resembling minimalist sculptures, Wall's transparencies are mounted on light boxes which glow with the back-lit allure of street advertising. He describes his work as closer in spirit to painting than photography, and deliberately works against the fragmentary and spontaneous nature of the photographic medium. Inspired by the staged melodrama of Baroque art, Wall creates epic tableaux of contemporary urban realism which distil a whole narrative into a single 'expressive gesture'. These isolated gestures often expose the aggression of modern urban interaction but can also reveal moments of positive contact or community.

A Sudden Gust of Wind (After Hokusai) is inspired by an image from a famous series of prints depicting views of Mount Fuji by the nineteenth-century Japanese artist, Hokusai. His prints are well-known for their acute observations of Japanese life and unusual, almost photographic viewpoints. Here Hokusai's group of peasants crossing a swaying paddy-field is updated into four men walking across a desolate industrial landscape. Wall's characters imitate the instantaneous reactions of Hokusai's figures to the unforeseen gust of wind, cowering and twisting in poses which mirror the leaning trees and curling trail of papers. While Hokusai explores a momentary human response, Wall encourages the viewer to consider the complex web of relations between his distinct characters. In contrast to Hokusai's pastoral scene, Wall presents an image of industrial devastation and implicit social hierarchies. Like many of his photographs this image has been carefully structured involving time-consuming research and choreography. Each element, including the sheets of paper, was digitally grafted onto the scene in a process which took the artist five months.

A Sudden Gust of Wind (after Hokusai) 1993, photographic transparency and illuminated display case 250 x 397 x 34 cm

ANDY WARHOL (b.USA 1928–1987) When Warhol started to make art, he used images from popular culture and everyday life, such as cartoon characters, dollar bills, Coca-Cola bottles and Campbell's soup cans. In the early 1960s he made his breakthrough in the New York art world with his silk-screen paintings. Taking pictures from newspapers and magazines, he repeatedly reproduced the same image, row after row, on a single canvas. At once quick, mechanical and employing a commercial process these works both celebrated and cynically remarked on American mass-production culture.

In 1962, when Marilyn Monroe died of a drug overdose, Warhol marked the event with a series of paintings based on a publicity still taken for the film *Niagara* (1953). *Marilyn Diptych* is one of the largest from the series, with the actress's face repeated fifty times across two panels. Each face, though reproduced from the same image, is slightly different – sometimes blurred, sometimes fading away, sometimes with much thicker paint, showing how Warhol's mechanical technique was quite humanly open to chance and error, as well as deliberate manipulation.

There was no hierarchy in Warhol's subject matter, with no difference in the way he treated flowers and fatal car crashes or Elizabeth Taylor and race riots. Likewise, he saw no need for a hierarchy between artistic media. A prolific film maker, he also ran a nightclub, where he staged multimedia happenings featuring the rock band the Velvet Underground and their guest singer Nico, published *Interview* magazine, and had his own cable television show, *Andy Warhol's TV.* Warhol, inevitably perhaps, became an inseparable part of this collision of art, popular taste and celebrity, becoming an instantly recognisable icon of twentieth-century culture.

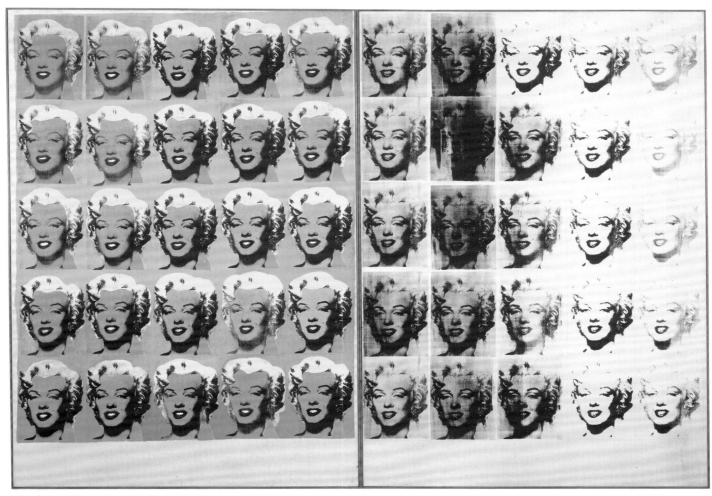

Marilyn Diptych 1962, acrylic on canvas 205.4 x 144.8 cm

GILLIAN WEARING (b. Great Britain 1963) Wearing is one of a generation of young British artists whose art responds to their everyday world and local environment. Wearing is endlessly fascinated by human behaviour and all her art works involve collaboration or interaction with the public. Although she disclaims a political agenda, her documentary use of video and photography creates an alternative channel for the *vox pop*. Several works include people marginalised by mainstream society: transsexuals, addicts and homeless people. But while her work is documentary in spirit, it is not an anthropological survey. Her videos offer reflections of self that can be funny but are frequently provocative and poignant.

In 1994 Wearing placed an advertisement in *Time Out* magazine asking people to 'Confess all on video. Don't worry you will be in disguise. Intrigued? Call Gillian'. A series of willing participants, their identities hidden, came forward to make their confessions to Wearing's camera. Some are tense and urgent, desperate to unburden themselves. Others take their time, seizing the opportunity for some ad-lib philosophising. Some tell of theft, perversion, sexual hang-ups and revenge, and others articulate the petty misdemeanours of everyday life. Wearing has often cited 1970s 'fly-on-the-wall' documentaries as an important influence, but this work can also be seen in the context of confessional TV chat shows. Both situations involve a confrontation between private self and public persona. Wearing takes this a step further by introducing props, such as Hallowe'en masks and party wigs, playing upon their dual role as a means of both disguise and revelation. In this case the masks also interject an element of ironic humour; one mask caricatures Neil Kinnock and another George Bush.

Confess All On Video. Don't Worry You Will Be in Disguise. Intrigued? Call Gillian 1994, video

RACHEL WHITEREAD (b.Great Britain 1963) In the 1990s Whiteread achieved an international reputation for her cool and evocative sculptures. Her works are often described as 'making space solid' because she captures in solid form the spaces around things by casting underneath chairs, around baths or inside a wardrobe. The casts bear the 'negative' imprint of these everyday objects, rendering them simultaneously familiar and strange. Whiteread's most famous and polemical work was a cast of the inside of an East London house. Like the house itself, the sculpture was later demolished, but as with much of her work, it remains a poignant testimony to the ephemeral nature of the spaces we inhabit; we leave our mark and move on.

Many of Whiteread's works retrieve places and objects made invisible through ritualised daily use. In *Untitled (Floor)* Whiteread cast the underside of ordinary wooden floorboards, capturing the cushion of air between the floor we walk on and the cemented ground beneath, and giving physical presence to the air in which we live and move. Laid out in a geometric configuration of fourteen separate blocks, this sculpture recalls the floor-works of Minimalist sculptor Carl Andre (see p.114). Whiteread has made several sculptures related to floors which are among her most regular and formal works. However at close range the ordered precision of the sculpture is softened by the uneven marks and cracks visible on the sculpture's surface. Cast in translucent aquamarine resin, these mesmeric blocks of colour record the traces of human life inscribed on a floor, transforming the mundane into the monumental.

Untitled (Floor) 1994–5, polyester resin 20.4 x 274.5 x 393 cm

BILL WOODROW (b.Great Britain 1948) In common with others who established their reputations in Britain in the early 1980s, Woodrow gathered discarded goods as raw material for his art. He had made pieces embedding domestic objects in plaster and concrete but with works such as *Twin-Tub with Guitar* (1981), he established the means to transform large appliances by cutting from them a second, unrelated, item. The 'parasitic' object was conceived in template and remained attached, so that the negative form in the 'host' could be seen. The discarded gave rise to the fantastic in a way that echoed Surrealist practice but was implicitly political in the context of the consumerism of the Thatcher years. *Elephant*, for which an ironing board and vacuum cleaner served as the head, arose simply from a desire on Woodrow's part to work on a large scale. Mounting the head

'colonial style' on the wall and adapting old maps of Africa and South America to create the elephant's ears, he wittily brought into fresh focus European perceptions of the Third World. The trophy head of imperilled nature was conjoined (above a watering hole of car doors) with the automatic weapon of political unrest. The chain of objects thus produces a narrative and the result is explicitly critical of the exploitation which supports the consumer societies discarding the items from which the piece is made.

In 1987 Woodrow gave up the hallmarks of his work to date – the found and cut objects – in favour of cast bronze on a monumental scale. This might appear a disavowal were it not for the ironic distance of the recent work in which the quintessentially traditional sculptural material can be used to question establishment values.

Elephant 1984, car doors, maps and vacuum cleaner 385 x 820 x 465 cm

ANDREA ZITTEL (b.USA 1965) Pleasure and confinement, the personal and the mass-produced, find paradoxical relationships in the works of Zittel. Since moving to New York from California in the late 1980s, her overriding concern has been with the place of the artist within and at the service of society. She has pursued a functionalism that heightens the paradoxical nature of her projects. To eliminate the anxiety of choice, for example, she designs garments to be worn daily over a period of months: the concomitant restriction is that any wearer is expected to set aside all other clothes. Her *A-Z Comfort Unit* (produced through her A–Z Administration company in annual editions since 1994) places functions within reach of the occupier of the bed at its heart. Frugality and luxury are combined, as these activities reflect Zittel's challenges to modern conveniences in her related *Living Unit* (for which she has designed even the bedpans). 'Service carts' couple up to *Comfort Unit* to provide for eating, dressing and writing. The unit is envisaged as being mass-produced but adaptable to individual needs – hence the fourth cart may be customised. The cosiness of the unit also suggests the pressures of confinement and of personal territory in an increasingly urbanised society. Such contradictions are a deliberate aspect of Zittel's work, and it is symptomatic of her humour that an earlier project, *Breeding Units*, involved the rearing of chickens reputedly with a view to creating '*the* luxury pet of the 1990s'.

A-Z Comfort Unit with Special Comfort Features by Dave Stewart 1994–5, mixed media

Selected Further Reading

General

Ellen H. Johnson (ed.), *American Artists On Art 1940–1980*, New York 1982

Dore Ashton (ed.), *Twentieth-Century Artists on Art*, New York and Toronto 1985

David Britt (ed.), *Modern Art: Impressionism to Post-Modernism*, London 1989

Charles Harrison and Paul Wood (eds.), *Art in Theory 1900–1990: An Anthology of Changing Texts*, Cambridge, Mass. and Oxford 1992

Kristine Stiles and Peter Selz (eds.), *Theories and Documents of Contemporary Art*, California and London 1996

The Twentieth-Century Art Book, London 1996

Ian Chilvers, *Oxford Dictionary of Twentieth-Century Art*, Oxford 1998

Peter Conrad, *Modern Times, Modern Places: Life and Art in the Twentieth Century*, London and New York 1999

Showing the Twentieth Century

André Malraux, *Museum Without Walls*, New York 1967

Andreas Huyssen, *After the Great Divide: Modernism, Mass Culture and Postmodernism*, Indiana and London 1986

Peter Vergo (ed.), *The New Museology*, London 1989

Douglas Crimp, *On the Museum's Ruins*, Cambridge, Mass. 1993

Roger Cardinal and John Elsner (eds.), *The Cultures of Collecting*, London 1994

Sherman and Rogdoff (eds.), *Museum Culture: Histories, Discourses, Spectacles*, London 1994

Tony Bennett, *The Birth of the Museum: History, Theory, Politics*, London and New York 1995

Bruce W. Ferguson, Reesa Greenberg and Sandy Nairne (eds.), *Thinking About Exhibitions*, London and New York 1996

Catherine de Zegher (ed.), *Inside the Visible*, Cambridge, Mass. and London 1996

Kynaston McShine, *The Museum as Muse: Artists Reflect*, exh. cat., MOMA, New York 1998

Landscape/Matter/Environment

Kenneth Clark, *Landscape into Art*, London 1949

Simon Cutts, *The Unpainted Landscape*, London 1987

Stuart Wrede and William Howard Adams (eds.), *Denatured Visions: Landscape and Culture in the Twentieth Century*, New York 1988

Jay Appleton, *The Symbolism of Habitat: An Interpretation of Landscape in the Arts*, Seattle and London 1990

Simon Schama, *Landscape and Memory*, London 1995

Jeffrey Kasthner (ed.), *Land and Environmental Art*, London 1999

Still Life/Object/Real Life

Mario Amaya, *Pop as Art*, London 1965

William S. Rubin, *Dada, Surrealism and their Heritage*, exh. cat., MOMA, New York 1968

Norman Bryson, *Looking at the Overlooked: Four Essays on Still Life Painting*, London 1995

Material Culture: The Object in British Art of the 1980s and 1990s, exh. cat., Hayward Gallery, London 1997

Margit Rowell, *Objects of Desire: The Modern Still Life*, exh.cat., MOMA, New York 1997

Sybille Ebert-Shifferer, *Still Life – A History*, London and New York 1999

History/Memory/Society

Griselda Pollock, *Vision and Difference: Femininity, Feminism and the Histories of Art*, London 1988

Craig Owens, *Beyond Recognition: Representation, Power and Culture*, California 1992

Peter Wollen, *Raiding the Ice Box: Reflections on Twentieth-Century Culture*, London 1993

Paul Wood, Francis Frascina, Jonathan Harris and Charles Harrison, *Modernism in Dispute: Art Since the Forties*, New Haven and London 1993

Richard Cork, *A Bitter Truth: Avant-Garde Art and the Great War*, New Haven 1994

Nude/Action/Body

Kenneth Clark, *The Nude: A Study of Ideal Art*, London 1956

John Berger, *Ways of Seeing*, London 1972

Laura Mulvey, *Visual and Other Pleasures*, Indiana and London 1989

Lynda Neade, *The Female Nude: Art, Obscenity and Sexuality*, London 1992

Kathleen Adler and Marcia Pointon, *The Body Imaged: The Human Form and Visual Culture since the Renaissance*, Cambridge 1993

Nicholas Mirzoeff, *Bodyscape: Art, Modernity and the Ideal Figure*, London 1995

Gregory Battock and Robert Nickas (eds.), *The Art of Performance: A Critical Anthology*, New York 1984

Sources of Quotations

Landscape/Matter/Environment pp.54–57:
Monet in Richard Kendall (ed.), *Monet by Himself*, London 1989; Cézanne in John Rewald (ed.), *Cézanne's Letters*, Oxford 1976; Derain in *The Georgia Review*, vol. 32, no. I, Spring 1978; Shevchenko first published Moscow 1913 (pamphlet), English translation in Harrison and Wood 1992; Léger first published in *Soirées de Paris*, 1914, English translation in Harrison and Wood 1992; Rozanova first published in the third issue of the journal of the Union of Youth Group, St Petersburg 1913, English translation in John Bowlt, *Russian Art of the Avant Garde*, London 1988; Mondrian first published in *De Stijl*, Leiden, February and March 1919, English translation in Harry Holzman and Martin S. James (eds.), *The New Art – The New Life: The Collected Writings of Piet Mondrian*, Boston 1986; Gabo and Pevsner first published as a poster in Moscow 1920, English translation in H. Read, *Gabo*, London 1957; Breton first published as a pamphlet in 1928, English translation by David Gascoyne, London 1936, reprinted in Harrison and Wood 1992; Hepworth in L. Martin, B. Nicholson and N. Gabo (ed.), *Circle – International Survey of Constructive Art*, London 1937; Arp first published in J. Alvard, *Témoignages pour la peinture abstraite*, Paris 1956, English translation by Joachim Neugroschel in Marcel Jean (ed.), *Jean (Hans) Arp: Collected French Writings*, London 1974; Ellen H. Johnson, excerpt from text introducing Gottlieb and Rothko's *Letter to The New York Times*, Sunday, June 13, 1943 in Johnson 1982; Kaprow in *Artnews*, vol.57, no.6, New York 1958; Newman first published in *Art in America*, vol.50, no.2, New York, Summer 1962, reprinted in Harrison and Wood 1992; Klein delivered as a lecture at the Sorbonne in 1959, English translation published in *Yves Klein*, exh. cat., Gimpel fils Gallery, London 1973; Smithson in *Artforum*, New York, September 1968; Merz first published in *Data*, no.1, Milan, September 1971, English translation in Germano Celant, *Mario Merz*, exh. cat., Solomon R. Guggenheim Museum, New York 1989; Krauss in *October*, no.8, Cambridge, Mass., Spring 1979; Morris in *October*, no.12, Cambridge, Mass., Spring 1980; Long in *Five, Six, Pick Up Sticks*, Anthony d'Offay Gallery, London, September 1980; Beuys in Carin Kuoni (ed.), *Energy Plan for the Western Man, Joseph Beuys in America*, New York 1990; Wall in Thierry de

Duve, Arielle Pelenc and Boris Groys, *Jeff Wall*, London 1996; Finlay in Yves Abrious, *Ian Hamilton Finlay: A Visual Primer*, London 1985; Criqui in *Parkett*, no. 44, Zurich, 1995

Still Life/Object/Real Life pp.70–73: Bryson in Norman Bryson, *Looking at the Overlooked: Four Essays on Still Life Painting*, London 1995; Cézanne in Rewald 1976; Matisse in J.D. Flamm, *Matisse on Art*, London and New York 1973; Boccioni first published as a leaflet by *Poesia*, Milan 1910, English translation from the Sackville Gallery catalogue, London 1912, reprinted in Harrison and Wood 1992; Gleizes and Metzinger first published as *Du Cubisme*, Paris, 1912, English translation in R.L. Herbert, *Modern Artists on Art*, New York, 1964; Léger first published in *Montjoie*, Paris 1913, reprinted in Harrison and Wood 1992; Duchamp first published in *The Blind Man*, New York 1917, reprinted in Lucy Lippard (ed.), *Dadas on Art*, New Jersey 1971; Ernst in Lucy Lippard (ed.), *Surrealists on Art*, New Jersey 1970; Agar in Eileen Agar, *A Look at My Life*, London 1988; Bataille in Georges Bataille, *Ouevres complètes*, Paris 1970; Benjamin from a lecture given on 27 April 1934, published in Walter Benjamin, *Understanding Brecht*, London 1983; Schapiro from a paper delivered to the First American Artists' Congress in New York in 1936, reprinted in D. Schapiro (ed.), *Social Realism – Art as a Weapon: critical studies in American art*, New York 1973; Greenberg first published in *Partisan Review*, VI, no.5, New York, Fall 1939, reprinted in Harrison and Wood 1992; Dubuffet first published in *Prospectus*, Paris 1946, reprinted in Harrison and Wood 1992; Oldenburg first published to accompany the exhibtion *The Store* 1961, reprinted in Harrison and Wood 1992; Banham in P. Barker (ed.), *Arts in Society*, London 1977; Cage first published in *Metro*, Milan, May 1961, reprinted in John Cage, *Silence*, Cambridge, Mass. 1969; Judd first published in *Arts Yearbook*, 8, New York 1965, reprinted in Stiles and Selz 1996; Cragg in *Tony Cragg*, exh. cat., Palais de Beaux-Arts, Brussels 1985; Woodrow in *Objects and Sculpture*, exh. cat., ICA, London 1981; West in *Possible Worlds: Sculpture from Europe*, exh. cat., ICA , London 1991; Hiller in Barbara Einzig (ed.), *Thinking About Art. Conversations with Susan Hiller*, Manchester and New York 1996; de Monchaux in *Tatler*, June 1997

History/Memory/Society pp.90–93: Marinetti first published in *Le Figaro*, Paris, 20 February 1909, English translation in Harrison and Wood 1992; Lewis first published in *Blast*, London 1914, reprinted in Harrison and Wood 1992; Hülsenbeck and Hausmann first published in *Der Dada*, no.1, 1919, English translation in Harrison and Wood 1992; Schlemmer first published in *The First Bauhaus Exhibition in Weimar* (pamphlet) 1923, reprinted in Hans M. Wingler, *The Bauhaus: Weimar, Dessau, Berlin and Chicago*, Cambridge, Mass. 1969 and 1976; Malevich first published in *The Non-Objective World*, Munich 1927, reprinted in Eric Protter (ed.), *Painters on Painting*, New York 1963; Davis in *American Magazine of Art*, New York 1935; Léger first published in *Art Front*, vol.3, no.1, New York, February, 1937, reprinted in Fernand Léger, *The Function of Painting*, New York 1973; Breton and Trotsky first published in *Partisan Review IV*, no.1, New York, Fall 1938, reprinted in Harrison and Wood 1992; Picasso in *Lettres Françaises*, Paris 1945; Mühl in *From Action Painting to Actionism. Vienna 1960–1965*, Klagenfurt 1988; Beuys in *Art into Society, Society into Art*, exh.cat., ICA, London 1974; Krauss in *Literary Review*, London 1982; Baselitz lecture entitled 'Vier Wände und Oberlicht' delivered on 26 April 1979, published in English in *Georg Baselitz: Works of the Seventies*, exh. cat., Michael Werner Gallery, New York 1992; Hall in *Identity*, ICA Documents 6, London 1987; Wall in de Duve et al. 1996; Horsfield in *Craigie Horsfield*, exh. cat., ICA, London 1991; Kruger in John Roberts (ed.), *Selected Errors. Writings on Art and Politics, 1981–90*, London and Colorado 1992; Pollock in Catherine de Zegher (ed.), *Inside the Visible*, Cambridge, Mass. and London 1996; Araeen in Jean Fisher (ed.), *Global Visions Towards a New Internationalism in the Visual Arts*, London 1994; Emin in *Frieze*, issue 34, London 1997

Nude/Action/Body pp.108–111: Freud first published in *Grundfragen des Neven- und Seelenlebens*, Wiesbaden, 1901, English translation in J. Strachey (ed.), *The Standard Edition of the Complete Psychological Works of Sigmund Freud*, London 1953–74; Matisse first published in *La Grande Revue*, Paris, 25 December 1908, English translation in Flamm 1973; Beckmann and Peckstein first published in Kasimir Edschmid (ed.), *Schöpferische Konfession, XIII, Tribune der Kunst und Zeit*, Berlin, 1920, English translation in V.H. Miesel (ed.), *Voices of German Expressionism*, New Jersey 1970; Hepworth in *Carvings and Drawings*, London 1952; Freud first published in *Encounter*, vol III, no 1, July 1954 reprinted in Stiles and Selz 1996; Giacometti in *Alberto Giacometti. Photographed by Herbert Matter*, New York 1987; Klein in *Zero*, no.3, Düsseldorf, July 1960, English translation in *Zero*, Cambridge, Mass. 1973; Manzoni in *Some Experiments. Some Projects*, Milan 1962, reprinted in Germano Celant (ed.), *Manzoni: Paintings, Reliefs and Objects*, exh. cat., Tate,London 1974; Schneemann in Bruce McPherson (ed.), *More than Meatjoy: Complete Performance Works and Selected Wrtitings*, New York 1979; Brus first published in *Le Marias, Sonderheft Günter Brus*, 1965, reprinted in Hubert Klocker (ed.), *Viennese Actionism/Wiener Aktionismus 1910–74*, Klagenfurt 1989; Gilbert and George in 'A Day in the Life of George and Gilbert the Sculptors', *Konzept-Kunst*, Autumn 1971; Bacon in David Sylvester, *The Brutality of Fact: Interviews with Francis Bacon*, London 1987; Warhol in Harcourt Brace Jovanovich, *The Philosophy of Andy Warhol*, New York 1975; Kelly first published in *Wedge* no.6, Winter 1984, reprinted in Mary Kelly, *Imaging Desire*, Cambridge, USA 1996; Haraway in *Simians, Cyborgs and Women: The Reinvention of Nature*, New York and London 1991; Richard in *Art and Text*, no.21, May–July 1986; Chawaf in Alice A. Jardine and Anne M. Menke (ed.), *Shifting Scenes: Interviews on Women, Writing and Politics in Post–68 France*, New York, 1991; Horn in *Rebecca Horn*, exh.cat., Guggenheim Museum, New York 1993; Balka in *Miroslav Balka: Die Rampe*, exh. cat., Stedelijk van Abbemuseum, Eindhoven and Museum Sztuki, Lodz 1994; Lucas in *Frieze*, issue 12, London 1994; Morgan in *Frieze*, issue 20, London 1995; Lippard in *Art International*, November 1966; Hatoum in Michael Archer, Guy Brett, Catherine de Zegher, *Mona Hatoum*, London 1997; Bourgeois in Christiane Meyer-Thoss, *Louise Bourgeois. Designing For Free Fall*, Zurich 1992

Quotations compiled by Iwona Blazwick, Susanne Bieber and Clare Fitzsimmons

Credits

Donors to Tate Modern

The Tate Gallery would like to thank all those who have given to the Tate Modern capital campaign. This list is correct as at 1 March 2000.

Donors to the Capital Campaign

The Annenberg Foundation

Arthur Andersen (pro-bono)

The Arts Council of England

Lord and Lady Attenborough

The Baring Foundation

Ron Beller and Jennifer Moses

David and Janice Blackburn

Mr and Mrs Anthony Bloom

Mr and Mrs John Botts

Frances and John Bowes

Mr and Mrs James Brice

Donald L. Bryant Jr Family

Melva Bucksbaum Goldman

The Carpenters' Company

Cazenove & Co.

The Clore Foundation

Edwin C. Cohen

The John S. Cohen Foundation

Ronald and Sharon Cohen

Giles and Sonia Coode-Adams

Michel and Helene David-Weill

Gilbert de Botton

Pauline Denyer-Smith and Paul Smith

Sir Harry and Lady Djanogly

The Drapers' Company

English Heritage

English Partnerships

Ernst & Young

Esmée Fairbairn Charitable Trust

Doris and Donald Fisher

Richard B. and Jeanne Donovan Fisher

The Fishmongers' Company

The Foundation for Sport and the Arts

Friends of the Tate Gallery

Alan Gibbs

GJW Government Relations (pro-bono)

The Horace W. Goldsmith Foundation

The Worshipful Company of Goldsmiths

Noam and Geraldine Gottesman

The Worshipful Company of Grocers

Pehr and Christina Gyllenhammar

Mimi and Peter Haas

The Worshipful Company of Haberdashers

Hanover Acceptances Limited

The Headley Trust

The Juliet Lea Hillman Simonds Foundation

Mr and Mrs André Hoffmann

Anthony and Evelyn Jacobs

Howard and Linda Karshan

Peter and Maria Kellner

Irene and Hyman Kreitman

The Lauder Foundation – Leonard and Evelyn Lauder Fund

Leathersellers' Company Charitable Fund

Edward and Agnes Lee

Lex Service Plc

Anders and Ulla Ljungh

The Frank Lloyd Family Trusts

Mr and Mrs George Loudon

The Stuart and Ellen Lyons Charitable Trust

Ronald and Rita McAulay

McKinsey & Co. (pro-bono)

David and Pauline Mann-Vogelpoel

The Mercers' Company

The Meyer Foundation

The Millennium Commission

The Mnuchin Foundation

The Monument Trust

Mr and Mrs M.D. Moross

Guy and Marion Naggar

Peter and Eileen Norton, The Peter Norton Family Foundation

Maja Oeri and Hans Bodenmann

The Nyda and Oliver Prenn Foundation

The Quercus Trust

The Rayne Foundation

John and Jill Ritblat

Lord and Lady Rothschild

The Dr Mortimer and Theresa Sackler Foundation

The Salters' Company

Stephan Schmidheiny

David and Sophie Shalit

Peter Simon

Mr and Mrs Sven Skarendahl

Belle Shenkman Estate

Simmons & Simmons (pro-bono)

London Borough of Southwark

Mr and Mrs Nicholas Stanley

The Starr Foundation

Charlotte Stevenson

Hugh and Catherine Stevenson

John Studzinski

David and Linda Supino

The Tallow Chandlers' Company

Carter and Mary Thacher

Thomas Lilley Memorial Trust

Townsley & Co.

The 29th May 1961 Charitable Trust

David and Emma Verey

Dinah Verey

The Vintners' Company

Robert and Felicity Waley-Cohen

The Weston Family

Mr and Mrs Stephen Wilberding

Graham and Nina Williams

Poju and Anita Zabludowicz

and those donors who wish to remain anonymous

Tate Collection Benefactors

Douglas Cramer

Janet Wolfson de Botton

Founding Corporate Partners

AMP

BNP Paribas

CGU plc

Clifford Chance

Energis Communications

Freshfields

GKR

Goldman Sachs

Lazard Brothers & Co., Limited

London Electricity plc, EDF Group

Pearson plc

Prudential plc

Railtrack PLC

Reuters

Rolls-Royce plc

Schroders

UBS Warburg

Donors of Works Illustrated

Absalon *Cell No. 1* 1992
Presented by the Patrons of New Art through the Tate Gallery Foundation 1997

Carl Andre *Venus Forge* 1980
Presented by Janet Wolfson de Botton 1996

Jean Arp *Constellation According to the Laws of Chance* c.1930
Bequeathed by E.C. Gregory 1959

Jean Arp *Winged Being* 1961
Presented by Mme Marguerite Arp-Hagenbach, the artist's widow 1975

Francis Bacon *Three Studies for Figures at the Base of a Crucifixion* c.1944
Presented by Eric Hall 1953

Giacomo Balla *Abstract Speed – The Car has Passed* 1913
Presented by the Friends of the Tate Gallery 1970

Matthew Barney *OTTOshaft* 1992
Presented by the Patrons of New Art through the Tate Gallery Foundation 1994

Georg Baselitz *Untitled* 1982–3
Acquired by purchase and gift from Hartmut and Silvia Ackermeier, Berlin 1993

Lothar Baumgarten *El Dorado – Gran Sabana* 1977–85
Purchased with assistance from the American Fund for the Tate Gallery, courtesy of Edwin C. Cohen and Echoing Green 1990

Max Beckmann *Carnival* 1920
Purchased with assistance from the National Art Collections Fund and Friends of the Tate Gallery and Mercedes-Benz U.K. Ltd 1981

Joseph Beuys *The End of the Twentieth Century* 1983–5
Purchased with assistance from Edwin C. Cohen and Echoing Green 1991

Christian Boltanski *The Reserve of Dead Swiss* 1990
Presented by the Fondation Cartier 1992

Pierre Bonnard *The Bath* 1925
Presented by Lord Ivor Spencer Churchill through the Contemporary Art Society 1930

Louise Bourgeois *Cell (Eyes and Mirrors)* 1989–93
Presented by the American Fund for the Tate Gallery 1994

Georges Braque *Clarinet and Bottle of Rum on a Mantelpiece* 1911
Purchased with assistance from a special government grant and with assistance from the National Art Collections Fund 1978

Anthony Caro *Early One Morning* 1962
Presented by the Contemporary Art Society 1965

Anthony Caro *Night Movements* 1987–90
Purchased with funds provided by the Kreitman Foundation 1994

Paul Cézanne *The Gardener Vallier* c.1906
Bequeathed by C. Frank Stoop 1933

Giorgio De Chirico *The Uncertainty of the Poet* 1913
Purchased with assistance from the National Art Collections Fund (Eugene Cremetti Fund), the Carol Donner Bequest, the Friends of the Tate Gallery and members of the public 1985

Richard Deacon *For Those Who Have Ears #2* 1983
Presented by the Patrons of New Art through the Friends of the Tate Gallery 1985

Jean Dubuffet *The Busy Life* 1953
Presented by the artist 1966

Marcel Duchamp *Fresh Widow* 1920, replica 1964
Purchased with assistance from the National Lottery through the Heritage Lottery Fund 1997

Marcel Duchamp and Richard Hamilton
The Bride Stripped Bare by her Bachelors, Even (The Large Glass) 1915–23, replica 1965–6
Presented by William N. Copley through the American Federation of Arts 1975

Luciano Fabro *Ovaries* 1988
Presented by the Patrons of New Art through the Friends of the Tate Gallery 1989

Jean Fautrier *Head of a Hostage* 1943–4
Purchased with assistance from the Friends of the Tate Gallery 1997

Ian Hamilton Finlay *A Wartime Garden [collaboration with John Andrew]* 1989
Purchased with assistance from the Patrons of New Art through the Tate Gallery Foundation 1992

Naum Gabo *Red Cavern* c.1926
Presented by the artist 1977

Alberto Giacometti *Hour of the Traces* 1930
Purchased with assistance from the Friends of the Tate Gallery 1975

Nan Goldin *Jimmy Paulette and Tabboo! undressing, NYC* 1991
Presented by the Patrons of New Art Special Purchase Fund through the Tate Gallery Foundation 1997

Arshile Gorky *Waterfall* 1943
Purchased with assistance from the Friends of the Tate Gallery 1971

Georg Grosz *Suicide* 1916
Purchased with assistance from the National Art Collections Fund 1976

Philip Guston *Hat* 1976
Presented by the American Fund for the Tate Gallery, courtesy of a private collector 1996

Mona Hatoum *Incommunicado* 1993
Purchased with funds provided by the Gytha Trust 1995

Barbara Hepworth *Three Forms* 1935
Presented by Mr and Mrs J.R. Marcus Brumwell 1964

Barbara Hepworth *Pelagos* 1946
Presented by the artist 1964

Damien Hirst *Forms Without Life* 1991
Presented by the Contemporary Art Society 1992

David Hockney *Tea Painting in an Illusionistic Style* 1961
Purchased with assistance from the National Art Collections Fund 1996

Jenny Holzer *Truisms* 1984
Presented by the Patrons of New Art through the Friends of the Tate Gallery 1985

Rebecca Horn *Ballet of the Woodpeckers* 1986
Purchased with assistance from the Patrons of New Art 1991

Rebecca Horn *Concert for Anarchy* 1990
Purchased with assistance from the National Art Collections Fund 1999

Gwen John *Nude Girl* 1909–10
Presented by the Contemporary Art Society 1917

Donald Judd *Untitled* 1972
Presented by the American Fund for the Tate Gallery 1992

Donald Judd *Untitled (DJ 85-51)* 1985
Presented by Janet Wolfson de Botton 1996

Wassily Kandinsky *Cossacks* 1910–11
Presented by Mrs Hazel McKinley 1938

Anish Kapoor *Adam* 1988–9
Lent by the American Fund for the Tate Gallery, courtesy of Edwin C. Cohen for A., A., A. and J. 1991

Sol LeWitt *Five Open Geometric Structures* 1979
Presented by Janet Wolfson de Botton 1996

Roy Lichtenstein *Interior with Waterlilies* 1991
 Presented by the Douglas S. Cramer Foundation in
 honour of Dorothy and Roy Lichtenstein 1997

Richard Long *Slate Circle* 1979
 Presented by Anthony d'Offay 1980

René Magritte *Man with a Newspaper* 1928
 Presented by the Friends of the Tate Gallery 1964

Kasimir Malevich *Dynamic Suprematism* 1915 or
 1916
 Purchased with assistance from the Friends
 of the Tate Gallery 1978

Henri Matisse *Back IV* c. 1930, cast 1955–6
 Purchased with assistance from the Knapping Fund
 1955

Henri Matisse *The Snail* 1953
 Purchased with assistance from the Friends
 of the Tate Gallery 1962

Steve McQueen *Bear* 1993
 Presented by the Patrons of New Art Special
 Purchase Fund through the Tate Gallery Foundation
 1996

Joan Miró *Head of a Catalan Peasant* 1925
 Purchased jointly with the Scottish National Gallery
 of Modern Art with assistance from the National Art
 Collections Fund 1999

Amedeo Modigliani *Head* c. 1911–2
 Transferred from the Victoria & Albert Museum 1983

Piet Mondrian *Composition B with Red* 1935
 Accepted by H.M. Government in lieu of tax with
 additional payment (Grant-In-Aid) made with
 assistance from the National Lottery through the
 Heritage Lottery Fund, the National Art Collections
 Fund and the Friends of the Tate Gallery 1999

Piet Mondrian *Composition with Red and Blue* 1935
 Lent from a private collection 1981

Piet Mondrian *Sun, Church in Zeeland* 1910
 Purchased with assistance from the National Lottery
 through the Heritage Lottery Fund, the Kreitman
 Foundation, the National Art Collections Fund and
 the Friends of the Tate Gallery 1997

Claude Monet *Water-Lilies* after 1916
 Lent by the National Gallery 1997

Henry Moore *Reclining Figure* 1951
 Presented by the artist 1978

Henry Moore *Recumbent Figure* 1938
 Presented by the Contemporary Art Society 1939

Edvard Munch *The Sick Child* 1907

 Presented by Thomas Olsen 1939

Julian Opie *It Is Believed That Some Dinosaurs
 Could Run Faster Than A Cheetah* 1991
 Presented by the artist 1996

Cornelia Parker *Cold Dark Matter: An Exploded
 View* 1991
 Presented by the Patrons of New Art Special
 Purchase Fund through the Tate Gallery Foundation
 1995

Pablo Picasso *The Three Dancers* 1925
 Purchased with a special Grant-in-Aid and the
 Florence Fox Bequest with assistance from the
 Friends of the Tate Gallery and the Contemporary
 Art Society 1965

Pablo Picasso *Weeping Woman* 1937
 Accepted by H.M. Government in lieu of tax with
 additional payment Grant-in-Aid made with
 assistance from the National Heritage Memorial
 Fund, the National Art Collections Fund and the
 Friends of the Tate Gallery 1987

Jackson Pollock *Naked Man with Knife* c. 1938–40
 Presented by Frank Lloyd 1981

Jackson Pollock *Number 14* 1951
 Purchased with assistance from the American
 Fellows of the Tate Gallery Foundation 1988

Germaine Richier *Storm Man* 1947–8, cast 1995
 Purchased with assistance from the National Art
 Collections Fund 1995

Bridget Riley *Hesitate* 1964
 Presented by the Friends of the Tate Gallery 1985

Auguste Rodin *The Kiss* 1901–4
 Purchased with assistance from the National Art
 Collections Fund and public contributions 1953

Mark Rothko *Black on Maroon* 1959
 Presented by the artist through the American
 Federation of Arts 1969

Mark Rothko *Untitled* c. 1951–2
 Presented by the Mark Rothko Foundation 1986

Karl Schmidt-Rottluff *Two Women* 1912
 Presented by the executors of Dr Rosa Shapire
 1954

Richard Serra *2-2-1: To Dickie and Tina* 1969, 1994
 Purchased with assistance from the American Fund
 for the Tate Gallery 1997

Gino Severini *Suburban Train Arriving in Paris* 1915
 Purchased with assistance from a member of the
 National Art Collections Fund 1968

Cindy Sherman *Untitled C* 1975
 Presented by Janet Wolfson de Botton 1996

Cindy Sherman *Untitled Film Still #17* 1978,
 reprinted 1998
 Presented by Janet Wolfson de Botton 1996

David Smith *Home of the Welder* 1945
 Lent from the collection of Candida and
 Rebecca Smith 1984

Thomas Struth *National Gallery I, London 1989* 1989
 Purchased with assistance from the Friends of the
 Tate Gallery 1994

Dorothea Tanning *Eine Kleine Nachtmusik* 1943
 Purchased with assistance from the National Art
 Collections Fund and the American Fund for the
 Tate Gallery 1997

Boris Taslitzky *Riposte* 1951
 Presented by the Friends of the Tate Gallery 1998

Bill Viola *Nantes Triptych* 1992
 Purchased with assistance from the Patrons of
 New Art through the Tate Gallery Foundation and
 from the National Art Collections Fund 1994

Jeff Wall *A Sudden Gust of Wind (after Hokusai)* 1993
 Purchased with assistance from the Patrons of New
 Art through the Tate Gallery Foundation and from
 the National Art Collections Fund 1995

Andy Warhol *Electric Chair* 1964
 Presented by Janet Wolfson de Botton 1996

Gillian Wearing *Confess All On Video. Don't Worry
 You Will Be in Disguise. Intrigued? Call Gillian* 1994
 Presented by Maureen Paley, Interim Art through
 the Patrons of New Art 1997

Rachel Whiteread *Untitled (Air Bed II)* 1992
 Purchased with assistance from the Patrons of
 New Art through the Tate Gallery Foundation 1993

Bill Woodrow *Elephant* 1984
 Presented by Janet Wolfson de Botton 1996 to
 celebrate the Tate Gallery Centenary 1997

Index

Artists and page numbers in **bold** type refer to main entries in the A-Z section.

Italic page numbers refer to illustrations.